ESS GEZUNTERHAIT

~

Eat in
good health

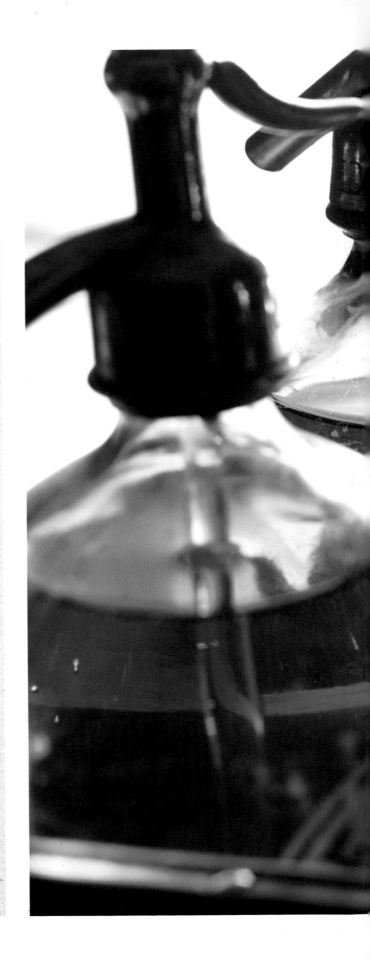

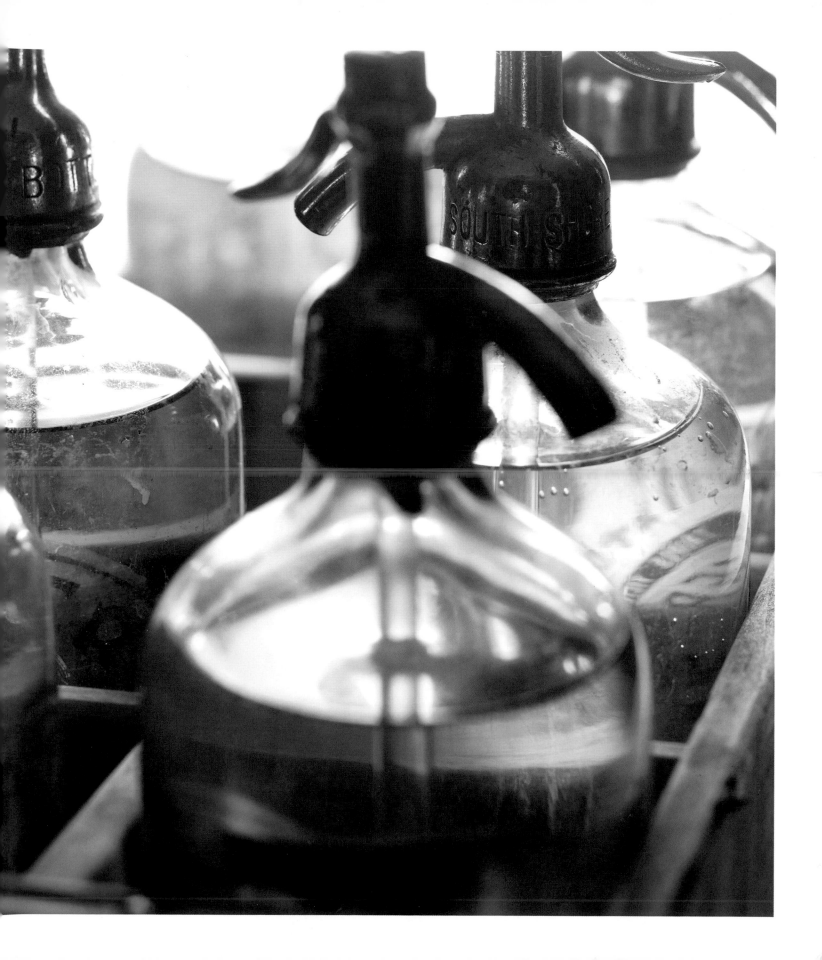

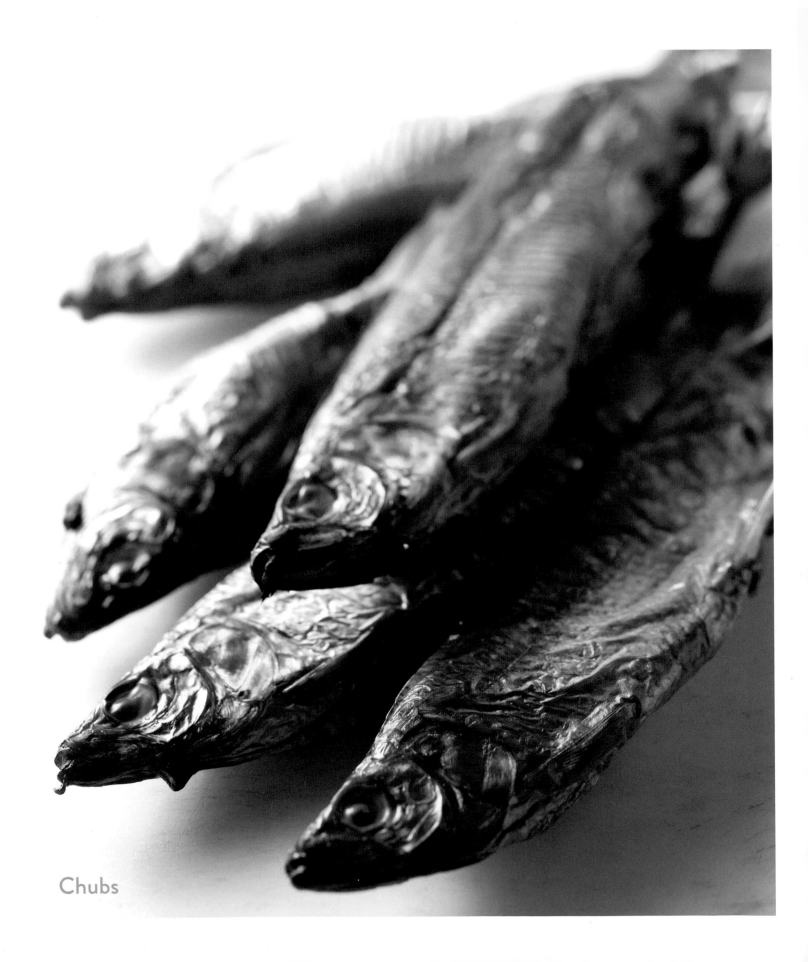

Chubs

EATING
DELANCEY

A Celebration
OF
JEWISH FOOD

Aaron **REZNY** ◆ Jordan **SCHAPS**

Introduction by **JOAN RIVERS**

Photographs by **AARON REZNY**

pH powerHouse Books

BROOKLYN, NY

So long as you have food
in your mouth,
you have solved all questions
for the time being.

FRANZ KAFKA

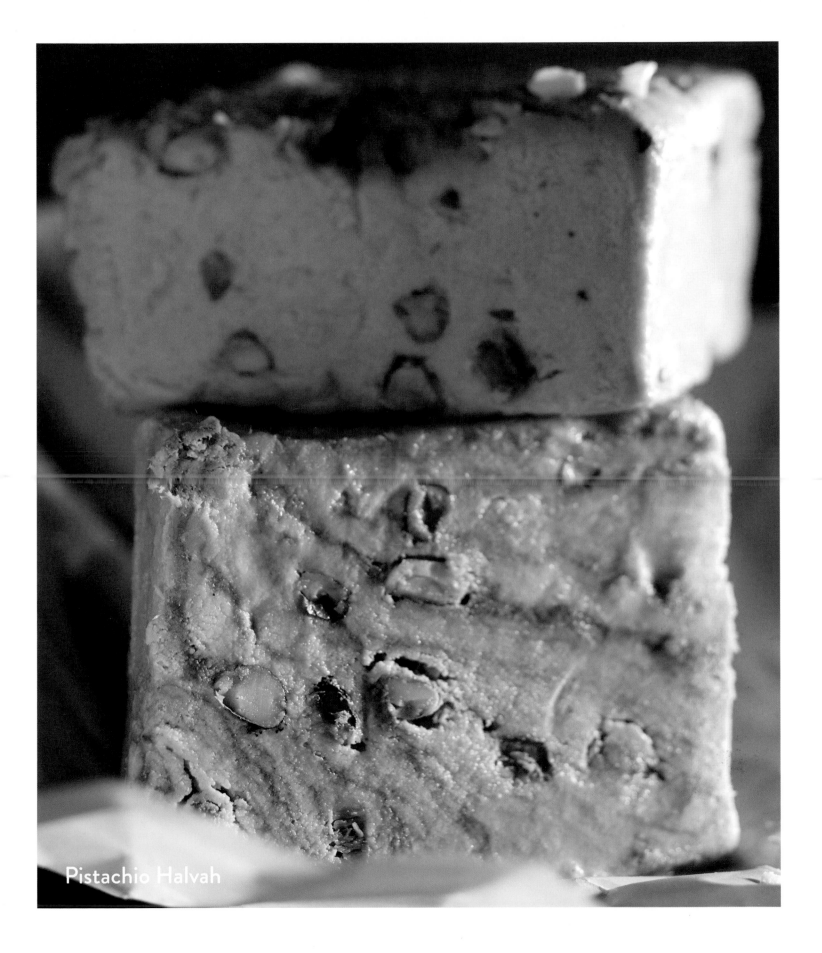

Pistachio Halvah

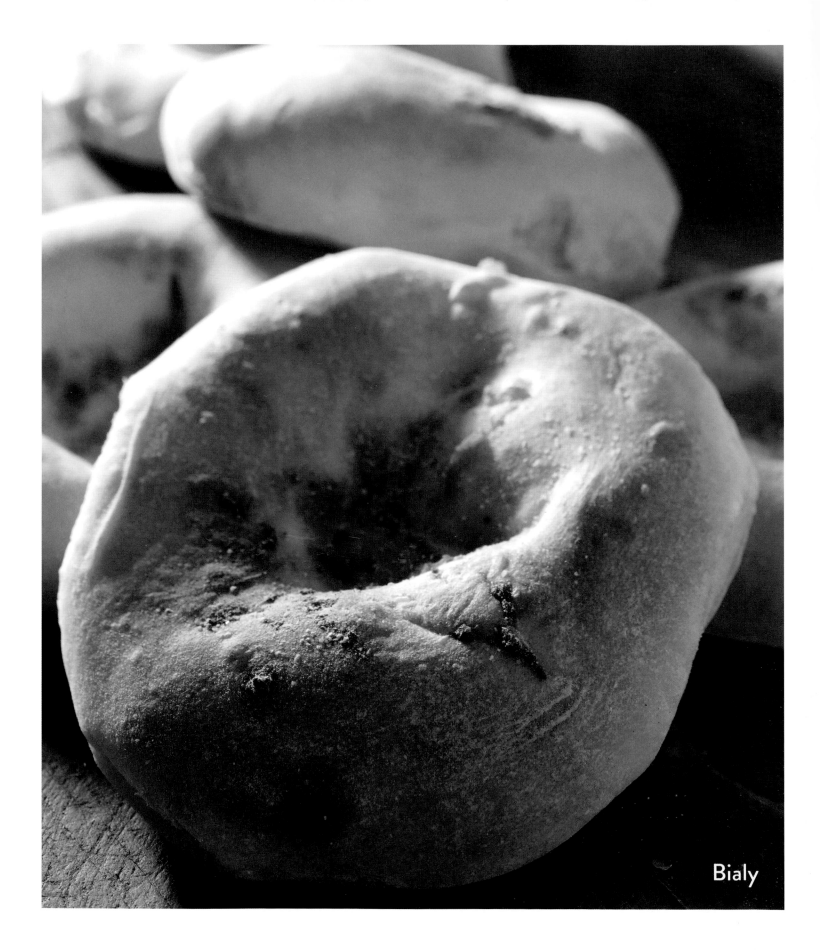

Bialy

AUTHOR'S NOTE

can trace my visual connection to food back to my early childhood, when some of my earliest memories were formed around the dinner table in our home in Brooklyn. To us, sharing a meal was a celebration of life and our world revolved around the traditional Eastern European dishes my mother laid out for us every night. Stories about the old country, insights, laughter, and love were free-flowing during those meals, and those experiences have made lasting impressions that are expressed in my work to this day.

Eating Delancey is a personal homage to the vanishing flavors of my youth. After scouring the streets and shops of Manhattan's Lower East Side, I brought select items—bagels, knishes, farfel, old seltzer bottles—back to my studio, where I restaged them, forever preserving them for others to enjoy.

AARON REZNY

AUTHOR'S NOTE

Bubbe Ethel, my Bubbe Ethel (née Kagan, married Raben, from Rabinowitz, from Rabinovitch, from Telechan, Belarus), was the best cook who ever lived. Not sure she could make scrambled eggs, but chopped liver, gefilte fish with chrain (horseradish), brisket, roast chicken, carrot tzimmes, that she could make! She also made, (perhaps invented) a turnip salad that no one seems to know of or about (thin sliced or shredded raw white turnip, chopped onions, garlic, and oil, or maybe chicken schmaltz, simply tossed together.) I loved it! I also loved her "special" dishes, and she knew I did. At family holiday dinners she proudly brought me delicacies that my cousins would NOT consider. A platter of stewed chicken feet, "unborn eggs" (from the cavity of fresh killed chicken), chicken giblets (the pipick, the gorgel, the herz, the leber, the helzel), and gribenes. It was offal and it was terrific. Who knew I was eating like Jacques Pépin in my Bubbe's Russian Yiddish American kitchen!

JORDAN SCHAPS

A CELEBRATION OF JEWISH FOOD
BY JOAN RIVERS

My mother was a very chic woman, very well read, a great hostess, and a horrible cook. She literally couldn't cook anything beyond just a few dishes. And we weren't kosher but she always went to kosher butchers. She thought the meat was better quality—not that it mattered since she didn't know what to do with it in the first place. You know how they butcher kosher meat, right? The cows aren't slaughtered. They're nagged to death.

There's an old joke: What does a Jewish woman make for dinner? Reservations. That was my mother. She did cook a few things: kasha varnishkes, eggele (or eyerlekh, which is Yiddish for "little eggs." These are creamy, flavorful unhatched chicken eggs, either cooked inside a chicken or in a soup), and gribenes, which I just loved until I was about 13 and realized how fattening they are. And we always had challah.

So how did I develop my love for good Jewish food when it wasn't on our table daily? I'll tell you. My father was a doctor with a huge ethnic practice in Brownsville, Brooklyn. Obviously, most patients paid him but some could not afford to, and so

Joan Rivers, age five.

they'd bring food in exchange for medical services. We got soups, blintzes. . .you name it. Stuffed derma was a big one for fixing a burst appendix. Oh my God, the food. . .it was just terrific and this is how I grew up—eating such food cooked with love and delivered by infirm and dying patients.

Let's talk knishes. We lived in Brooklyn on New York Avenue and President Street, which was known as "Doctor's Row." Every Sunday we drove into Manhattan to my "rich" aunt's apartment on Park Avenue. She had these very grand parties—musicales—guests in attendance had sung at the Metropolitan Opera, written the latest novels, and produced lavish Broadway spectacles. In other words, they were a very successful and artsy group. On our way to my aunt's place we'd drive over the Manhattan Bridge and stop at Yonah Schimmel's on Houston Street for a knish, because even though my aunt threw these extraordinary soirees, we knew the kind of finger foods she'd be serving didn't compare to a great knish. We'd show up on Park Avenue,

smelling of onions and potatoes and hand her white-gloved doorman a greasy brown paper bag full of napkins and wrappings and say, "Here, hide the evidence!"

I still yearn for all of those delicious childhood treats. Matzo balls that melt in your mouth! Chopped liver that's just creamy enough. Flanken so tender that it doesn't require a knife to eat it.

So, what do I do about getting these? Starbucks doesn't have a kosher section where I can order a "glatte." So I go to Sammy's Roumanian on Chrystie Street every four years or so with friends and indulge. I took Melissa once and I thought she was going to die. And my grandson—it's so sad—he looks at Jewish food and doesn't really get it. But I look at Jewish food and think, "How can anyone hate the Jews with all of the scrumptious things they produce?" I still can't believe the Israelis won the Six Day War because with all of those tasty goodies, when did they find the time to pick up their weapons and fight? I'm imagining them just sitting around, eating their rations and saying, "Yeah, yeah, we'll get to the fighting in a little bit."

If I had to choose, my last meal would be a good piece of gefilte fish with some fantastic freshly grated horseradish on it. Or noodle kugel. Or halvah—Turkish delight, fuck you. And kreplach. Don't take me out for Chinese. I'm not happy at a Chinese restaurant. I want kreplach! Jewish food makes Italian food seem like Lean Cuisine.

The amazing thing is, believe it or not, I only had so-so Jewish food in Israel. Maybe it's because my hostess's daughter was a vegan, but the food of my childhood. . .prune hamantaschen, a good macaroon, tzimmes! I'm in heaven. And chicken feet. Oh my god, those burnt, scraped chicken feet. Sign me up. I'm in. The only thing that I'll pass on is the Manischewitz. I don't like sweet wine. But, even that's worth it if it's paired with flanken's cousin, a good brisket. ◊

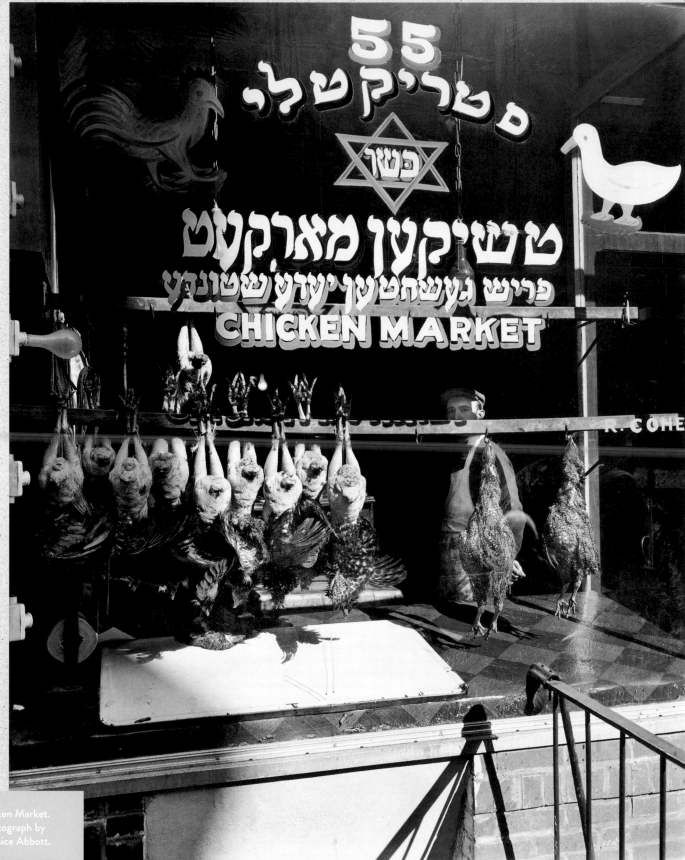

MASTERS/GETTY IMAGES

Chicken Market.
Photograph by
Berenice Abbott.

FOREWORD
BY FYVUSH FINKEL

When I was growing up in the 1920s in New York—Brooklyn, specifically—many Jewish mothers and grandmothers would beg their children, "Essen, mein kind!" Mine didn't have to say that to me!

All of my life, I have loved Jewish food and kept a kosher house. I have traveled the world and eaten all kinds of foods, but, in my book, nothing compares to the sort of food I was raised on.

My mother, who was born in Russia, was a good cook. She didn't have "specialties," but she could cook anything, and well! Jewish people of that era never had a recipe; they inherited everything they needed to know from their mothers and their mother's mothers and so on.

My family—my father, my mother, me, and my three brothers—celebrated Shabbos every Friday night, usually at our house, but sometimes at my grandparents' house. (My grandfather was a shamash at the synagogue and our Hebrew teacher, and was more religiously observant than

MASTERS/GETTY IMAGES

Jacob Heyman butcher shop.
Photograph by Berenice Abbott.

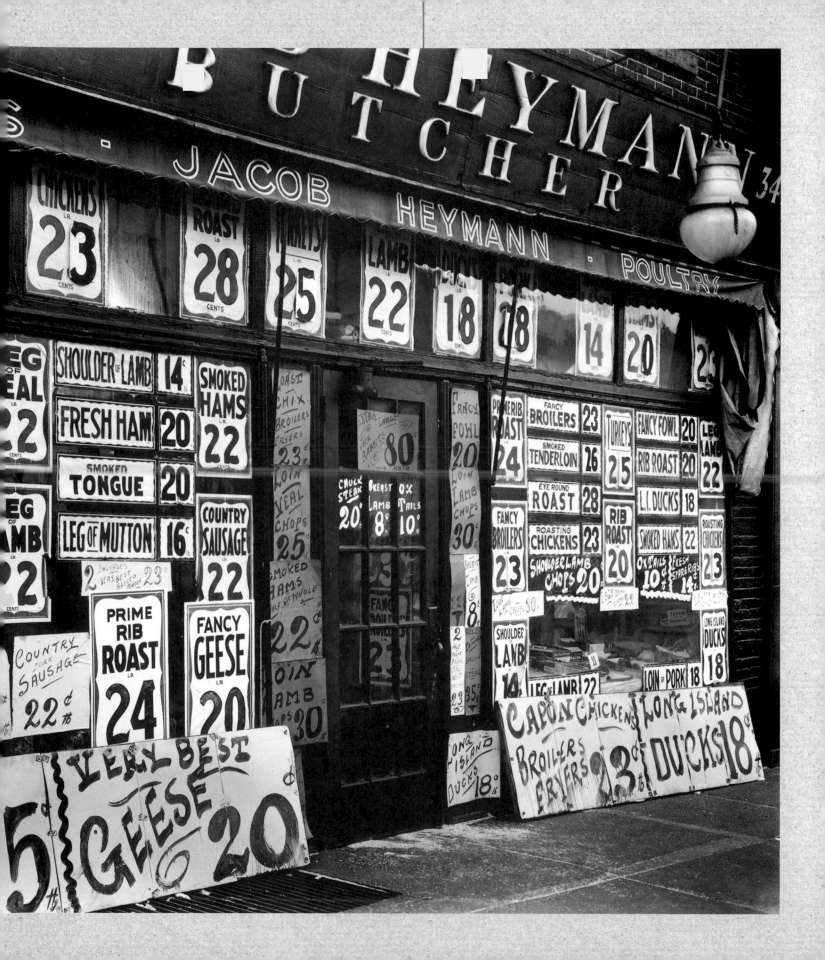

we were.) Either way, we always had chicken, sweet potatoes and vegetables—oh, my God!

For the other Jewish holidays like Passover, we would always go to my grandparents' house, where my grandmother would cook the food. For the Seder she would make the usual meal—but the best thing that my grandmother would make was chuls [cholent]: a stew of potatoes, meats, and the filling of the derma [intestines] that has to be cooked for 24 hours. I don't think anybody's ever duplicated it.

Now you're getting me hungry!

I first learned to cook when I got married. My wife was a teacher and when our two boys were young and she was away at school, I had to prepare meals. She told me what to do and I actually became pretty good at it.

My own career began when I was just nine as an actor in the Yiddish theater. I was fluent in Yiddish (it was all we spoke in the house), I was a ham (even then), and a Yiddish theater in Brooklyn needed a little boy to sing a song in Yiddish ("Oh Promise Me"), so it was a match made in heaven. In the ensuing years I made my way to the Yiddish theaters on the Lower East Side on and around Second Avenue, where greats like Molly Picon and Ludwig Satz were big stars, and where I achieved quite a bit of success myself. Of course, I also ate around there, too!

(Funnily enough, one of my most popular songs was "No Matter What Happens I've Got to Eat"—it was a hit, and audience members all yelled back, "Essen! Essen!")

There were pushcarts in the streets—even a kosher one that sold hot dogs, which I used to love! That particular vendor would advertise a foot-long hot dog, which he folded up and put in a club roll, along with sauerkraut and whatever else you wanted, and I'd have that with a knish and a soda for my lunch. Oh, my God, was that great.

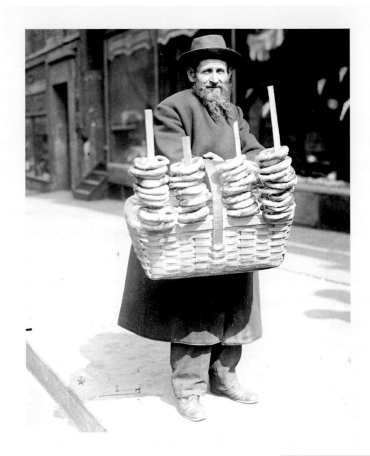

Lower East Side pretzel vendor.

NEW YORK DAILY NEWS ARCHIVE/NEW YORK DAILY NEWS/GETTY IMAGES

After shows, everyone in the Yiddish theater used to go to the Cafe Royal at Second Avenue at 12th Street, just like everyone on Broadway went to Sardi's. The owner was Hungarian, but the food was American-style. They served everything, but they had certain specialties like Hungarian goulash. It wasn't kosher, but it was irresistible.

Delicatessens, of course, have also been a big part of Jewish life for as long as I can remember. We were brought up on that kind of food. During the Depression, deli was what we ate because that was the cheapest—foods like whitefish—but today it's very expensive! It's interesting how things change.

Bagels were always a big thing, too. They were fast to make, and they were good—egg

bagels, bialy bagels, and regular bagels. And, in those days, there were no unions, don't forget, so the bagel bakers were like the aristocrats: they got paid by the bagel!

The Yiddish theater eventually went away because the neighborhood around Second Avenue changed. Many Jewish people relocated to other parts of the country, and many people of other denominations moved in. But Jewish food remained a big part of the scene. There were still a lot of restaurants, delicatessens, and bakeries—some of which are still there today! Take, for example, Streit's Matzo Factory on Rivington Street, which has been there for over 100 years. I always ate Streit's because most other matzos tasted bland, but Streit's put flavors in, like matzo with onions, egg matzo, matzo with garlic—oh, they had all different kinds.

Today, I still love Jewish food and eat it all the time. If I had to pick a last supper, it would be knaidlach [matzo ball] soup, boiled chicken, and any kind of a potato and green vegetable. I love

There were pushcarts in the streets — even a kosher one that sold hot dogs, which I used to love!

boiled chicken—I know it sounds crazy, but I do! Broiled chicken is good, too, but boiled chicken plopped in the soup is heaven to me.

The best Jewish food in New York is at 2nd Ave Deli, where I have been going for years. When I walk in there I don't even have to tell them anything—they know what I like! In the beginning, it was a tiny dairy restaurant on 10th Street and Second Avenue. Then, when the owner retired, Abe Lebewohl—he should rest in peace—inherited the place. He came to America with his family in 1950, and I met him right "off the boat!" We became very close. He didn't want a dairy restaurant and decided to make it into a deli, which opened in 1954. Eventually, after Abe's death in 1996, his family moved the restaurant to 33rd Street between Third and Lexington, and then opened a second location at 75th Street and First Avenue, as well.

(If you walk by the site of the original 2nd Ave Deli, even to this day, you will see on the sidewalk the Yiddish Walk of Fame, which Abe installed to honor the stars of Yiddish theater and I'm proud to say that my name is on it.)

The food at the 2nd Ave Deli—or delis—today is just as it was when I first ate there over 60 years ago: never anything but excellent. At this point the Lebewohls and I are like family—even closer! I go there once every week or two. If there's bad weather, they deliver to me. They cater all my parties—among them, my golden wedding anniversary party and my 90th birthday party, which were very lavish. And a few years ago, when I was in Hawaii doing the revival of Fantasy Island, they even sent a big care package to my hotel, which I shared with all of the cast and crew who raved about it! There are other New York restaurants that people love—Katz's, Russ & Daughters, Yonah Schimmel, Sammy's, and the list goes on—but I go to just one, and that's 2nd Ave.

I'm now 91 years old and still going strong. People often ask me for my secret to a long life. I'm not sure there is one. But I know that if you have a steady diet of Jewish food a long life is possible. I'm living proof of that!

So, without further ado, bon appétit! ◊

As told to Scott Feinberg

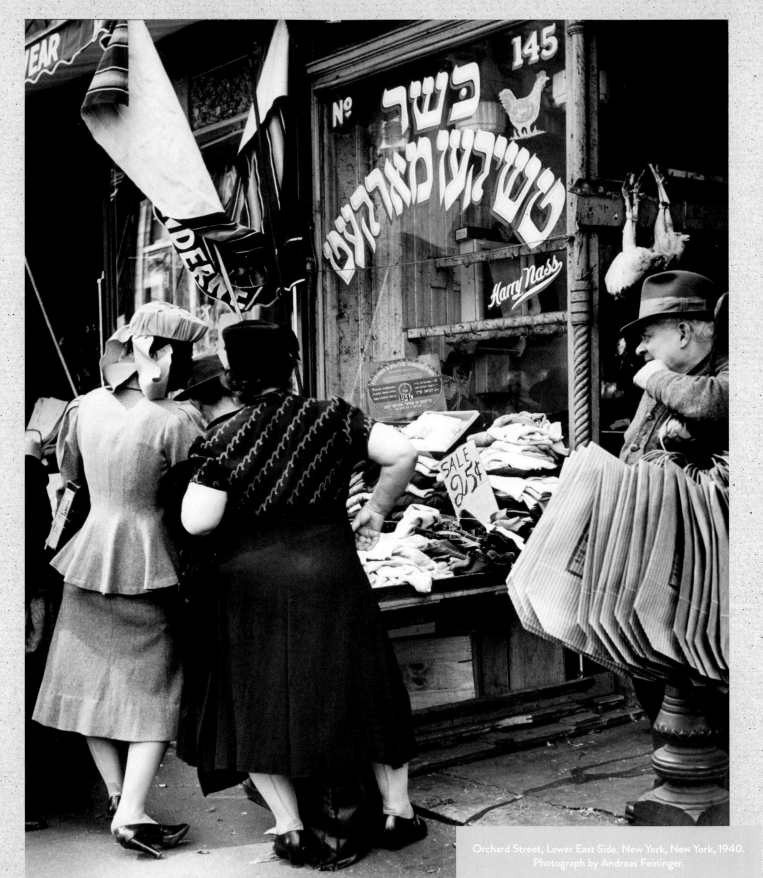

Orchard Street, Lower East Side, New York, New York, 1940.
Photograph by Andreas Feininger.

GETTY IMAGES

DELANCEY ON SCREEN

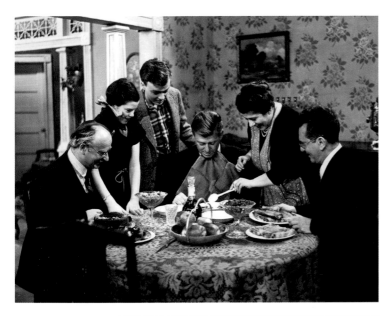

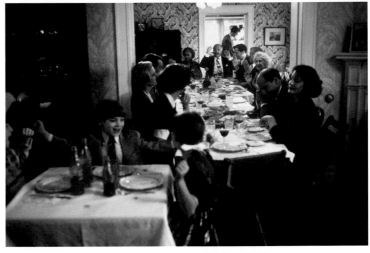

CLOCKWISE FROM TOP LEFT:

The Goldbergs (CBS) 1950
Shown from left: Eli Mintz, Arlene McQuade,
Larry Robinson, Arthur Godfrey,
Gertrude Berg, Philip Loeb

Avalon (1990)

Crossing Delancey (1988)
Shown from left: Peter Rieger, Amy Irving

Lost in Yonkers (1993)
Shown from left: Brad Stoll, Mike Damus

When Harry Met Sally. . . (1989)
Shown from left: Meg Ryan, Billy Crystal
(shot at Katz's Deli)

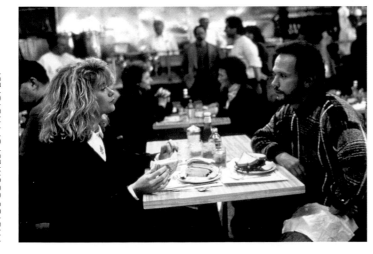

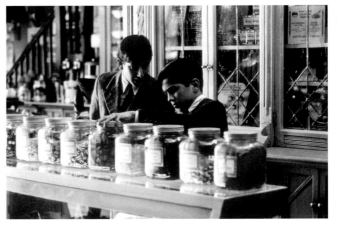

PHOTOS COURTESY OF PHOTOFEST

THE HONORED GUEST

Food is an honored guest at every significant event in each Jewish life.

Notwithstanding where we live, regardless of our race, irrespective of the God we believe in or deny, the solitary certainty that holds true for Jews is that no major moment is observed without a heaping helping of traditional dishes that nourish our bodies and souls.

I have been lucky enough, in my work as a Rabbi, to share in so many meaningful moments in people's lives. As I reflect on those experiences (18 years of which took place in New York), I realize it is more than religion and ritual—and even food—that unites these remarkable markers in the life of a Jew. I have come to learn that smoked salmon is omnipresent in Jewish life.

When we usher a new soul into the world, we Jews have a weird way of welcome: we circumcise the poor little boy in elaborate rite replete with shouts of "mazel tov." Perhaps the only thing an unknowing observer might find more peculiar than this strange ritual is that—moments after the ceremonial bloodletting—the whole family blesses bread with the words of Hamotzi and then digs in to catered trays layered with lox and bagels.

Bagels and lox are the expectation at every bris and baby naming. Likewise, prepared platters of smoked fish are de rigueur for every synagogue social hall into which a famished congregation walks following a Bar Mitzvah service. As guests in black tie walk away from the wedding huppah towards the cocktail hour, they are greeted by frozen bottles of vodka served astride caviar, blintz, and gravlax. And, when mourners return home from the cemetery to observe seven days of shiva, the same catered trays once served at a bris greet them, letting them know the circle of life has come complete.*

Food comforts. Food roots us in our past as we face our future. Food is inseparable from identity. This everyone knows is true.

My job is to persuade people the same can also be true with religion.

*Lox is even purported to be our eternal reward: Our sages of the Talmud imagined that smoked fish [specifically, leviathan] was served to those who merited the World-to-Come.

RABBI SETH M. LIMMER
Senior rabbi, Chicago Sinai Congregation
[but born and bred in New York]

HAMANTASCHEN

I prefer to make my hamantaschen dough the day before baking.
The crust rolls out beautifully.

Makes 24 cookies

DOUGH

3 cups all purpose flour

1 large egg

1½ sticks butter, softened

⅓ cup granulated sugar

1 teaspoon vanilla extract

pinch salt

FILLING

1½ cups raspberry jam, apricot marmalade, or poppy seed filling

1 egg, beaten

2 tablespoons milk

In a small bowl combine the flour and salt and set aside.

In an electric mixer, cream the butter and sugar until light and fluffy. Add the egg and vanilla and mix until well combined.

With the mixer on low, add the flour a little at a time until incorporated. The dough will be crumbly. Form the dough into a disk and chill at least an hour but preferably overnight.

Heat oven to 375° F.

Sprinkle your work surface with flour. Roll the dough to ¼-inch thickness. You can do this in two steps if you like, keeping half the dough in the fridge until you are ready.

Using a 2 ½-inch fluted or non fluted biscuit cutter, cut out circles. Transfer the circles to parchment lined cookie sheets.

Place a teaspoon of filling in the center of each piece of dough. Carefully pull up three sides of the dough and pinch the corners together. If the corners are not sticking you can add a touch of milk or water and press closed. You will have a triangular shaped cookie. Finish all the dough.

Brush the dough with the lightly beaten egg mixed with the milk.

Bake for 25–30 minutes, until light golden brown.

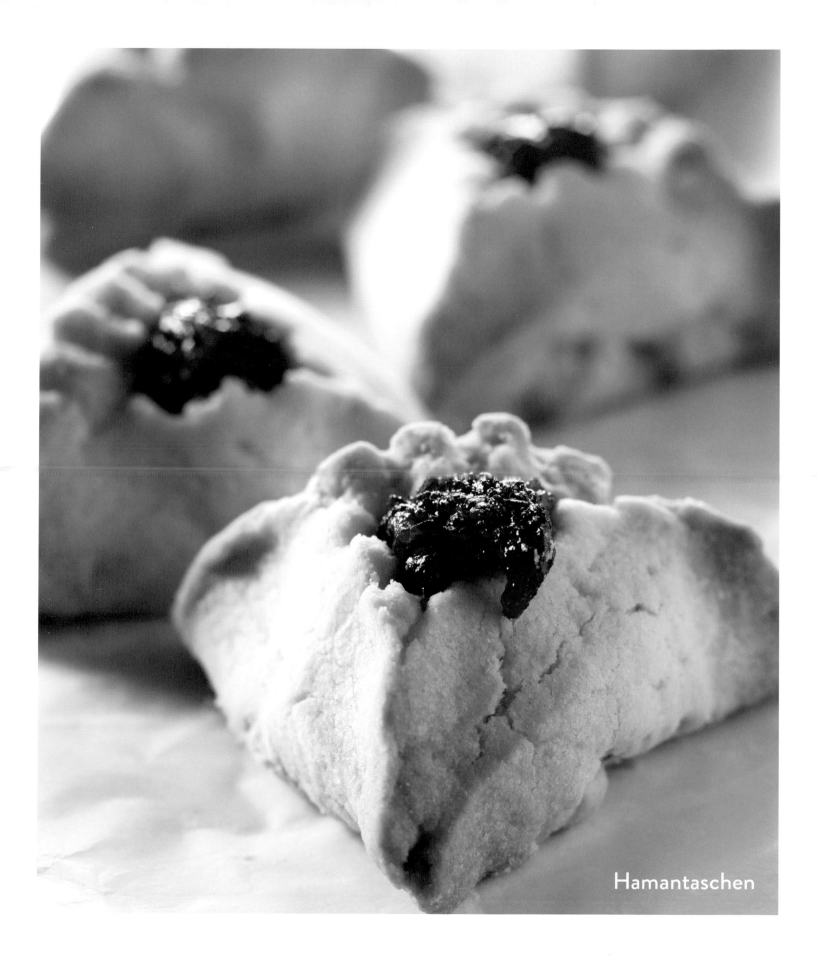

Hamantaschen

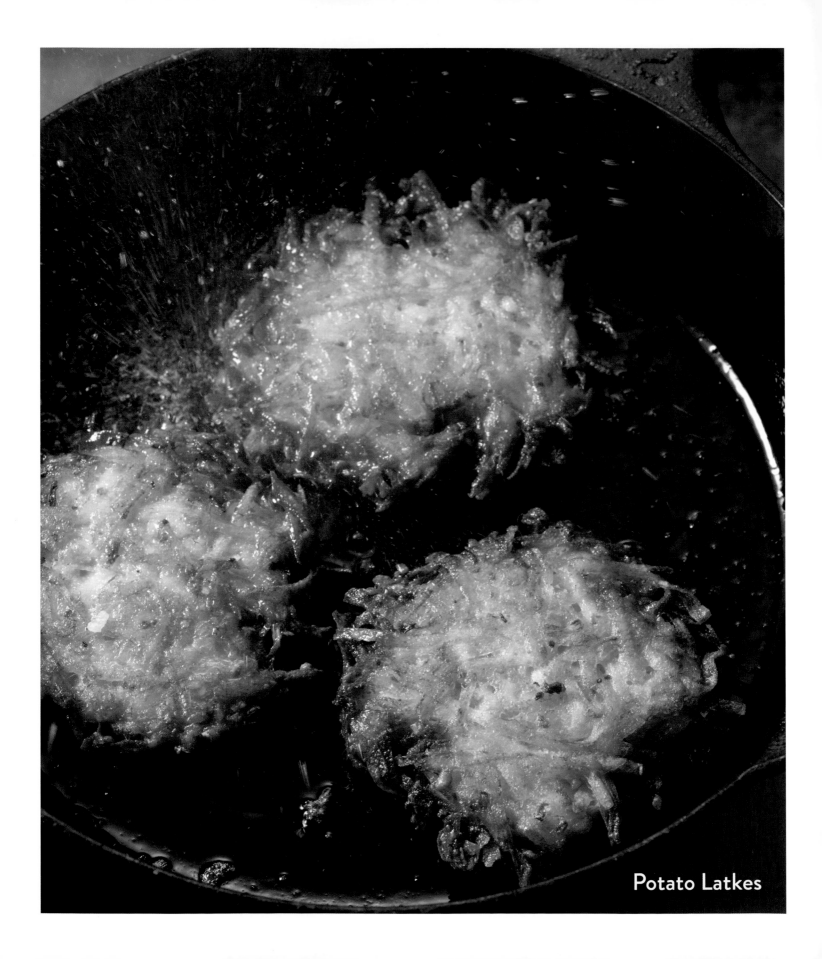

Potato Latkes

TOO MUCH AIN'T ENOUGH

I grew up believing that my maternal grandmother Bertha was a masterful cook. Somehow, out of a small kitchen in Passaic, New Jersey, with a tiny refrigerator, a small stove with a single oven, no dishwasher, and almost no cabinet space she churned out a cream of mushroom soup that taught me to love mushrooms; a chicken and matzo ball soup that I thought was as natural a part of life as breathing; mounds of stuffed cabbage that made me eager to eat that otherwise awful thing called cabbage; casseroles of moist roast chicken; and platters of brisket, carrot and raisin tzimmes, roast potatoes, sweet potatoes, noodle kugel, asparagus, and more.

The problem—or maybe the miracle—was that she would often cook all of these things for the same meal. It was only years later, when my palate became a bit more discerning, that I came to realize that the only thing in cooking that she must have valued more than quality was quantity, and that she probably believed that the noblest calling of the Jewish cook (or at least the Jewish mother) was to be sure that every large holiday family meal had almost as many food choices as the menu of a Greek diner.

My favorite memory of my grandmother's penchant for multiple main courses was at one Passover Seder. We were long past the gefilte fish (store-bought, as I recall—she had to draw the line somewhere at what could come out of that kitchen), long past the matzo ball soup, and just eating the last of our brisket, our chicken, and our tzimmes when my grandmother jumped to her feet. "Oh my goodness," she cried out. "I forgot the roast beef!" And indeed, sitting at the back of the oven was a warm, slightly overcooked roast, which she had prepared just in case someone wasn't in the mood for brisket.

The family resisted her proposal to serve it before we moved on to the sponge cake and macaroons, and it was saved for our first post-Seder meal.

PAUL GOLDBERGER
Architecture critic; author, *Why Architecture Matters*;
contributing editor, *Vanity Fair*

2ND AVE DELI POTATO LATKES

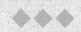

Makes 20 latkes

2½ pounds potatoes, peeled and quartered

2 large onions
(use 1½ cups grated; don't tamp down)

3 eggs, beaten

2 cups matzo meal

1 cup flour

¾ cup corn oil

½ cup corn oil for frying

2½ teaspoons salt

1 teaspoon baking powder

¼ teaspoon pepper

applesauce

sour cream

In a food processor, fine-grate potatoes (don't liquefy; leave some texture), and strain to eliminate excess liquid. Don't overdo it; just let the water drain out.

Fine-grate onions, and mix in a large bowl with potatoes. (If you don't have a food processor, you can grind the potatoes and onions in a meat grinder.)

Add eggs, baking powder, ¾ cup corn oil (most of it cooks out), flour, salt, and pepper; mix well. Fold in matzo meal, making sure that everything is very well blended.

Heat ½ cup corn oil in a deep skillet. Spoon batter (use a large kitchen spoon) into the pan to create pancakes about 3½ inches in diameter. Fry on low heat for 3 to 4 minutes until underside is a deep golden brown, turn, and fry another minute or two. Drain on paper towel. Serve with applesauce and/or sour cream.

The most
remarkable thing
about my mother
is that
for 30 years
she served the family
nothing but
leftovers.
The original meal
has never been found.

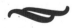

CALVIN TRILLIN

CHRAIN (RED HORSERADISH)

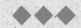

2 medium beets
1 horseradish root
2–4 tablespoons white vinegar
or cider vinegar
2 teaspoons kosher salt
1 teaspoon sugar

Place the unpeeled beets in a large saucepan and add water to cover. Bring to a boil and cook until tender, 30 to 45 minutes, depending on the size of the beets.

Drain the beets and rinse them under cold running water until they're cool enough to handle. Using your fingertips, slip off the skins. Then coarsely chop the beets.

Mix to combine with the rest of the ingredients.

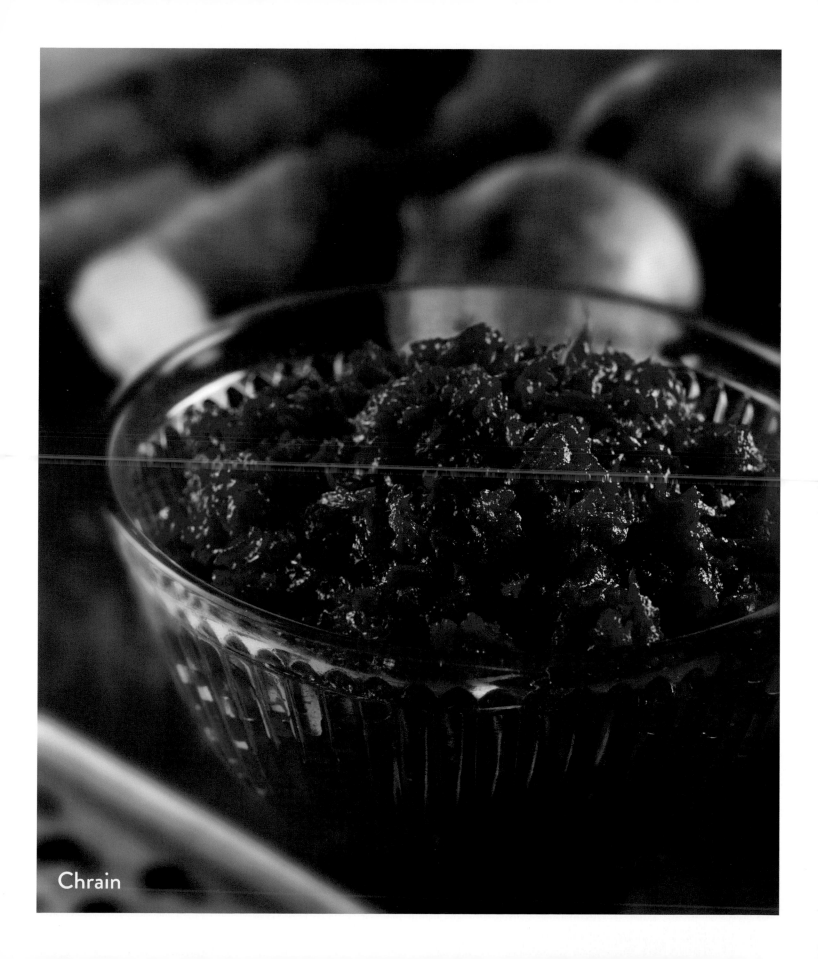

Chrain

Ratner's

Delancey Street Ratner's, 2005.

worked there all of my life but took over running the place with my brother Fred after graduating from college. It was a time of lots of changes. Everywhere, including the Lower East Side, was changing. There were no Sunday blue laws anymore, for example, so people could shop whenever they wanted. It was in the 1970s that we started our frozen food business, which ended up being a big success. The blintzes, soups, and potato cakes were easy to transition to frozen foods and the business grew and grew, which was a nice thing because at the same time the Second Avenue Ratner's location closed. It had been located right next to the Fillmore East. Listen, children today want to eat sushi—they don't want to eat blintzes. And in actuality, Eastern European Jews started to change the way they ate after the war. But initially, back then, the customers and the waiters and cooks were mostly Jewish immigrants and there was a real familiarity between them. Then flavors changed, and they continued to change. As an example: in the early days, Ratner's was strictly dairy and was THE place for kosher customers looking for a dairy meal. But in the 1960s, we began to offer fish since we got requests for that. Back in the day, people took buses up to New York from Philadelphia, from Baltimore, they went shopping on Orchard Street, they went to a Broadway show. Not anymore.

We eventually opened Lansky Lounge in the back of Ratner's in the late 1990s. Lansky Lounge was the idea of my cousin, Theodore, who was in his 30s and thought it would appeal to a younger generation, playing up the idea that Ratner's was known as a hangout for some infamous gangsters like Bugsy Siegel and Meyer Lansky. We had a good run. Lansky Lounge closed in 2003, just before our 100th anniversary when Bloomberg gave us the key to the city. Now that bar space operates under the name The Back Room and of course Ratner's itself is a Sleepy's mat-

tress store. We still own the real estate and these days real estate is worth more than a restaurant business.

We had dozens of celebrities pass through our doors over the years. Governor Rockefeller used to come in on Sunday before elections to get his "good luck blintzes." Groucho Marx came in. Walter Matthau, Elia Kazan, and others were customers. A few movies were shot in part at Ratner's, including *The French Connection*. Even Michael Jackson ate at Ratner's once. Funny thing is, none of our customers knew who he was.

The restaurant got its name in a coin toss. My grandfather (Harmatz) and his sister's husband (Ratner) started the business and decided that was how they would determine the restaurant's name. And when Ratner moved to California in around 1918, our family took it over completely.

My wife Nanette's father was one of the owners of Katz's—yes, really. She and I met in the 1970s. Her grandmother came in and wanted to introduce us. The deli was called Katz, Katz & Tarowsky and Mrs. Katz always talked about her granddaughter. So, I said OK, OK. Forty-some years later, here we are. We still go down to the Lower East Side sometimes, wander around, stop in for a sandwich. You know those tickets you get when you walk into Katz's? That was her grandmother's idea. Some things never change.

ROBERT HARMATZ
Former co-owner, Ratner's
As told to Abbe Aronson

PHOTOGRAPH BY JEFFERSON SIEGE

GROWING UP RATNER'S

My aunts, uncles, and cousins were always at Ratner's. Hell most of my relatives worked there almost their entire lives. I loved going to Ratner's in the late afternoon, where I would find my aunts, grandma, and mother sitting in the back room at the same Formica table, drinking Dewar's on the rocks, smoking cigarettes (Slim 100's of course), and gossiping, like the yentas they were, about every schlemiel and schlimazel in the neighborhood.

Most of what I heard all day was kvetching and kvelling about the waiters (who spent not years, but decades in that famous yellow tux) and the regulars (who after 30 years eating at Ratner's, planned on ending their life face down in a bowl of soup). I was amazed by my aunts' knowledge of these people's lives.

As for me, I was a witness to all this fast talk and I loved it. I would be at the end of the table eating my potato pancakes, kasha pirogen, or blintzes. I'd finish off a big bowl of matzo ball soup if it was Friday, otherwise it was mushroom barley. Then I would make myself a cookie box: ruggies, black and whites, and hamantaschen. There's really nothing like that memory of that place for me.

At age three I started working the cash register, sitting on my cousin's lap, pressing the change button. Next, I worked my way up to the bakery counter, like the shop I have now, learning how to tie cookie boxes like my Aunt Nat. After college I started as the host and eventually opened Lansky Lounge, a "kosher" bar in the back of Ratner's.

It's inspiring to think how the entire neighborhood would come together at Ratner's. My relatives knew everyone in the neighborhood and essentially grew up with them as a community. They knew these people for decades, some of them for over 50 years, and went through several life cycles of friendship—from liking them to disliking them and back again, usually twice.

After eating at Ratner's, more often than not, we would go shopping. I'd go with Mom to Tushman's on Orchard to get underwear—awkward. They knew us for years from Ratner's, so of course we'd get a discount. A drawback, however, was having to discuss my underwear in public when Mr. Tushman came to eat.

Ratner's was a New York institution. Ratner's was the community. It was the Lower East Side. They do not make restaurants like that anymore.

There were no boundaries at Ratner's. It might have been the funniest place to be in the city.

If you really want to understand Ratner's, consider Mother's Day. Every Mother's Day they would seat over 600 people. The kitchen had three lines, 20-foot conveyor belt dishwashers, soup tureens as tall as I am, ovens in the basement that could bake a thousand cookies at a time and hundred's of onion rolls. We had two Polish women just making pirogen all day, thousands of them.

Ratner's was a New York institution. Ratner's was the community. It was the Lower East Side. They do not make restaurants like that anymore. You knew your neighborhood from eating at Ratner's. It was the place you stopped at on your way home to get a box of cookies for your wife, where you celebrated Sundays, where you went after temple. It was the kind of place where you were with people from your community whether you liked them or not, and really, where you figured out whether or not you liked them.

THEODORE PECK
Owner, Peck's, Brooklyn;
second cousin of Robert Harmatz

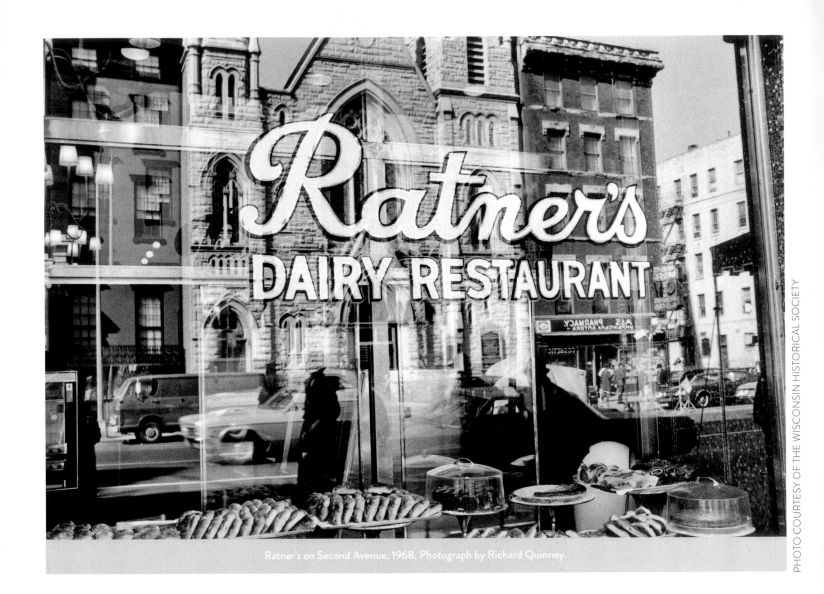

Ratner's on Second Avenue, 1968. Photograph by Richard Quinney.

PHOTO COURTESY OF THE WISCONSIN HISTORICAL SOCIETY

THE OTHER RATNER'S

Sardines, kasha varnishkes, and a dessert of stewed prunes, all washed down with Dr. Brown's Cel-Ray, aka the Jewish Champagne. You might have ordered this combination at Ratner's on Second Avenue during the last days of the dairy restaurant's half-century in the section of the Lower East Side known as the East Village. On a given night at that time you might have sat by Andy Warhol holding court among the huckleberry blintzes, a pack of hippies filling their pockets with onion rolls, or a rock leg-end—Jim Morrison, Janis Joplin, The Grateful Dead—after a gig next door at Fillmore East.

Opened around 1918, Ratner's closed in 1974. Owner Abraham Harmatz died the very next day. In the obituary, the *Times* called the restaurant "a gastronomic diadem in the crown" of what had been the Jewish Rialto. Today, in the supermarket that took its place, Ratner's glittering tile mosaic remains—and Dr. Brown's Cel-Ray sells by the six pack.

JEREMIAH MOSS
Author, *Jeremiah's Vanishing New York*

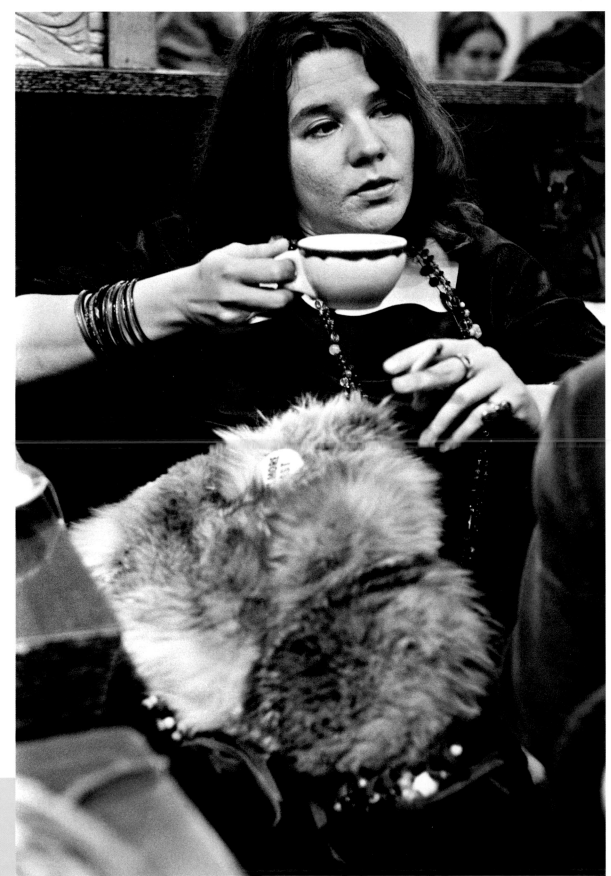

Janis Joplin in Ratner's after the opening night of the Fillmore East, March 8, 1968. Photograph by Elliott Landy.

Sex — like eating Jewish foods such as chopped liver and gefilte fish — should always be a totally private matter.

MEL BROOKS

RATNER'S
MOCK CHOPPED LIVER

Makes 4–6 servings

½ pound lentils

8 hard-cooked eggs

2 cups chopped onion

3 tablespoons olive oil

1 tablespoon peanut butter

1 teaspoon salt

¼ teaspoon white pepper

lettuce

tomato slices

horseradish

Cook lentils according to package directions.

Pour ½ cup onion into bowl. Finely chop the lentils and eggs. Add to onions.

Sauté remaining onions in half the oil until brown.

Mix lentil mixture with sautéed onions, the remaining oil, peanut butter, salt, and pepper.

Serve on lettuce leaves with white or red horseradish and a slice of tomato.

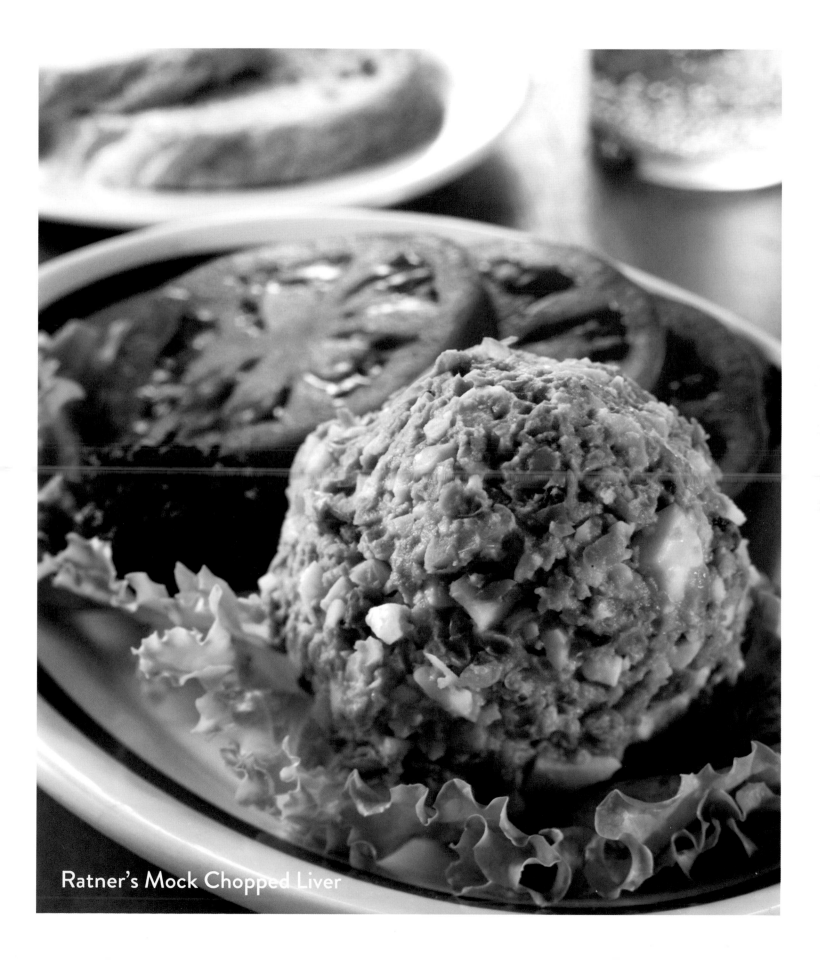

Ratner's Mock Chopped Liver

HUNTING THE GREAT WHITE PIKE

My Brooklyn of the 1950s was a magical place. The Dodgers were still a home team, the iceman still cometh, and kosher butchers had live chickens which they ritually killed before your eyes. The knife sharpening truck still rode the streets. In addition to sharpening knives, this craftsman could also repair umbrellas. Can you imagine that an umbrella could be so valuable as to warrant this type of maintenance and repair? Belmont Avenue was lined with pushcarts selling every type of good that could be hawked: clothes, fruit, furniture, pots and pans—our stores were these pushcarts. Retail did not exist, or at the very least, it was a sacrilege. It was another time, another place.

One of my favorite places was Patsy's, the fish store on Sutter Avenue. Patsy's, as the name implies, was owned and operated by a burly Irishman named Patsy, a dark haired, blue-eyed Irishman planted in the middle of this Jewish enclave. The fish store was totally covered, floor to ceiling, in what is now fashionably referred to as "subway tile." Patsy was an imposing figure, perched on a platform overlooking his tray of iced fish, and in the middle of his throne was a huge porcelain tank, approximately eight feet by three feet, containing the live catch of pike and carp. These are of course the principal ingredients of gefilte fish.

Gefilte fish was not only a staple of the Shabbos Friday night dinner, making it was a Jewish household ritual. True gefilte fish is not easily found these days. The name gefilte means "stuffed." Carp or pike steaks were stuffed with ground fish, carrots, matzo meal, and spices. The stuffed fish was then simmered in a fish stock, along with carrot slices, until perfectly cooked, the bones creating a gelatinous aspic.

The fish had to be fresh, and the fresher the better. Going to Patsy's was an event. Friday morning crowds resembled those on Christmas Eve at the local shopping center, minus some of the gentility. There were no numbers taken at Patsy's which might have preserved an orderly ascent to the throne. It was survival of the fittest, with Patsy being the final arbiter of who was served, and when. When an audience with Patsy was finally granted, you would have a very short time in order to choose your fish—one carp, one pike—time was money at Patsy's. Patsy would then scoop the fish up in a large poled net, slam the fish on the cutting board in front of him, stun them with a wooden mallet, and then decapitate and clean them. After being wrapped in yesterday's newspaper, the fish were bagged and ready to be taken home to be processed.

You would think that this would provide fish that was fresh enough. For most households, yes. For my mother, no. The fish would be stunned at Patsy's, then wrapped to be brought home still alive, to be placed in our family's bathtub—already filled with water, awaiting their arrival. While both pike and carp are rather large fish—approximately 18 inches or more as I recall—carp, a relative of the goldfish, is somewhat docile. Pike on the other hand is a vicious sharp toothed creature, a force of nature to be reckoned with. The image of these two creatures swimming in the family bathtub on a weekly basis is eternally imprinted on my mind. I continue to feel a mixture of joy, curiosity, and fear when I recall this weekly ritual—the joy of a child who has the largest "pets" in the neighborhood, combined with a child's curiosity about the behavior of the wild creatures swimming in the bathtub, and the anticipation and fear of the upcoming events that culminated in their capture and final processing.

My mother was a hunter. While Patsy required a net, my mother caught the fish bare-handed. She would grab a fish with both hands and then whisk it over to the kitchen sink where her knife was awaiting its mission. With one hand on the flapping fish and the other on the blade, within seconds the deed was done and the fish was finally ready to be cleaned, sliced, ground, and seasoned into the ultimate weekly delight. Times are different now. The gefilte fish we now serve may taste somewhat like the fish that I remember my mother preparing; however, it lacks a certain freshness—and it certainly lacks the drama which unfolded each Friday in the Brooklyn home of my childhood.

MALCOLM S. TAUB
Attorney/partner, Davidoff Hutcher & Citron LLP

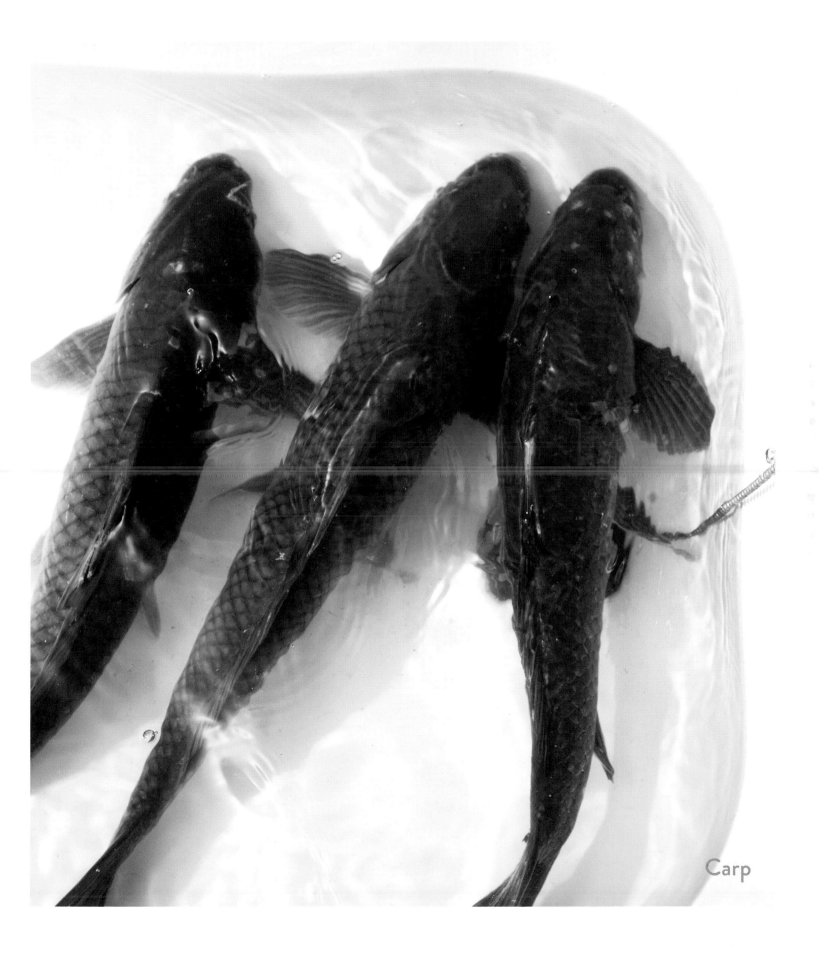

Carp

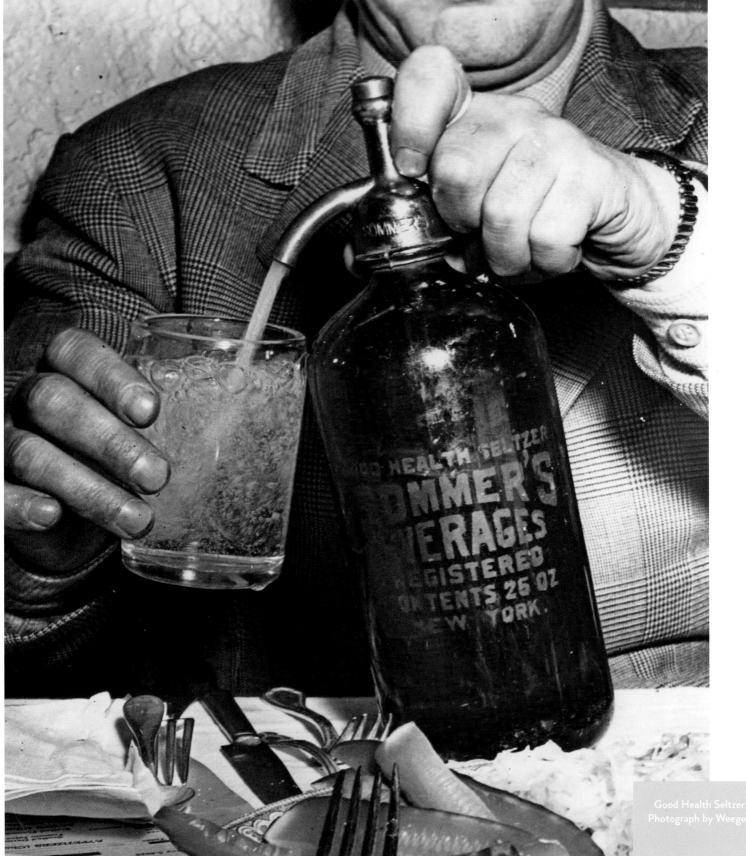

INTERNATIONAL CENTER OF PHOTOGRAPHY/GETTY IMAGES

Good Health Seltzer.
Photograph by Weegee.

SELTZER! SELTZER!

Seltzer Boyyy! Seltzer BoYYY!!!!

t's obvious that Andy Warhol was from Pittsburgh and not New York City. If he had been, he would know that we really didn't know from Campbell's Tomato Soup, and the image of a seltzer bottle would have been the single unifying image that would have merged our souls and our spirits. HE WOULD HAVE PAINTED SELTZER BOTTLES, and that's what he'd be remembered for.

For two cents plain!! "One egg cream, doc, one lime rickey. . ." and on and on it would go.

In New York City, brought over from Eastern Europe, the Bohemian or Czechoslovakian seltzer bottle was the most beautiful piece of functional art glass a family could dream of having on their table. Seltzer companies preceded the branded capped sodas to come later, such as Coca-Cola, Pepsi, 7 Up, Moxie, or any of the many more. Good Health Seltzer was pure New York City tap water, carbonated, and the seltzer bottles refilled hundreds of times. (The original sustainable, fair trade, no genetically altered organisms, organic, no-cal, fat-free, perfect beverage.)

So why Delancey Street? Why the Lower East Side? Why New York City? Why ethnic??? I always heard varying versions of the idea that in the old country, when food was scarce and a meal served to both family and friends was truly special, the acknowledgement of a contented guest would come in the form of a nice hearty "eructation" of a mixture of stomach gas and bubbly breath—a nice big belch. Not a meager burp, concealed in a napkin near the edge of the table heading down towards the floor, meekly released. No, I mean a full blown crescendo, a belch that arose from the now full and expanding bowels, the stomach, the loins of a gustatory guest. . .one that would shake the rafters.

Well what better aid to help bring forth the big belch but nice, tall, clear glasses of seltzer? And after passing the seltzer bottle around the table, the joy of squeezing the trigger, the handle. Ah, the release of fresh, ice-cold seltzer into the glass.

The single image of a seltzer bottle invokes so many happy memories. Growing up in New York, I took for granted that a truck could come by and deliver a case—or crate with ten seltzer bottles—to your home. My friends and I would go to an apartment house, and find a crate of seltzer bottles in the hall, grab a few, and in the ensuing minutes, a fabulous seltzer war would have us screaming in hysterical laughter.

The first kids' TV show, *Howdy Doody*, had a character, a clown called Clarabell. Clarabell the Clown must have had the same background, growing up and using the seltzer bottle as an instant gag, whoop dee doo.

In the 1920s to 30s to 40s the drugstores had soda fountains, and the seltzer came from the fountain. The druggist would be called Doc, and he would be the master of the fizzy, carbonated drinks.

Anyone who grew up in the New York area was fond of the call of the soda man, and the delivery of his wooden box with ten full seltzer bottles could turn any small apartment into a major soda fountain.

DR. LEW SELLINGER
Director of obstetrics, Harlem Hospital

So why Delancey Street?
Why the Lower East Side?
Why New York City?
Why ethnic???

Jackie Mason, 1980.

THE SIMPLE FACT

The simple fact is that Jews eat ten times more than gentiles. Why should I make such an issue? The simple fact is that Jews eat ten times more than gentiles eat. It's a historical fact, gentiles are all seven feet tall and weigh two pounds, Jews are four feet tall and weigh 500 pounds. So, Jews never finish eating. There's a historical reason for this, too. There's a historical reason—Jews were always persecuted in Europe, they never had any food anywhere, they were the most starving people in the world. And they came here with nothing. That's why food became symbolic of security to a Jew. That's why your Jewish mother kept telling you "eat, eat, never finish eating, you're Jewish." You couldn't stop eating. To this day if a Jew sees a sandwich, ha HA!, he can't believe it! Why do you think every portion of food comes out ten times the size in a Jewish coffee shop than it does in a gentile coffee shop? Ten times the size! Go into any gentile coffee shop and order cake. You ever see the size of it? Go to Wyoming, Montana, Nebraska, order a piece of cake in a gentile coffee shop and it comes out like *this*. To a Jew it can be a cookie.

JACKIE MASON
Actor; comedian

40

Schmaltz Herring Fillets

COUNSELOR'S SON

My dad is from Brooklyn. My mom is from Queens. My brother and I were raised on Long Island. But we're all New Yorkers. And that's how we ate growing up. Birthdays demanded Brooklyn blackout cake. (Actually, all cake occasions demanded the fudgy masterwork.) After-school snacks: black-and-whites. I didn't realize what a lucky snacker I was until I moved out-of-state as an adult and never found a decent cookie again. And don't get me started about pizza.

But Saturdays were always the most special days to eat at home. That day was reserved for Andel's Delicatessen. There was no more holy day in our household. Mom would go to the renowned Jewish deli on Fridays—and those weekly visits were almost as exciting to fifth-grade-me as the next morning's feast. "Hey, Counselor!" they'd shout as Mom entered. My mother had just started law school (all while raising two children). She was a student just like me. The men of Andel's—old Jewish men with thick foreign accents and even thicker eyebrows—were so proud of her. And they told her so in between filling orders for rich chopped liver (for dad to schmear on rye beneath red onions for tomorrow's lunch), salty, whole-fish "chubs," and the crown jewel, thinly-sliced smoked Nova lox (for stacking above Andel's homemade cream cheese with tomato and raw onion on a Long Island bagel). The lox was hand-shaved by an ancient man with a razor-sharp knife and impressively steady hands (despite his age). The lox-master always handed me a taste over the counter, "for Counselor's son." I felt special.

One day, early on, I noticed the man's tattoo. My mom had ordered, and as hoped, he handed me the taster slice with a smile. There on his forearm, a string of numbers crudely marked. At that age, I instinctively knew in my gut what this meant. . .but I couldn't believe it. The Holocaust was something we studied in school, discussed in temple, yet only saw in films. Not something in everyday life. Not something before our eyes. But there the numbers were.

I was silent on the ride home. Later that night, I asked my dad, "Why doesn't he wear long sleeves? Why not hide it?"

"Never!" Dad nearly shouted in reply. And then followed a more patient explanation that wasn't immediately obvious at my age. These men were survivors. They had suffered the unspeakable. Yet now they cooked, they created, they shared—they loved. This was nothing to hide. Quite the contrary. Their food was triumphant.

> There on his forearm, a string of numbers crudely marked. At that age, I instinctively knew in my gut what this meant.

Long after those original men retired, replaced by younger lox-men (with apprenticed but developing knife skills), their food continued to mean more. And now, decades later, even though Andel's has sadly closed, the triumph and love in those delicacies remain.

One birthday soon after I entered college (while the deli was still thriving) I received a big box in the mail with a clear stamp on the side: "Andel's." Instead of blackout cake, my mother had ordered a box of my favorite deli—bagels, lox, the works. (Now a lawyer, mom still had no time for cooking. Fine by me.) In the box, along with the treasure trove of foods, there was a hand-scrawled note from the aged lox-master: "Counselor's Son—Your mother loves you."

Indeed. I could taste it.

DAVID ROTHKOPF
VP creative director; ad writer;
New Yorker (at heart)

Bagel and a Schmear

DID I ASK YOU?

A long time ago (spring of '66, I believe, but who's counting!), my friend Mitch and I were having dinner at a New York dairy restaurant—I forget the name. There was one waiter whose job was simply to circulate through the room carrying a tray of butter and dropping a couple of pats onto each diner's bread plate.

When he got to our table, Mitch said, "No thanks, I don't want any butter." The waiter replied, "Did I ask you?"

FRED GOLDRICH
Conductor

A Jewish woman in London, approaches the counter of Harrod's (prestige) Food Hall:

Counterman (distinguished, with a very proper English accent): May I help madam?

The Jewish Woman (with a distinct "accent"): Certainly. I'd like half a pound of belly lox.

CM: Oh, no, madam, you mean Nova Scotia smoked salmon.

JW: Sure, why not!

CM: Will there be anything else?

JW: Yeah, gimme half a dozen bagels.

CM: Oh no, madam, you mean curvilinear yeast rolls

JW: Sure, why not!

CM: Will that be all, madam?

JW: No. Gimme two fingers cream cheese.

CM: Madam, you mean a half pound of Philadelphia processed cheese.

JW: Yeah—dats what I mean.

CM: Will there be anything else for madam?

JW: No, that's it.

CM: And where would madam like this sent?

JW: Oh no. Just wrap it up and I'll take it with me.

CM: Madam! Surely you're not going to *schlep* this around the store!

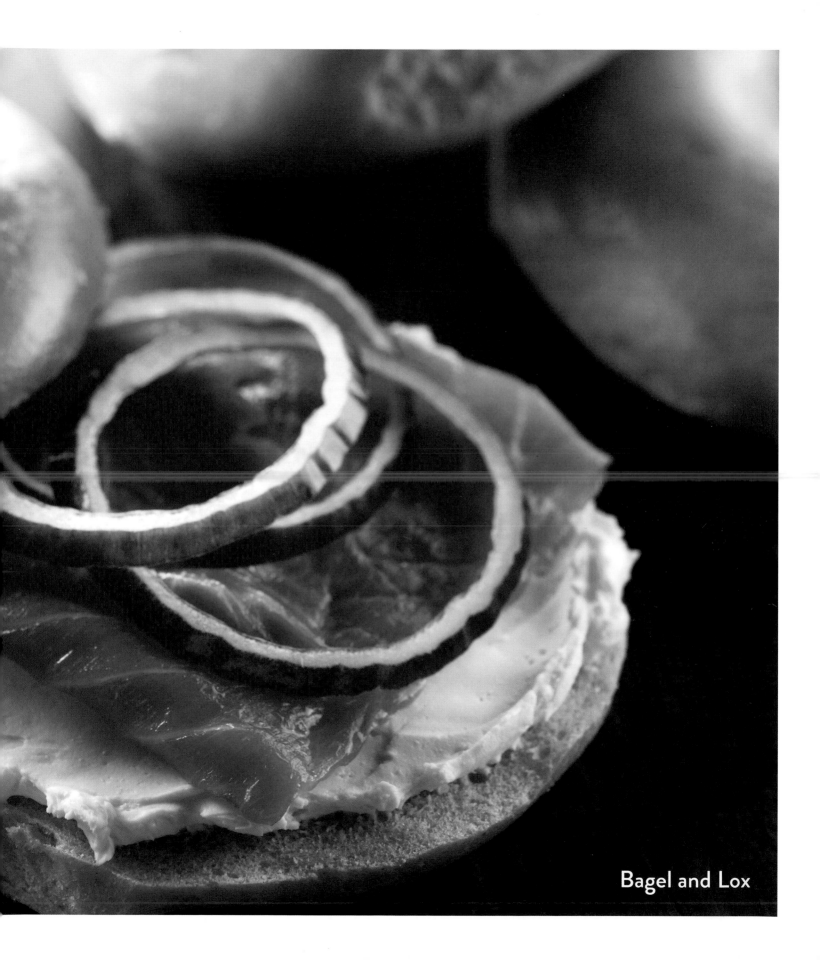

Bagel and Lox

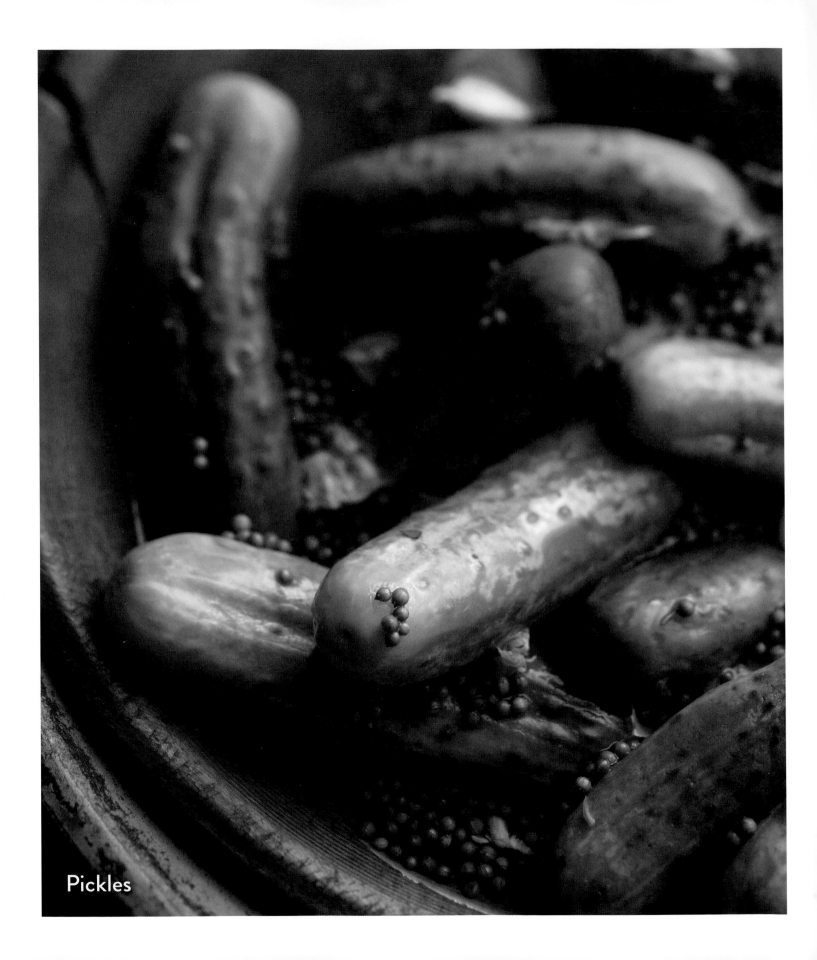

Pickles

A nickel will get you
on the subway;
garlic will get you a seat.

Streit's Matzos

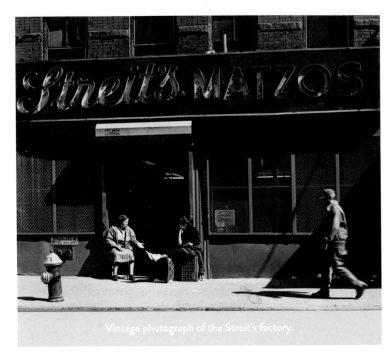

Vintage photograph of the Streit's factory.

"It's an amazing thing how you take flour and water, the same two ingredients that make paste, and create something edible."

—JACK STREIT

I n four nondescript, conjoined tenement buildings on Rivington Street on Manhattan's rapidly gentrifying Lower East Side, sits the Streit's Matzos factory. In 1925, when Aron Streit opened the factory's doors, it sat at the heart of the nation's largest Jewish immigrant community. Today, in its fifth generation of family ownership, in a rapidly gentrifying Lower East Side, it remains as the last family-owned matzo factory in America.

Inside the factory walls, sixty or so workers buzz around the five uneven floors of the converted tenements. With a mix of precision and intuition, they run up and down the length of the two behemoth, plaster-encased, 73-foot-long ovens, tightening a screw here, oiling a gear there, in an effort to keep the hulking ancient machinery in line.

At the end of each oven, workers wipe sweat from their brows, battling the ovens' 900 degree heat, cracking sheets of matzo that emanate without cease from the ovens mouth, and placing the counted stacks of hot matzos into baskets on steel conveyors that carry them out of sight, to the packaging room on the second floor.

On each floor, rabbis keep constant watch with timers to ensure that the entire baking process, from the moment flour and water meet until the matzo reaches the oven's halfway point, takes place within the 18 minutes allot-ted by Jewish law. They stand by with towels, perpetually scrubbing the mixing bowls, the cutting machines, and the factory floor, trying to keep pace with the flour dust that inevitably fills the air. The mixing is done in batches, and if the smallest bit of flour from one batch remains on the machinery when the next batch arrives, the dough must be immediately discarded, and the entire operation shut down and cleaned, top to bottom. It's happened, not often, but enough times to lend urgency to their work.

The fact that Streit's remains on the Lower East Side, at a time when upscale boutiques and boozy brunches dominate the landscape, when Ratner's has become a Sleepy's mattress store, and a hundred years after manufacturing began its decline in the city proper, defies rational explanation. The reasons for its still occupying this half block of prime Manhattan real estate are, in fact, based almost entirely on family tradition, and an intangible connection to this place and between the people who work here.

The owners of the factory are three cousins, and are the great-grandsons and great-great-grandson of founder Aron Streit. None of them planned to end up here.

Alan Adler, 64, is the oldest of the three cousins. His grandfather, Irving Streit, born in 1900, was in the business from the start and remained there until his death in 1982.

Alan describes his grandfather as coming home each night exhausted and covered in flour dust, urging his grandson to find another way to make a living. Heeding his advice, Alan spent 25 years as a lawyer with the state prosecutor's office, only to find himself drawn back to the family business. Each day he arrives at the factory on his Harley Davidson motorcycle with a license plate that reads "MATZO" and sits down to work in his grandfather's office, at his grandfather's desk.

Aron Yagoda, 47, also sits at his grandfather's desk. The middle cousin, Aron is the grandson of Jack Streit, Irving's brother, who is still lovingly referred to by the workers who are old enough to have known him, as "Mister Jack." Aron, too, started off with plans outside the matzo business, working in the Garment District for a number of years until his grandfather, by that time in his early 80s, asked if he could come in to help for a few days. That was 24 years ago. After Jack's passing in 1998, Aron settled in behind Jack's desk, but only to an extent: Insisting that the desk still truly belongs to his grandfather, he has left the contents of the desk drawers undisturbed for the past 16 years, opting to keep his own paperwork on the desk's surface, where the stacks pile up three feet high.

Aaron Gross, 39, is the youngest of the three cousins, the great-great-grandson of founder Aron Streit and the great-grandson of Irving. He began work in another Streit family business, horse racing—each generation of Streit's has owned horses, and the tube television in the office remains on the races every hour of the day. After leaving the tracks, he attended Georgetown University with a mind to go into finance, a business in which he worked for one year, before joining his father, Mel, at Streit's. Mel passed away in 2005, and Aaron remains at the factory, overseeing the business with a concentration on sales and marketing.

All three well-understand the changes in the neighborhood around them, as well as the shaky economics of producing 2.5 million pounds of matzo—40% of the nation's output—in a five-floor Rube Goldberg-esque factory, using machinery out of a Charlie Chaplin film. They could easily, by their own admission, sells these buildings and move operations to a modern factory on one floor outside the city, like the one run by their chief U.S. competitor, Manischewitz. Production would be more efficient and would necessitate a work force of perhaps half or less the employees currently working on Rivington Street.

Everyone who works in the factory considers the entire operation to be one extended family. Just as the Streits have operated the business for generations, so are many of the employees multigenerational, having had fathers or grandfathers working at the factory. Those that have not have often been working at their jobs for 30 years or more and remember the two younger owners running around the factory as children. The workers attend the funerals of Streit family members, and the Streit owners attend the graduations of the workers' children, their college tuition paid for by decades pulling matzo from the ovens. Under these conditions, the standard rules of economics tend to get somewhat obscured.

As for the workers themselves, they are as representative a slice of Lower East Side history and immigration as one could expect to find.

Jewish law dictates that only Shabbos-observant Jews can touch the dough between the moment flour and water meet, and when the matzo is baked. Thus, the workers in the mixing rooms, and those working the cutting machines that flatten the matzo into sheets, are all Jewish, and primarily immigrants. At least seven of these workers emigrated from Kazakhstan after the fall of the Soviet Union. One recalls a childhood spent baking matzo by hand, in secret, in a small windowless room in his home there. Another a white-haired gentleman in his 70s, was a member of the 1964 Soviet Olympic boxing team.

Once the matzo emerges from the ovens, work is not restricted to Jews, and the rest of the factory is a mélange of immigrants from around the world, as well as native New Yorkers.

There's the worker from Bangladesh, who has worked at the first-floor oven for over 20 years, with two sons, one of whom is earning his doctorate in physics, and one of whom owns a successful chain of salad bars in the city.

There are the two brothers from Venezuela, one a former professional soccer player, another, like Alan Adler, a former lawyer who saw more opportunity working in a matzo factory in New York than in practicing law in his home country. For 20 years he has worked alone on the fifth floor of the building, making sure that the flour bins are stocked to fill the mixing bowls below. Recently, both his children earned their masters degrees, their tuition again paid for through their father's work at Streit's.

There are Puerto Ricans, African Americans, native

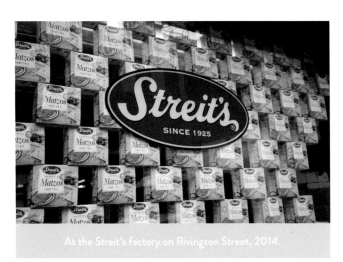

At the Streit's factory on Rivington Street, 2014.

Lower East Siders. There's the full time mechanic, an Italian immigrant, who is busy day-in and day-out in his second-floor workshop, building and rebuilding parts to keep the machinery of the factory rolling. There's the worker who, despite recently having lost part of a finger in one of the cutting machines, continues to work at the factory each day. And one who, when the burner for the third-floor oven burst into flames, ran into the factory with a garden hose in an attempt to extinguish the flames, even as the owners and workers ran from the building. He, too, has put his two children through college by his work at the factory.

At Streit's, then, it is not only the physical machinery that provides a tie to the Lower East Side of the past, but the stories of the men that work there today, like those of the generations before them, who found in their work at the factory means of providing a better life for their families.

While the factory may seem like a relic of another time, it has also been the source of many innovations in matzo, if one can imagine such a thing. The Streit's factory was the first to produce flavored matzo, intended to be consumed year-round, rather than solely during the week of Passover. It was Aron Streit and his son Irving who originated Streit's Moonstrips, a poppyseed and onion flavored matzo, and a play on the Yiddish word "mund," meaning poppy. Other flavors followed and today Streit's produces 13 flavors of matzo.

The Mediterranean matzo, made with sun-dried tomatoes, garlic, basil, and olive oil, is the most time-consuming to produce. Buckets of full sun-dried tomatoes are brought into the factory, and workers spend the better part of the day hunched over them with immersions mixers, chopping the tomatoes down to the appropriate size. At the end of the day, all the ingredients are poured into a massive tank to sit overnight. The resulting mixture could pass for a high-end pasta sauce. The following the day, the mix is blended with flour and baked, and within an hour is being loaded onto trucks for delivery.

But it is Passover matzo for which Streit's is best known, and the several weeks prior to Passover constitute a full 50% of Streit's annual matzo sales. The months before Passover are the busiest of the year at the factory, and often necessitate operating 24 hours a day, which takes a toll on the machinery as well as the men who work there, sometimes 16 hours at a time, only to return to work 8 hours later. But the workers share the trait of being dedicated perfectionists, and the factory buzzes on—and the overtime pay certainly doesn't hurt.

As Alan says, making matzo here is more of an art than a science, and while the ingredients for Passover matzo, flour and water, have remained unchanged for 3,000 years, the ratios between the two are constantly adjusted. Workers in the mixing room feel the dough as it mixes, awaiting the proper consistency, adding a bit more water, a bit more flour. Changes in humidity can affect the dough, as can the temperature differences between floors. The ovens

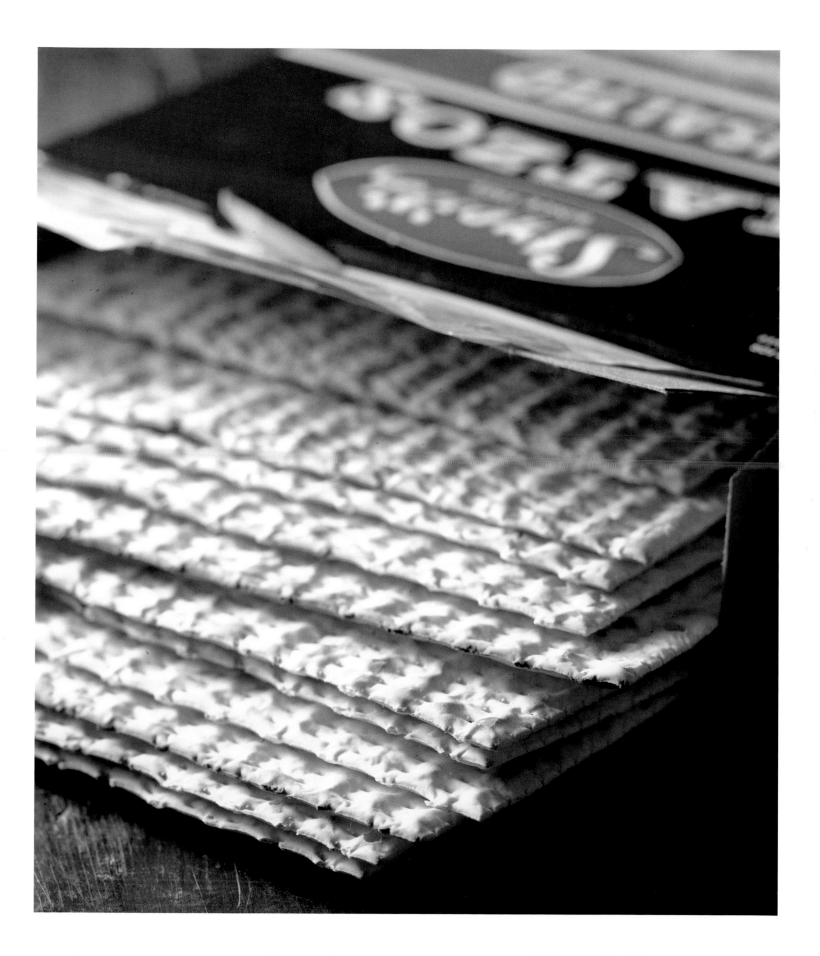

themselves, while identical in construction, have individual personalities that cause differences in the appearance of the end product. If you hand a worker a piece of matzo, he can tell you in an instant in which oven it was baked. To keep the bake as consistent as possible, the workers at one end of the oven communicate with those at the opposite end through a system of bells, indicating that the belts in the oven need to be slowed or quickened, or that the temperature on one side of the oven has gotten too high or too low. Matzo that emerges from the oven too burned or undercooked is thrown into bins, which are trucked out of the factory to New Jersey, where they are used as cow feed.

Those matzos that pass the test are sent via the conveyor system to the second floor packing room. Here, they are taken by hand from their baskets, packed into boxes, and wrapped with the ubiquitous pink Streit's Passover labeling. They are then sent to the oldest machine in the factory, the bundler, a massive piece of 1920s mechanical art, whose sole purpose is to take five one-pound boxes of matzo and wrap them into the five-pound bundles that have been the core of the Streit's business for the last century. Today, though, the five-pound bundle has become their greatest challenge.

While many of the Lower East Side's Jewish businesses closed due to a declining Jewish population and rising rents, these changes have affected Streit's less than one might expect. The vast majority of their business has been their national distribution for most of their history, so they are not as dependent on local sales as many other businesses are. Their forbearers also had the means and good sense to purchase their buildings during the Great Depression, meaning they are not beholden to the rising rents faced by other businesses in the area. But the very factors making moving such a rational choice are the very ones that make it such a difficult decision to make. For the time being, Streit's is here to stay.

MICHAEL LEVINE
Documentary filmmaker,
Streit's: Matzo and the American Dream

SAM SCHAPS' MATZO BREI

Makes 4 servings*

4 matzos
4 large eggs
¾ stick (6 tablespoons) unsalted butter
2 tablespoons milk
1 teaspoon salt, or to taste

Take each matzo sheet in both hands, and hold it under running water, turning a couple of times. After about 15 seconds, you should feel the matzo get "tender." Remove from water and pat dry. You don't want the matzo to crumble or get soggy—just a bit soft.

In a large bowl, break matzo sheets into pieces, about 1½ inches square. Add eggs, milk, and salt, and mix gently with a fork.

Heat butter in a 10–12-inch skillet over moderately high heat. Add matzo mixture and cook, stirring constantly, until eggs are scrambled and matzo has begun to brown a bit.

Either stand over the frying pan and eat, or serve immediately.

* While this recipe makes 4 portions—those would be what we might call "refined Gentile" portions. For hearty Jewish fressers, this is a two-person breakfast! Especially on a Saturday morning, when you can nap after and not have to go to work.

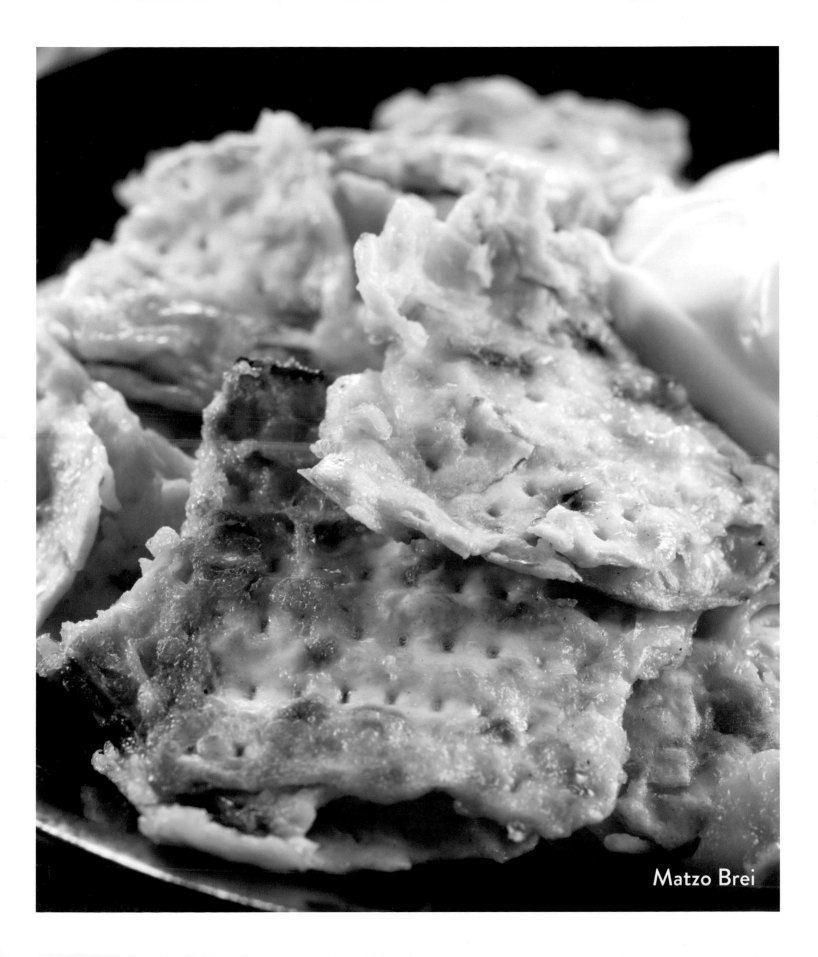

Matzo Brei

Yonah Schimmel

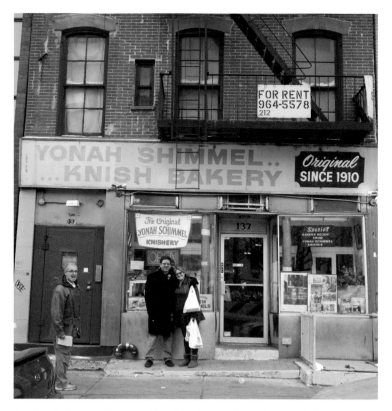

She sits at the first table, facing the door. That first seat at that front table is her office. Her desk items consist of a cordless landline and a cell phone. The day I interviewed her, also an ice pack wrapped in plastic—she'd had some dental work done that day.

I didn't notice this set up when I walked in the door. By instinct, I turned to the left to the tall glass bakery counter. Behind the glass were no-nonsense knishes, behind the knishes, two no-nonsense young people—college-age "yingsters" as my Bubbe Ethel would refer to them—tending to the customers with efficiency and dispatch, and with more warmth the better they knew you. The customer orders were—and I like this—"I'll TAKE:" "I'll take a potato with a Cel-Ray." "I'll take a dozen cheese to go." No one said "I'd like," or "I want." It was "I'll take." I got into it in a second. "I'll take a spinach knish with a Dr. Brown's Black Cherry Soda."

On this occasion I was there to interview Ellen Anistratov, the latest generation of family owner/descendents of Yonah Schimmel—the ORIGINAL Yonah Schimmel. I asked the guy, a lad of perhaps Latino heritage, and a black-haired looker with delicate oval rhinestone earrings, where I could find Ellen. The guy gestured to the back dining room. I went. It was pretty empty—Monday, 3 p.m.—not what you'd call a "high-traffic day/hour" in a knishery. I sat and waited. The yingster came over with a place mat and menu. Some mistake. I told him I was there to meet with Ellen. OK. He goes back to the front. Then the dark cute female yingster comes to me, and I tell her I'm here to meet with Ellen. "I'm Ellen!" Surprise! On closer inspection, she did look older than I originally thought. But as our meeting/interview went on, she alternately appeared like an enthusiastic, stylish (black skirt and sweater over black tights) girl, and a savvy, straight-shooting businesswoman.

Jordan Schaps: Who was Yonah Schimmel and how did this knishery come to be?

Ellen Anistratov: Yonah Schimmel was a scribe—a Torah scholar—and his dream was to teach people spirituality, but at that time nobody had money. So his wife started to make knishes and they were selling them from a push cart at Coney Island. That's how they started.

JS: What's exactly is a knish? Who "invented" the knish?

EA: A knish is a Yiddish word that means dumpling, and Yonah Schimmel was the first knishery that came to the United States. This type of a knish was invented in Eastern Europe. There are different kinds of dumplings—kreplach, pirogen—because the knish, which means a dumpling, can be baked, fried, whatever you like. But kreplach and pirogen come with a lot of dough on the outside and very little on the inside! That's what a dumpling or pirogen is. So what Yonah did was reverse it. They made a lot of stuffing and very little dough. It was the first knish that came to the United States. It was the "Granddaddy of all knishes" for a reason, the "king of knishes."

JS: I did research on the knish. The knish can be made with very little eggs, oil, and baking powder. Is it possible a knish

is like "health food?"

EA: It is health food!

JS: We're talking about 114 years ago.

EA: I call it gourmet food. We put a little oil in the dough, but the dough is like a paper dough, so I tell people if you don't want to have any flour, just take away the crust. The crust is very special, but some people can't eat white flour.

JS: Gluten.

EA: Gluten, yes, so they can still eat the knish. You don't have to eat the outside, you can eat what's inside and it's delicious. But for those that can eat both, it's double the pleasure.

JS: Double pleasure, that's exactly right. I can't imagine eating a Yonah Schimmel knish without the crust. So Yonah Schimmel went from a pushcart to a store not far from here.

EA: Across the street on Houston, right there where the park is. They opened up a store there in 1890, and in 1910 they moved here.

JS: One hundred and fourteen years ago. This is the headquarters. What is your relationship to Yonah?

EA: It's not direct family. We are a family, but it's not direct family. From my father's side.

JS: You came here in 1979?

EA: Yes. We came here and the second day he started to work

Yonah Schimmel,
East Houston Street,
New York, 2014.

here. He came here and he was working as a bus boy because he didn't speak any English. He would do all the dirty work and then he worked his way up.

JS: How come it took so long?

EA: I guess we were the last ones to come out of the Ukraine.

JS: Who's the boss?

EA: The people that come and buy from us, they're the boss.

JS: I love where you're sitting.

EA: Yes, I observe everything.

JS: And you face the door.

EA: Everything, yes.

JS: So when the "boss customer" comes in, they get taken care of. I love that. That's great.

EA: And the biggest boss is my father.

JS: What generation are you? Fourth, fifth?

EA: My kids are sixth generation.

JS: Six? Do you imagine them going into some kind of work here?

EA: When they are on vacation, they come and they help me out.

JS: Do you cook knishes?

EA: I can.

JS: You can?

EA: Yes. A boss should know how to do everything. If not, don't do it.

JS: These knishes, they're baked?

EA: Baked, yes.

JS: They're not fried.

EA: No, they're baked. You know too much of anything is not good. You know how they say carbs are not good. This is not good. In moderation everything the body needs. So how bad can mashed potatoes be, with spices and onions, or spinach, or cheese with cherries. We make cherry cheese, like all the cheese knishes, with Hahn's Fine Baker's Cheese. It's similar to farmer's cheese and it's made with skim milk. We add our own stock, but the base is skim milk, so you can eat it and not feel guilty. You feel like you're in heaven but you don't have to feel guilty about it. For years we've been using it and one day I looked at the box, I see it says, "no fat, no cholesterol." It was at a time when everybody was watching their weight, counting calories, maybe 10–15 years ago. After that they started to go into carbs— no carbs, no this, no that—but before it was calories, everything was about calories. Remember?

JS: Sure. Absolutely.

EA: So I was like, "Wow, this is great. I never knew about this."

JS: You made some changes to what goes into the knish, right?

EA: I just added different kinds of knishes. I added to the menu, a "special of the day."

JS: What did you add that was red?

EA: Ahhh, you want to hear that story?

JS: Yes.

EA: We used to have a cabbage knish with white cabbage. My father had to have a procedure, he had a hernia, so he wasn't here for two weeks. I asked why we didn't have baked cabbage one morning, and they said, "We can't, your father got the wrong cabbage. He got red cabbage instead of white cabbage." So I said, "I don't care, make whatever is there, we'll try red cabbage." And we made red cabbage and people were buying it like I don't know what. It was the biggest seller. Everybody was buying it. So my father comes back and he sees something new in the window. He comes in and he says, "What is this, meat? In a knish?" And I'm like, "No, it's red cabbage." He's like, "What do you mean

its red cabbage. We don't sell red cabbage!" He's very old-fashioned, we have to go by the book. I said, "You were the one that bought it." He was very upset with me. He's like, "You're going to ruin the business!" And I got very upset with him; we had a little fight. I had to leave the store because I didn't want to be here for a while, and while he was here he saw how people were buying it, so he calls me and he says, "OK, listen, so we're going to have white cabbage AND red cabbage! Come back." So then for a while we had red cabbage and white cabbage, until there was no demand anymore for white cabbage, so we just went to red cabbage and if you ask my father, today, what is your the most favorite knish in the store, he will tell you "red cabbage!"

JS: That's great. Do you have other "flavors of the day?" Do you do variations or slight differences? I see one with a different kind of cheese.

EA: Yes, today's special is jalapeno and pepper, with cheddar, potato, and onions and spices. It's amazing. It's a heavenly knish. It's not very spicy, it's really like beyond delicious.

JS: Who comes up with those ideas?

EA: I do, most of them. We have a pizza knish, mozzarella and potato, pepper and onions, lox and potato, toasted garlic and onions, fried onions with peas.

JS: These are on different days? Or you have all of them every day?

EA: No, no, we choose one and it's like a surprise. But people really demand jalapeno and pepper with cheddar. They come in and we don't have, they get very upset.

JS: It really caught on.

EA: Yes it really did.

JS: Who invented that?

EA: I did.

JS: What do you see happening in the future for both the cuisine and for Yonah Schimmel? Because everyone talks about Yonah Schimmel and other places as the past. It's the past. It's great that it's here, but what about the future?

EA: Well, I always believed bringing the past into the present. That's how the world goes around and how genuine things stay alive. But I want the store to prosper here, I also believe it should be all over the world. I believe there should

EA: Yes.

JS: Who's your favorite customer?

EA: All of them. I enjoy when somebody comes in and they don't know what a knish is and there's a customer who does know what a knish is and when they ask me, "What's a knish?" I don't have to say a word, because the customer wants to explain, and I just listen and enjoy.

JS: Why has the store survived for so many years?

EA: My personal opinion is because behind the store there's a man who was writing the Torah, the scribe, and his desire was to teach people spirituality. He injected that energy into the food that he was making with his wife. So behind a knish is the Bible, it's a song, it's the consciousness of a man that wants something that never dies, so when you eat a knish you feel very soothed, you feel comfort, you feel love, from the Bible. You connect to the Bible when you eat a knish.

JS: That's amazing. Well I don't want to interpret your story, but the knish is even round, like eternity, like continuity.

EA: Like the world.

JS: Do you cook Yonah Schimmel knishes?

EA: No, I usually get them from here.

One time Barbra Streisand was here, and she was standing here with three young guys, bodyguards, and my father was here. He didn't recognize her. She took her kasha knish and she ate it so fast. When she performed her show, it was part of a scene. She said, "I'm sorry I was late, I was at Yonah Schimmel's. Do you know where that is?" And somebody cursed or something, so she threw them out of the theater. That's what I was told. I wasn't there.

JS: Tell me about Francis Ford Coppola.

EA: He came in. There was nobody here, so he came in and he said, "I would like a dozen kasha knishes." So I was packing it and then I asked him, do you know how to warm it up? I figured he was probably an old customer and he tells me, "You've probably seen me somewhere else." "Why would you tell me that if you wouldn't want me to know it, right?" So I'm like, "Are you a famous actor? Because we have a lot of actors coming here." He's like, "No." I said, "What is your name?" And he says "Oh stop." So then he gives me

be many stores all over. Everybody should know how real knishes taste.

JS: Like having a Yonah Schimmel in Chicago.

EA: Yeah, a franchise? Of course, that's how we're going to keep it alive.

JS: That's amazing, absolutely.

EA: That's why we ship all over the United States.

JS: One-day, right?

EA: Overnight, yes. So we can have many stores all over. We won't have to ship. You can just say "Do you want to go for a Yonah Schimmel knish?" And you are where you are and have that experience.

JS: You'll go on Collins Avenue in Miami Beach.

his credit card and it says something, Robert something. So I said, "Oh, I have your name here." And he's like, "No I go by a different name." So I'm like, "OK so I'm back to square one. What's your name?" And he was like really giving me a hard time, so then I take a postcard, like I do with all the other ones and I turn it around and I'm like, "Can I please have your autograph?" And he scribbles something. He writes Francis Ford Coppola and I really didn't understand. I'm like really, "I don't understand what you wrote. Who are you? I'm sorry." And then on the bottom he wrote *The Godfather*. And then I was like, "Thank you for stopping by. It took me 20 minutes to know who you are." Then about a year later, he was back. He was wearing Converse sneakers and driving a Nissan, so he really threw me off, but I remember him, his personality. He's really tall. So I look at him and I'm like, "I know you." And he also ordered a kasha knish, so I said, "I know you." And he's like, "Oh stop." But he really wanted me to remember him. So then I asked him again, "Can you please give me your autograph again?" And it was our 100 year anniversary, so he wrote "FFC for your 100."

ELLEN ANISTRATOV
Owner, Yonah Schimmel Knish Bakery
INTERVIEW BY JORDAN SCHAPS

Gabrielle and Andrew.

KNISH ME

. . .this time-worn Yiddish joint offered up all the romance we needed.

He was 23, I was 20. It was late afternoon in the winter of 1987. We were both hungry after working a gallery shift on East 1st Street, and so we scrambled through a bitter wind on Houston Street to the steam and warmth of Yonah Schimmel Knish Bakery.

We were a couple of NYU students, newly in love, and this time-worn Yiddish joint offered up all the romance we needed. (Although, in those days, even the L train might have seemed romantic to us.) Yonah Schimmel may not appear on anyone's list for that special night out, but for us it will always be remembered as the place where Andrew declared his intentions and pronounced our future together—with marriage and kids, the whole deal.

It took a few years, but things did work out for us that way. And Yonah Schimmel is where it all began.

The knishes were also excellent.

GABRIELLE BORDWIN
Graphic designer

Q

What did the waiter ask
the group of dining Jewish mothers?

A

"Pardon me ladies,
but is ANYTHING all right?"

The Underground Gourmet

Where to find great meals in New York for less than $2.00 and as little as 50¢

BY MILTON GLASER AND JEROME SNYDER

$1.95

YONAH SCHIMMEL'S KNISHERY, 1968

Yonah Schimmel's Knishes Bakery, 137 E. Houston Street, is a remnant of another era. This quiet little bakery-restaurant evokes the time when tens of thousands of Jewish immigrants found a friendly haven on the Lower East Side. Now, a half century later, this area has changed its character. Puerto Ricans, the newest wave of immigrants, have brought their Latin-American culture to this traditionally Jewish neighborhood, and the vestigial Jewish shopkeepers have had to adapt by adding Spanish to their linguistic repertoire, while the Puerto Rican has added the knish to his gustatory pleasures.

The original Yonah was the "shamus" (sexton) of the local Romanian synagogue when he established this bakery in 1910. Since his death, the business has been operated by his grandchildren. Their debt to the patriarchal Yonah is symbolized by their display of his portrait in the bakery's window. The raison d'être of this landmark has always been and is today the potato knish. Although the knish has played an active role in many New York political campaigns, some readers may still never have seen or eaten one.

The authentic hand-made knish made at Yonah Schimmel's is an irregularly shaped, fat, bun-like amalgam of mashed potatoes, flour, and onions, all encased in a thin, crisp, brown pastry skin, and as a food contains great stomach-filling properties. As is the custom with simple dishes, the knish is at its best when fresh, hot and made of ingredients of good quality. The mass-produced commercial knish most often encountered in New York delicatessens lacks these essentials. It can be recognized immediately by a thick, embossed surfaced of an unnaturally yellow hue. Another clue of its identification is its hard-edged rectangular shape. Because the commercial knish is often kept on a hot grill for days at a time, the potato filling tends to go sour. The real tragedy of this abuse is that many people brought up on this inferior product have never known a real knish. Yonah Schimmel's is perhaps the last bastion of

"No New York politician in the last 50 years has been elected to public office without having at least one photograph showing him on the Lower East Side with a knish in his face."

the genuine item. Yet, this brave restaurant lives mainly on its past glory. Izzy Finkelstein, the waiter who has been with Yonah's for 45 years, recalls the day when Mrs. Roosevelt came in to order a bag of knishes for her husband, Franklin, who was campaigning in the district. "On Sundays, rich people, very rich people, used to come in their cars and they would wait on line for hours to get in." A more recent regular visitor was former Mayor Robert F. Wagner. Now the restaurant is run down, almost seedy and full of nostalgia.

The dining room is small and plain and the 50-year-old wood framed glass showcase at the entrance has been painted over at least a hundred times. Arranged along the walls like hurdles are the long, narrow, Formica-topped tables. Silverware, like a metallic bouquet, is kept in glass containers on the tables. Other room decorations are small mirrors, and two ancient electric fans. Knishes are ordered from the store-long kitchen beneath the dining room. They are sent up promptly and piping hot by means of a dumbwaiter.

Purists consider knishes other than potato an affront, but in the interest of non-partisan reportage the other types should be listed. One is kasha (a heavy lump of cooked buckwheat groats), which—if it can be imagined—is even more filling than the potato knish mutants. They are closer in taste and appearance to what we know as Danish pastry. The cheese varieties are really more suitable as desserts. Apart from the sandwiches, which are undistinguished, the remaining offering is the "potatonik," which was called "sputnik" during the early days of Russian space accomplishments. Potatonik is essentially a baked-potato pudding. A large oleaginous square costs 20 cents. All knishes are 25 cents each, potato being the obvious authors' choice. Mr. Finklestein, our waiter-historian, remembers with a sign when knishes cost three cents. To wash it all down, soft drinks are available, and a decent cup of coffee is served for only 10 cents. Service is simple and quick.

Beyond the pleasant remembrance of things past, a visit to Yonah Schimmel's bakery is rewarded by those things the Underground Gourmet values most highly: good quality at low prices.

UPDATE, 2014

Sadly, the other night I heard a TV report, that the company who originally manufactured "the mock knish," a square, virtually inedible product, was going back into business after I would suspect, the duration of 30 or 40 years. This is sad news for anyone who has never had a REAL knish. But mostly, a degradation of the word, itself.

Yonah Schimmel represents the aspiration of many hundreds of immigrants to have a REAL knish—made in the proper way using real potatoes, AND BAKING IT!

MILTON GLASER
Graphic designer

Milton Glaser as a child.

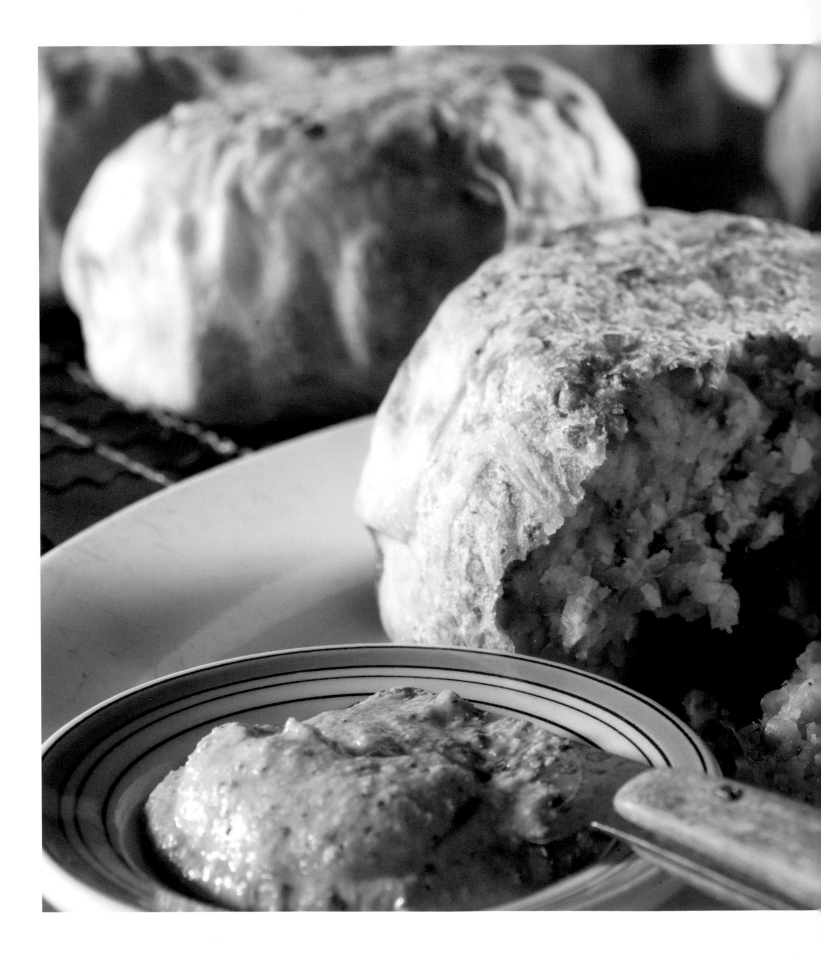

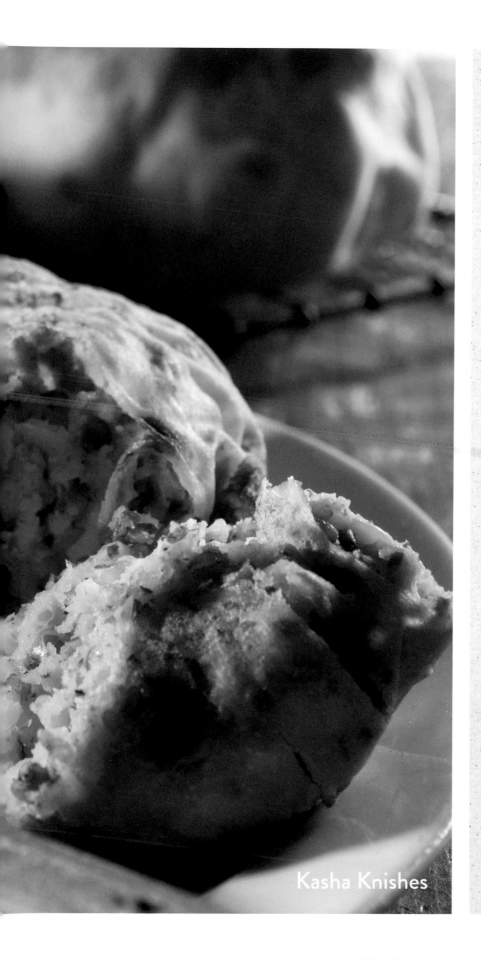

Kasha Knishes

YONAH SCHIMMEL'S
KASHA KNISH

WHAT'S IN A KASHA KNISH?

kasha

mashed potato—
just enough to hold the kasha together

onion—
crushed, so they're invisible.

"When it comes to Yonah Schimmel's knishes, what you see is what you get. There's nothing else, chemicals or fancy."

—Ellen Anistratov, owner, Yonah Schimmel

If there ever was decent
inexpensive comfort food
to be had for a poor ambitious
young person trying to survive
in New York. . .the old Jewish
hood was the place to go.

HEAVY LIFTING

Around the year 1950 I lived, and was part-time janitor for a period (in exchange for tuition), in a now long-gone Greek Orthodox church which was used as an extension of The New School for Social Research's film department. The building was located on Houston next to the Bowery between a Jewish-language theater and the famous Sammy's Bowery Follies Night Club. My nutriments at that time relied heavily (literally heavy) on Katz's Delicatessen and a couple of the knish stores a few yards going east on Houston.

Well, that culinary experience in my formative years did not kill me as I am still around to tell the tale. If there ever was decent inexpensive comfort food to be had for a poor ambitious young person trying to survive in New York with enough muscle to lift one of those substantial delicacies, the old Jewish hood was the place to go.

Now, so many years later, the knish has survived if not prospered in spite of the inevitable changes in the old quarter and changes of culinary habits. Still, the knish may triumph again one day as classics have a way of reappearing. But at this time, the occasional visits to the old quarter of Houston, Delancey, and Katz's is an exercise in nostalgia.

ELLIOTT ERWITT
Photographer

"If I didn't have
potato knishes
and Chinese food
every week,
I do not believe
my blood
would have
run properly."

BRUCE
"COUSIN BRUCIE"
MORROW

DESPERATELY SEEKING SABLE

When I moved to the ungentrified East Village in 1985, I was trying to get as far away as possible from my lox-and-bagels, pastrami-on-rye childhood in suburban Scarsdale. I did not want to live on the Upper East or Upper West Sides, the neighborhoods my parents considered safer and more appropriate. I did not want to be one of those yuppies who shopped at Zabar's.

Moving to the East Village was my rebellion against my roots. I loved roaming the scruffy streets, discovering shops and cafes that were rarely featured in the "Best Bets" column of *New York* magazine where I then worked. I was only interested in places that were gritty or marginal.

However, you can take the boy out of Scarsdale, but you can't take Scarsdale out of the boy, and I grew nostalgic for Sunday brunch at home with prune danish or coffee cake, lox and bagels. I found a shop at 99 Second Avenue with a sign that said "Appetizing," a place called M. Schacht. It wasn't crowded like uptown places like Zabar's or Barney Greengrass, but it did have men in white jackets who stood behind a refrigerated glass counter hand-slicing smoked salmon and pearly-white sable. M. Schacht sold fresh bagels and bialys, scallion cream cheese, and addictive whitefish salad which is basically crack cocaine for secular Jews. Although it had a down-at-the-heels East Village aura, it reminded me of the Daitch Shopwell supermarket in Scarsdale where the deli department always carried chopped liver, gefilte fish, and at least four types of salmon (belly lox, Nova, kippered, and pickled) that was hand-sliced by men in white jackets who wielded long, skinny knives as if cutting fish was brain surgery.

I also discovered a bakery called Moishe's at 115 Second Avenue (which I understood was kosher because it was closed on Saturdays) that sold the most amazing loaves of babka for just $3. Dense with chocolate and a crumbly top, it was more delicious than the danish and Entenmann's coffee rings I had grown up eating. The East Village offered a taste of the Old World that did not conflict with my new life.

I lived down the block from the 2nd Avenue Deli, too, and I resisted going in there. On Sunday afternoons, there would be Cadillacs with Jersey plates double-parked out front and zaftig couples emerging with huge bags of food. Oy vey. They were the type of people I had moved to the city to escape.

One day, Amy Virshup, the hippest editor at *New York* magazine, who lived in a walk-up tenement on East 9th Street, told me that whenever she thought she was going to get a cold or the flu, she went to the 2nd Avenue Deli for a pint of take-out matzo ball soup. I had no fondness for matzo balls because my mother made hers from the Manischewitz mix. But if Amy Virshup, whom I considered the arbiter of all things cool, approved of the 2nd Avenue Deli's matzo ball soup then I had to try it.

Amy was right. The soup was supernal—the broth crystal clear and flecked with fresh dill, the baseball-sized matzo ball fluffy and flavorful. It became my get-well ritual to head to the 2nd Avenue Deli every time my throat felt scratchy or I got the sniffles. When I felt flush, I upgraded to the soup-and-half-sandwich combination. I always got pastrami with coleslaw and a side of Russian dressing. I would bring the meal home to my apartment, dip the two pickles that came in a separate plastic bag into the dressing, and savor this meal that had been a staple of my grandparents' lives.

I considered living so close to the deli a blessing—bashert. I looked forward to the cough or sneezing jag that would give me an excuse to go there. Eventually, I needed no excuses, and I would head there whenever I wanted to feel connected to the past that I thought I'd run away from. I had come to understand that lox and bagels, pastrami-on-rye were my soul food. I also realized that nothing's more important than feeding your soul. Indeed, it was the very reason I'd moved to the East Village in the first place.

DAN SHAW

Writer; contributor, *The New York Times*, *Architectural Digest*; founder, Ruralintelligence.com

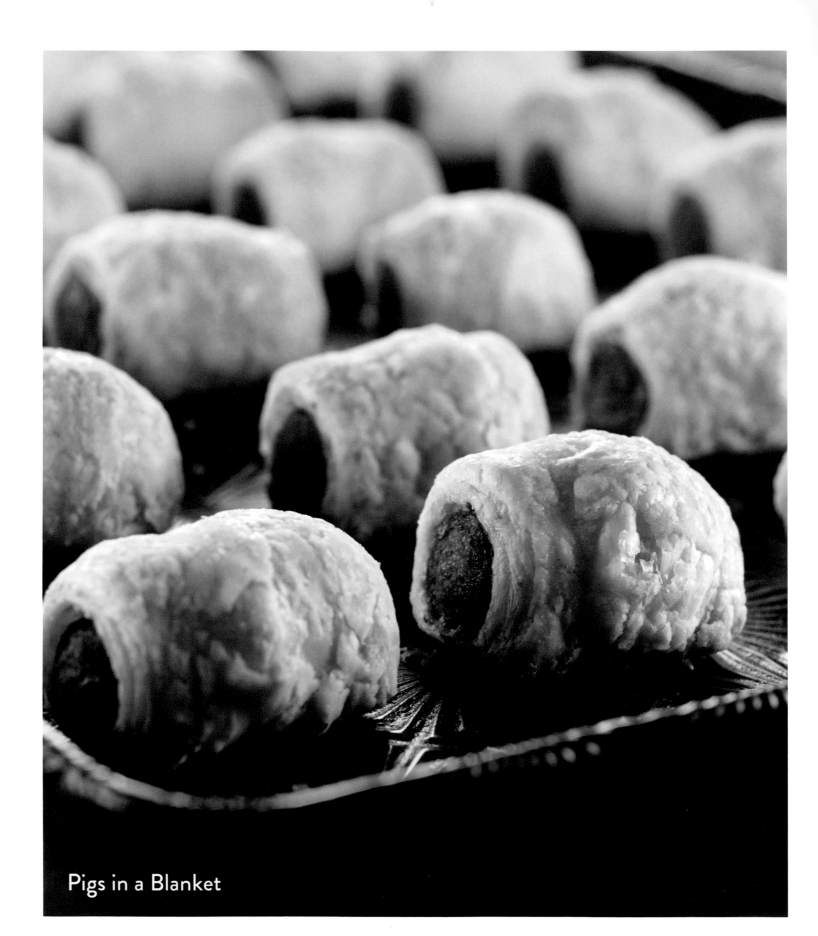

Pigs in a Blanket

SHABBOS GOY

Confession: I've always wanted to be Jewish! When I was in the fifth grade, I raised my hand and told Sister Joyce I could not participate in religious education class that day. When she sternly asked me why, I responded, "I'm really Jewish." What precipitated this revelation was watching *Yentl* the night before with my grandfather on the pullout couch in our living room. I was hooked!

You see, my grandfather was actually my first Jewish enabler. Papa worked in SoHo and lived in Bushwick, so he drove over the Williamsburg Bridge every day to work, and on his way home he would always stop at Katz's for either a pastrami or tongue sandwich and a bottle of Cel-Ray soda.

I must have been seven years old when he took me out for this, a fine culinary meal, and if *Yentl* didn't have me at hello, that first well done hot dog, square knish, and root beer meal changed my life!

I come from a VERY Italian family that treasured three things equally: Jesus, meatballs, and al dente spaghetti. However, it was my very Italian parents that decided to move from Bushwick the year I was born, to a town on Long Island called Great Neck. Population: 99% Jewish. The migration of my mom, dad, sister, and grandparents made up the other 1%.

It was there that incredible people like the Levinsons, the Balkins, and the Gads entered my life. While Sundays were for meatballs and spaghetti at my house, Friday nights were for brisket and gefilte fish at the Gads. Diggy and Hal took me to my first aufruf and my best friend Lauren allowed me to attend Hebrew school with her so often that by the time I turned 13, I was able to recite the Haftorah.

And the boys. . .there was Ivan Goodstein, Andrew Finkelstein, Derek Silberstein, and Josh Rothstein. If there wasn't a "stein" at the end of his name, I wasn't interested.

Their mothers were less than interested in me and I'll never forget standing in line at the bagel buffet at Andrew Finkelstein's Bar Mitzvah when I overheard his mother's friend point and say, "You're OK with your son dating that shiksa?" I of course went home that night and asked my Papa what "shiksa" meant. After a brief tutorial in the words shiksa and goy, he then divulged that he was in fact a Shabbos goy himself. A very proud moment in our family history indeed.

It was also at the 130+ B'nai Mitzvahs that I attended where I developed a deep love for the pig in a blanket, so much so that I have gone on to devote my career to that hors d'oeuvre. And I continue to love all things Jewish: there is not a knish I do not cherish, kugel makes me kvell, and Barbara Streisand will blast loudly and proudly from my iPod until the day I die.

Shiksa, goy, Shabbos goy. . .I wear it as a badge of honor. Call me what you want! As long as you save a space for me in the hora circle and bring me a blintz or a warm slice of challah, I'll be putty in your hands.

MARY GIULIANI
Caterer to the stars, "I'm Your Little Shabbos Goy"

MARY GIULIANI'S INFAMOUS PIGS IN A BLANKET

◆ ◆ ◆

16 sheets of phyllo dough

8 all-beef hot dogs (Sabrett or Nathan's are my favorite)

1 cup mustard

Lay out 2 sheets of dough for each full hot dog.

Brush mustard on inside of phyllo and roll tightly around hot dog.

Place on baking sheet, seam down.

You can brush the outside of the phyllo with melted butter for a little extra taste and color.

Bake according to phyllo package directions until golden.

Slice into bite sized pieces.

Serve with more mustard for dipping.

Did you hear about the bum
who walked up to a
Jewish woman
on the street and said,
"Lady I haven't eaten
in three days."
"FORCE YOURSELF,"
she replied.

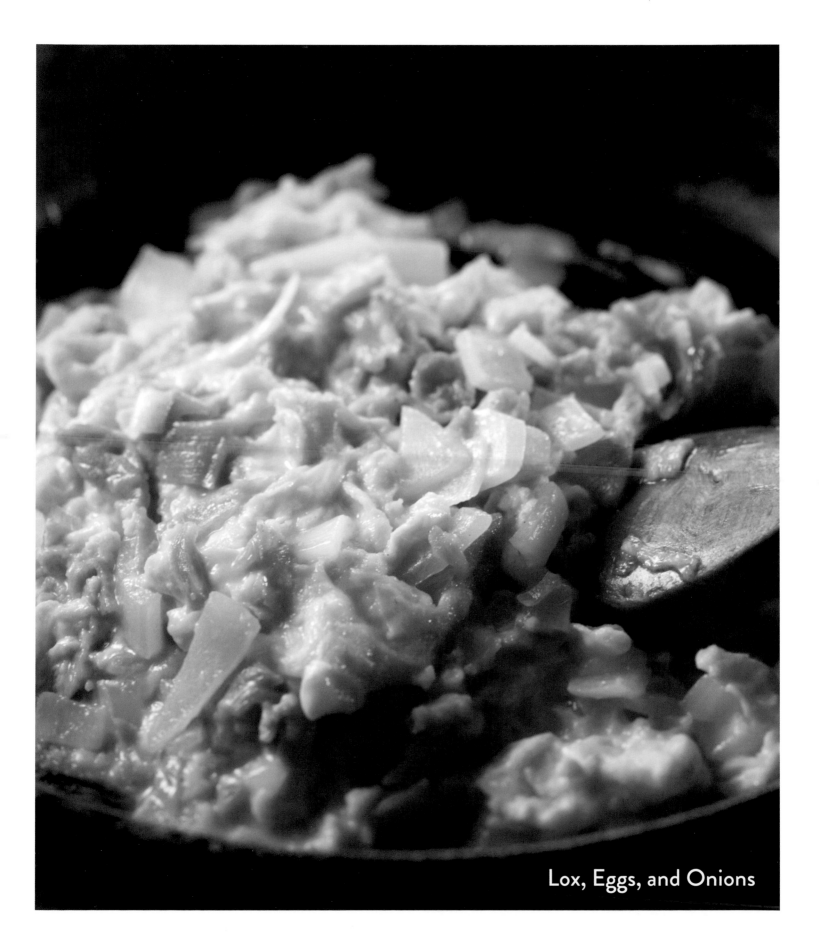

Lox, Eggs, and Onions

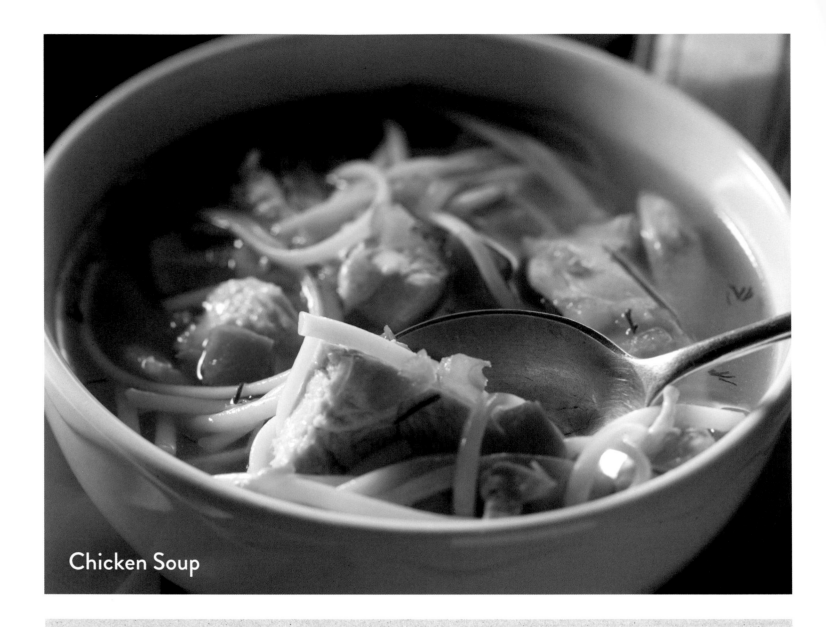

Chicken Soup

CHICKEN SOUP

4 pounds stewing chicken (include gizzard, heart, neck, and feet)

1 quart boiled water per pound of chicken

2 stalks celery (with leaves)

1 large onion

1 large carrot, diced or sliced

1 bay leaf

6 peppercorns

Remove excess fat from pieces of chicken.

Place chicken, spices, and water in a pot and bring to a quick boil. Turn heat down and simmer slowly for 30 minutes.

Skim carefully. Add vegetables and continue simmering until chicken is tender.

Adjust seasonings to taste.

SOMEHOW THE INGREDIENTS
THAT ARE IN CHICKEN SOUP
PREVENT COLDS
AND RELIEVE HEADACHES.

HOWEVER...

MY FAVORITE JEWISH FOOD IS
CHICKEN CHOW MEIN.

"PROFESSOR" IRWIN COREY
Comedian

THE PLUCKING SONG

We pluck pluck pluck pluck pluck all day long

as all this pot we stew.

We pluck pluck pluck and sing a song

as we make chicken soup.

With a pluck pluck here, and a pluck pluck there,

here a pluck, there a pluck, nearly everywhere a pluck.

Oh my, some plucking all day.

Soup soup soup soup, we dream of soup every night.

Soup soup soup soup, you are our soup-reme delight.

With a bone, and some beans, with some salt and some greens,

we are making chicken soup.

With some corn and some rice with some peas and some spice,

we are making chicken soup,

chicken soup, chicken soup.

LYRICS BY WALTER BULLOCK, FROM THE 1939 MOVIE *THE THREE MUSKETEERS*, COURTESY OF JANNA RITZ

The Ritz Brothers in *The Three Musketeers* (1939). From left: Jimmy Ritz, Harry Ritz, and Al Ritz.

PHOTO COURTESY OF PHOTOFEST

RITZ BROTHERS

Food and the Ritz Brothers go together like bagels and lox. As in their classic 1939 film *The Three Musketeers*: who else but the crazy Ritz Brothers would sing a song called "Chicken Soup" (otherwise known as "The Plucking Song").

And when Al, Jimmy, and Harry weren't singing about chicken soup, they were devouring giant hero sandwiches on the big screen. Or was it, big hero sandwiches on the giant screen. This was first seen in the brothers' 1940 film *Argentine Nights*. With perfect precision, the Ritz boys jumped from one end of the sandwich to the other with lightning speed, to ensure they all got that last bite of roast beef.

The Ritz Brothers loved this bit so much that when they came out of retirement in 1975, Jimmy and Harry recreated the routine in the film *Blazing Stewardesses*.

JANNA RITZ
Daughter of Harry Ritz

The Dubroff siblings with Mama and Papa, at Michael Dubroff's Bar Mitzvah, 1952.

BROWN FOOD

Have you ever asked yourself what distinguishes Jewish food from Italian, Vietnamese, Danish, or American food—culturally speaking? Although, even bagels have become American food, I'm not sure how to describe American food, except it's what you eat at Thanksgiving. When I was growing up I thought that Jewish food had to be brown or a shade of brown (except beet horseradish) If there was color of any kind we knew it was a foreign delicacy. For example, we had Chinese food every Sunday and there were green vegetables. And when we ate Italian, there was bound to be some red. Foreign!

This was not the case on my bubbe's table. There was always meat. If it wasn't brown or some shade of brown initially, it most assuredly became brown when it was cooked. There were potatoes fried in chicken fat—a lovely shade of beige—and although the chicken soup had some color,

I never considered that Jewish. However, the matzo balls, were Jewish and a shade lighter than the fried potatoes. Think about it: knishes, cholent, matzo, chopped liver, kugel, fish, fried kippers, matzo brei, pot roast, and even tzimmes (which was made with carrots and sweet potato) were always cooked until they looked brown. Kasha varnishkes, mandel bread, oatmeal soup, and fluden (challah dough filled with onions and baked), were certainly beige.

Understand, this wasn't a terrible thing. Until we grew up and tastes changed, we all thought the food was delicious. "It was," as Bubbe and the tantas always said, "what was."

With that in mind, here is my recipe for amazing challah. And why is it amazing? Because it tastes like cake—a beige cake with brown crust, of course.

IRIS BURNETT

Producer, *The Gefilte Fish Chronicles*

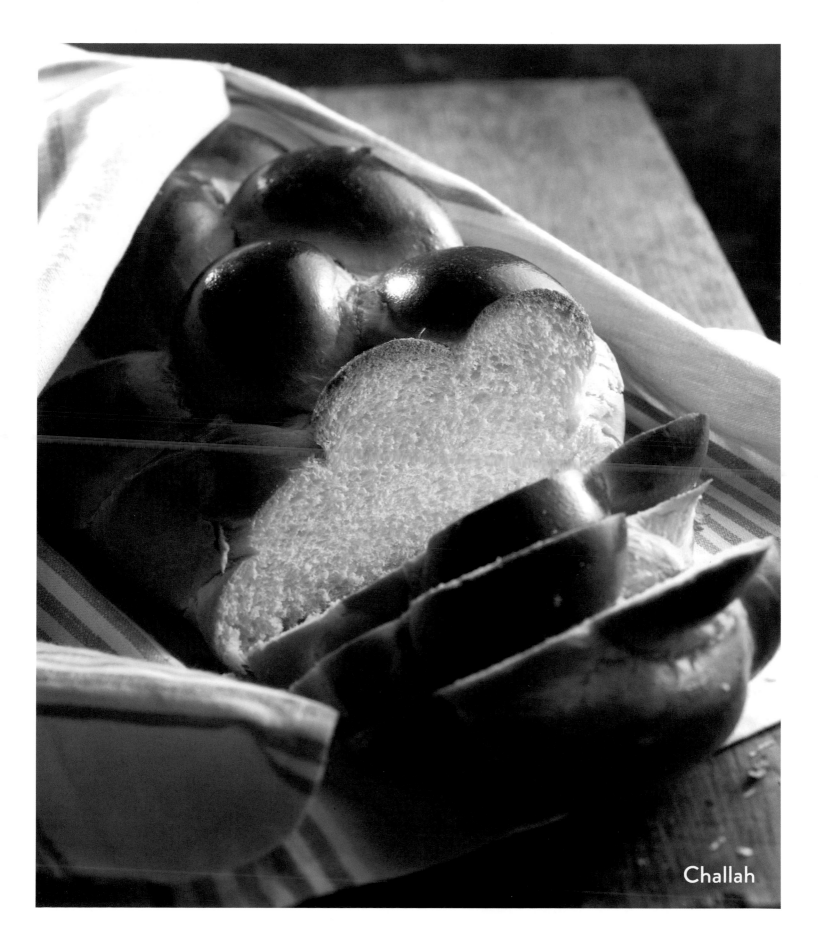

Challah

Challah French Toast

IRIS BURNETT'S "BROWN" CHALLAH

bread flour

2 cups water

2 packages yeast

6 whole eggs

1 egg, white and yolk separated

½ cup sugar

½ cup canola oil

1 tablespoon sour cream

2 teaspoons salt

1 teaspoon vanilla

Don't preheat the oven. You won't need it for hours.

Dissolve the yeast in lukewarm water, (rapid rise is fine, but it won't make it any faster).

Beat together the eggs and 1 yolk. Save the extra white for later. Add the sugar, canola oil, vanilla, sour cream, and salt.

Beat all this together and slowly, still beating (or use an electric mixer—but you won't be able to feel the dough), add in bread flour one cup at a time until it's too thick to mix with anything but your hands.

Keep adding flour until the dough is no longer sticky but is certainly firm. Keep kneading on a board or marble, until when you press the dough together it stays that way. Knead it as much as you want because that's the fun part.

Make it into a ball. Place the ball in a big bowl covered with one tablespoon of oil and a towel. Allow it to express itself. It should rise for at least an hour or more in a warm place. If it doesn't rise, your yeast was probably bad, or your water was too hot. So start over.

Once it rises beat it down like you were trying to win a boxing match.

Once again, make it into a ball and let it rise again.

After an hour you can divide it into two pieces (I don't), braid or shape the dough and place on a parchment covered cookie sheet.

Now you can preheat the oven to 350° F, and let the dough rise again in whatever shape, outside the oven for another hour.

Right before you put it in to bake, coat it with the beaten egg white you haven't used in the recipe. (Remember 6 eggs, one yolk).

Bake for about 50 minutes if you made two loaves, and an hour if you made one giant loaf—this one should now be the size of Miami.

Immediately cool on a rack—you don't want it to get soggy. Cut when cooled, and you can freeze if you don't finish it for dinner.

This will probably become your favorite treat, from all the brown food groups.

D.I.Y. BLINTZES!

Most of the people I grew up with always talked about the rude waiters at Ratner's. For me, as a child, Ratner's wasn't about waiters, it was about blintzes. Ratner's was the first place I ate cheese blintzes with sour cream and cinnamon and sugar. While my Aunt Rosie's were a close second, Ratner's blintzes were the best, even compared to the cheese blintzes at Gross's Dairy restaurant in the Garment District.

Having started doing my own cooking and baking in my 30s, I was determined to learn how to make my own blintzes. The trademark for a great blintz is the bletlach (Jewish word for crepe). I bought a great crepe pan at the original Dean & Deluca in the pre-Teflon days, and spent hours and days seasoning it, warming it in the oven, rubbing oil into it, scouring it out with salt and never ever washing it. I was a fanatic!

To make the perfect blintz, you had to pour the batter into the hot pan then immediately spill the excess out. Too hot and it burned; too cold and you had no crepe. Hundreds of pounds of butter and dozens of eggs later, rubbing the pan out with salt again and again, I had the perfect bletlach.

Now for the filling. NO cottage cheese! You need farmer's cheese, which has had most of the moisture pressed out of it, even more than pot cheese. The rest is a secret that I distilled from eating blintzes in hundreds of restaurants and making thousands of my own. I will give you a hint though. I have a sweet tooth. I like sweet gefilte fish and sweet blintzes, so mixed into the farmer cheese are sugar and cinnamon. But the real killer ingredient is raisins that have been rolled in the cinnamon and sugar. Yum!

I will leave you to choose your own favorite sour cream, but of course a homemade fresh blueberry sauce along with the sour cream is when the party really begins.

MARTIN KELTZ
Emmy Award-winning producer

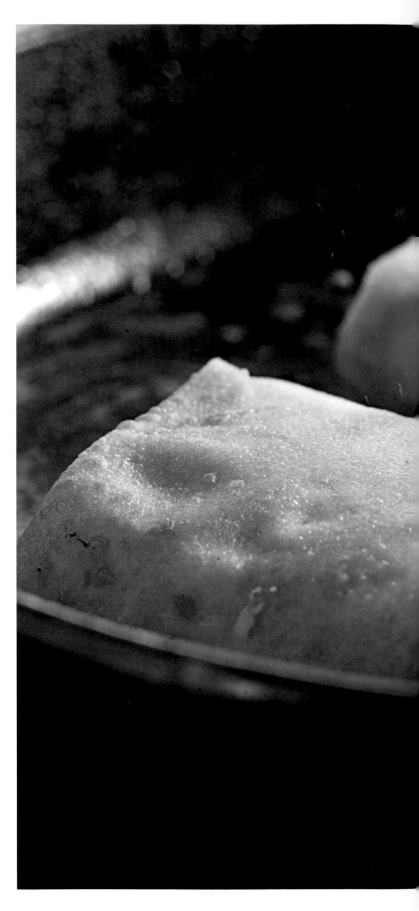

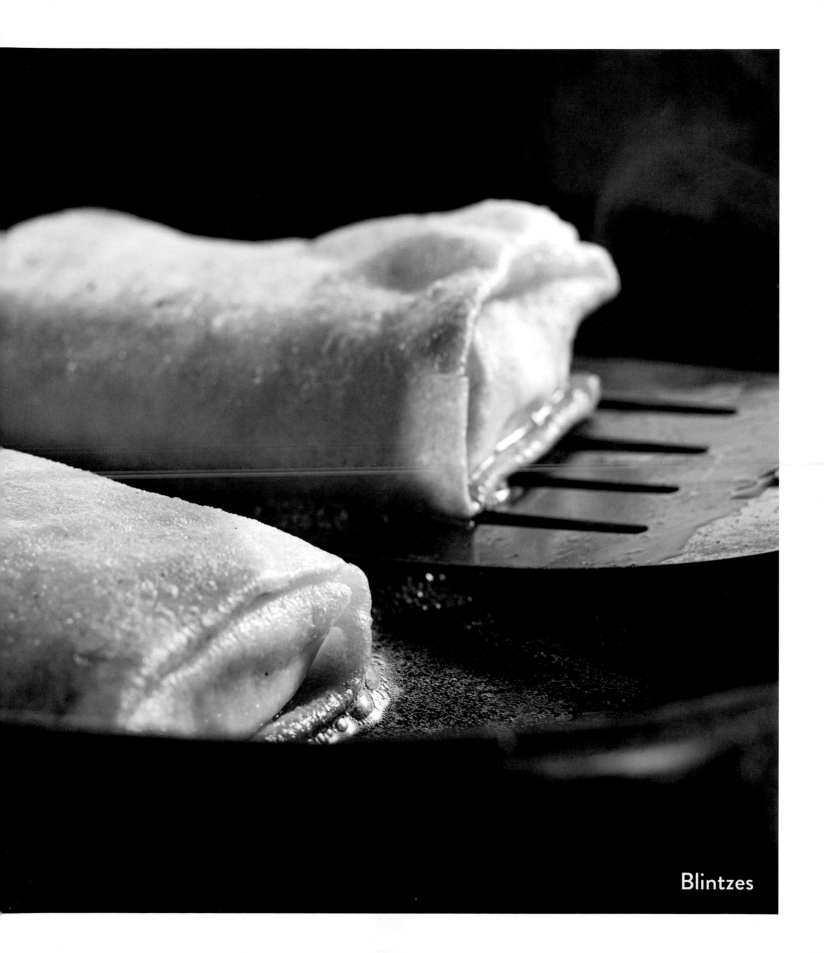

Blintzes

An elderly man in
London during WWII
refuses to run
for the air raid shelter
until he can find his false teeth.
His wife yells at him,
"What? Do you think
they're dropping, blintzes?"

RATNER'S CHEESE BLINTZES

◆◆◆

Makes 24 blintzes

PANCAKE

4 eggs

2 cups sifted all-purpose flour

2 cups water

⅓ cup clarified butter
(1 pound clarified butter or parve margarine)

½ teaspoon salt

Makes 1⅔ cups

CHEESE FILLING

2 (8-ounce) packages farmer cheese

2 egg yolks

¼ cup sugar

1 teaspoon vanilla

To make the filling, combine all ingredients in a bowl and mix thoroughly.

To make clarified butter, melt butter in a saucepan over low heat. Remove from heat and let stand for 2 minutes. Skim foam from butter, if any, and then pour off clear, oily looking butter into a container. Stop pouring when you reach the milky residue in bottom of pan. Refrigerate until needed.

To make the pancakes, in a bowl combine eggs and water and blend thoroughly. Beat in flour and salt. Mixture will be runny.

Pour 2 tablespoons of the batter into a hot, greased 7-inch omelet pan. Rotate skillet so bottom of pan is covered evenly.

Cook for 3 or 4 minutes on one side, or until golden. Remove from pan and repeat process using all the blintz batter. Pile one on top of the other, uncooked side down. At this point blintz pancake is ready to be filled.

Place 2 heaping tablespoons of filling on one half of the unbrowned side of the pancake. Fold pancake over once to cover filling. Fold in sides of pancake. Continue rolling.

Heat butter in a skillet until hot. Place blintzes, seam side down, in skillet and sauté until golden on all sides.

Serve hot with sour cream.

PEACE, LOVE, AND PICKLED HERRING

So it's probably May of '69. We're deep into it [planning for the iconic Woodstock Festival '69, which had grown to a national event that was being discussed all around the country]. I had done most of my booking for the festival and one day John Morris, who worked on my senior staff and had worked for Bill Graham for years at Fillmore East comes running into my office. John's panicked. He says, "We've had it! Bill's going to pull the plug!"

"What Bill? What plug? There's no plug here," I tell John. "Calm down."

"You don't understand!" he says. "It's Graham—he's got the power and he can do this! He can shut us down!" "We're fucked. We're completely fucked. I realize that John firmly believes we're completely fucked. "Call him back and set up a meeting. I'll take care of this. Trust me, John. Don't worry."

"No, no, Bill's got all the power he needs in this business," John insists. "He's completely livid and he's going to pull the show out from under us."

I said, "Just calm down, John. We'll work it out."

I really didn't think it was likely that we'd have a problem with Bill, because I did have signed contracts with my acts. Generally, your contract covers you with exclusivity for an area of 50 miles, a radius of 50 miles, from your show. We were more than twice that with Woodstock. And while I know that Bill generally tried to get exclusive deals for engagements at the Fillmore, again, within a 50-mile radius, I also knew that I had done my bookings early, before Bill had done his, so I wasn't that worried.

John's completely distraught but does call Bill and so we set up this breakfast meeting at Ratner's, next to Fillmore on Second Avenue. This was when there were two Ratner's, this one and the one on Delancey.

John and I go over, and there's Bill and I think one of his security guys at the table already. So we say hello and we introduce ourselves. We sit down and start to talk, sort of generally. The conversation gets heated quickly. Bill

is glowering at me. "This is my business!" he says, as he pounds his fist on the table. "Where do you come off, trying to screw with me, kid?"

Finally, I think I said, "Let's eat." Bill orders pickled herring. I ordered the blintzes. I don't remember what John orders. But even though Bill seems eight feet tall, even though he's telling me, loudly, "I'm going to pull your acts! YOU'RE OUT OF BUSINESS!" the pickled herring in front of him puts him back in focus for me. This sets me at ease, somehow. I'm pretty nervous because Bill is the most powerful guy in the business at this point and I AM the new kid. And I'm completely dedicated to making sure the festival happens, obviously, and at this point it's May; we're in.

We start to talk and I say, "I understand you have a problem with my bookings. What's the issue?" I went into this thinking that this is just Bill's ego and it's going to be a difficult conversation to have because there's no rational way through this. He says to me "Look, you have booked my entire spring season and who's going to come and pay $5 or $7 at the Filmore when they could see them all at your place for the same amount of money?" So the light bulb goes off in my brain and I realize he's got a real point and is concerned about his box office, so as we go through breakfast and we're devouring our meals, it occurs to me that there is a solution and so I suggest this. I said, "I'll tell you what we'll do. I'm adding acts to the bill every week. I won't add an act that will play the Fillmore until after they play the Fillmore, so we'll do our advertising in accordance with your spring season." He softens. He says, "Okay." And that was it; everybody relaxed.

We finish our meal and the rest is history. I invited him up to the concert. He came up with Santana. Actually, after that meal, around a week later, he sent me tapes of a couple of acts that he was working with, including an unrecorded Latin rock act called Santana and It's A Beautiful Day. Santana completely blew my mind, so I booked them. I asked Bill to emcee as well because I knew he loved to introduce his acts, but he declined. He said, "You're the producer—

PHOTOGRAPH COURTESY OF MICHAEL LANG

Michael Lang (left) with Bill Graham, onstage at the Woodstock Festival, 1969.

it's your show, we can't both be God on the same day."

But Bill spent the weekend at Woodstock and there was a great scene in the (Scorsese) film where Bill describes how he would have controlled the crowds. He talks about a particular army of red ants from Mumbai. . .I forget the name, but these ants that devour everything in their path in Africa. In order to combat them, you dig a trench, fill it with oil and then you set it on fire. Bill thought that would be a great way for us to control the crowd at Woodstock.

Back to that meeting. Bill was the one who picked Ratner's. I had been there with my parents a bunch of times, but it wasn't one of my haunts, but Bill ate there often. It was next to his office and of course, Bill was Jewish. He had escaped from Germany when he was a kid, around 12, with his sister. It was a pretty famous story. . .

Of course I knew that food well. Growing up in Ben-sonhurst, my mother was a really good cook. She made kreplach, potato pancakes, gefilte fish, an amazing chicken soup, and pot roast and tzimmes for the holidays. And of course, there were the local delis, one on every corner. So I grew up on that food. But my mother made it all, the whole nine yards. She made gribenes, with the onions. That was Jewish caviar. It was really a treat. Obviously it's heart attack food and I still love Jewish food but I only eat it very occasionally now.

It's funny, thinking back to that day, that breakfast with Bill. Woodstock might have been a very different event, a wholly different concert altogether, if it weren't for the pickled herring.

MICHAEL LANG
Concert promoter; cocreator, Woodstock Festival

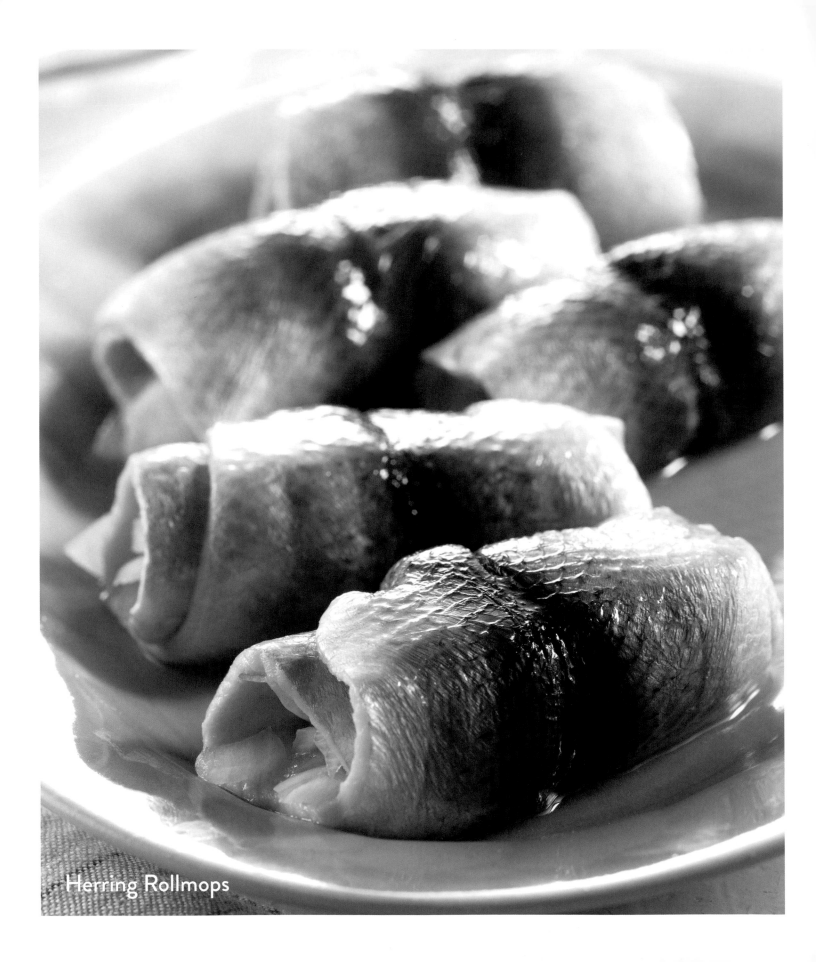

Herring Rollmops

THE HERRING WONDER

In 1999, I was living on the Lower East Side, just a few blocks from Russ and Daughters, the great smoked fish emporium on Houston Street, where I would often go to buy herring in cream sauce. My family, Jewish immigrants on both sides, had started out on the Lower East Side at the turn of the 20th century, and so I, nearly 100 years later, a prodigal great-grandson, had returned to my roots. My forebears were a mixture of Polish, Ukrainian, and Austro-Hungarian Jews, and I think it's safe to say that they all, culturally, ate herring, and I imagine that they loved it as much as I did.

At the time, I made my living, barely, by writing a column for a free downtown paper, *New York Press*, and teaching at a night school. I also performed sometimes as a monologuist at little nightclubs downtown, and one time I told a story of how I boxed a stranger in the St. Mark's hotel in 1995. It's an odd story—a bit too complicated to go into here—but to summarize: I met someone on a phone chat-line who had a fantasy of boxing in a hotel room. Game for adventure, and a longtime fan of boxing, I decided to indulge this stranger's wish. We sparred for about two minutes—wearing gloves and headgear—until I threw a right cross which smashed my opponent into the room's dresser. He gouged his hip on the dresser, howled in terrible pain, and our little match came to an end.

When I told this story onstage a few years later at the Fez nightclub, there was a performance artist in the audience, David Leslie, who was known as the "Impact Addict." His performance art was to put his life at risk, kind of like an Evel Knievel but of the East Village. He had once jumped off a six-storey school building on East 9th street, dressed as Maria Von Trapp, and one time he fought the famous heavyweight boxer Riddick Bowe on a crossing of the Staten Island ferry. When he heard me tell my story of my hotel boxing match, it irked him. He wanted to be the only performance artist in downtown New York to have a thing for boxing. So he challenged me to a fight, and I, in a moment of insanity, accepted his challenge. I also immediately—and I don't know why—dubbed myself "The Herring Wonder." I had this vague sense that I would be a reincarnated Lower East Side Jewish boxer, since many Jewish immigrants at the beginning of the century were fighters.

My training regimen—along with boxing every day at Gleason's gym in Brooklyn—was to eat a lot of herring, purchased at Russ & Daughters. I figured that by consuming pounds of herring—a fish rich in everything that one needs in life—I would have great strength in the ring. I would also have, I imagined, herring breath, which could further repel my opponent.

On November 10, 1999, before 600 fans, we fought at Angel Orensanz, the 19th-century synagogue on Norfolk Street, which had been converted into an event space. I came into the ring waving a small container of herring and wearing a robe that read "The Herring Wonder." My fans waved herrings homemade out of cardboard tin foil.

My glorious entrance into the ring, sadly, was the highlight of the fight for me. The "Impact Addict" beat me soundly, breaking my large Jewish nose in the second round, and thrashing me for all four rounds. He outweighed me by almost 30 pounds and all the wondrous herring I had eaten could not compensate for that disadvantage. Plus, I wasn't a very good fighter.

But there is a happy ending to this fish story. Eight years later I was challenged to a fight by a Canadian writer and so "The Herring Wonder" came out of retirement. I entered the ring to chants of "Herring! Herring! Herring!" and once again silver cardboard herrings were waved. I won that fight handily and Russ & Daughters generously catered the party that followed my triumph.

JONATHAN AMES
Author

Russ & Daughters

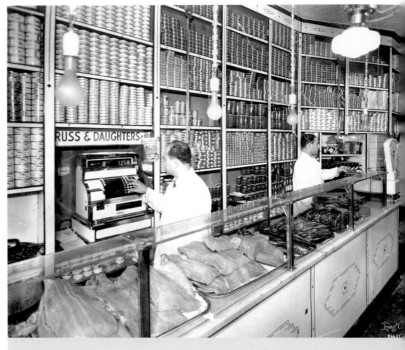

To paraphrase the classic 1960s ads for Levy's Rye Bread, you don't need to be Jewish to love Russ & Daughters, the Houston Street "appetizing" shop that's listed on the National Register of Historic Places. The last surviving store specializing in smoked fish on the Lower East Side, Russ & Daughters is not only a touchstone for New York Jews but also a cult favorite among gentiles such as Mario Batali, Anthony Bourdain, Louis C.K., and Martha Stewart. Compared to uptown Manhattan appetizing stores such as Barney Greengrass and Murray the Sturgeon King, Russ & Daughters has a refined air that's earned it the nickname the "Louvre of Lox."

Founded in 1914 on Orchard Street by Joel Russ and originally called J.R. Russ Cut Rate Appetizers, Russ moved the shop to East Houston Street in the 1920s and enlisted his three daughters—Anne, Hattie, and Ida—to work with him after school. By 1933, they were such an integral part of the operation that their father changed the name to Russ & Daughters, which the company believes may be the first business in the United States to have "&

Vintage Russ & Daughters.

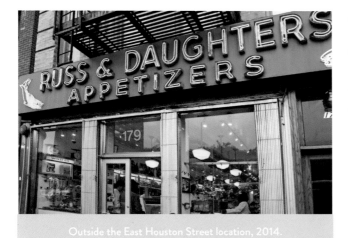

Outside the East Houston Street location, 2014.

Daughters" in its title. Today, the family firm is run by two of Joel Russ's great-grandchildren—Josh Russ Tupper and Niki Russ Federman.

That Russ & Daughters is now considered a temple of gastronomy would have seemed meshuggah to Federman's forebears. "You have to understand that for the first three generations of Russ & Daughters, there was nothing glamorous about being in the food world, running a specialty food shop," she has said. "It was really hard work, and it was a way to support a family and get a foothold in this country. . . but there's a reverence now for people who work with their hands, who work with food. People appreciate it more, and sometimes they glamorize it too much."

Still, "appetizing"—a cold feast of smoked and pickled fishes along with cream cheeses, bagels, bialys, and maybe some chopped liver and egg salad, too—is one of New York City's homegrown food traditions, and Russ & Daughters' newfound status is due to several factors: the high quality of its herring, salmon, sable, sturgeon, whitefish salad,

and other mainstays of special occasions such as brises, Bar Mitzvahs, weddings, and shivas; its artisanal approach that is newly appreciated by hipsters and other foodies; and its location on the Lower East Side, which has morphed from a neighborhood that people wanted to move out of into a neighborhood they want to move into.

Like any heritage brand, Russ & Daughters has had to balance authenticity with innovation (such as online ordering and overnight FedEx delivery) while maintaining the essential Russ & Daughters gestalt. "It's sort of intangible," Tupper has said of the shop's aura, "but it's made up of the look and feel of the place when you walk in, how you're spoken to the by the staff, the quality of the food you're getting." The meticulous organization of the shop and the immaculate fish slicers in their crisp white laboratory coats makes an impression every time you enter the store.

It was Niki Federman's father, Mark, who preserved tradition by defying it: In the early 1980s, he persuaded some

slice salmon so thin that you can read a newspaper through it, they schmooze and kibitz with their customers.

Recently, Federman and Tupper opened the first Russ & Daughters café around the corner on Orchard Street, where their great-grandfather started out. For the first time, Russ & Daughters aficionados won't have to schlep a shopping bag of food home to enjoy it but can have it served to them as if dining at Russ & Daughters was a century-old tradition. The café's Old World flavor—what Federman deems its haimish-ness—will be the essential ingredient for its success. "Do you know this word haimish-ness?" she asked in an interview with Eater.com. "It's a Yiddish word that means comfort, familiarity, lack of pretension. It's like real-ness, authenticity. I think that's something really unique at the store. There's a hundred years worth of history and this human element. There's this real democratic feeling that you get, where celebrities take a number just like anyone else, everyone is important, everyone is interesting."

From left: Interior, East Houston Street location, 2014; Exterior of the new Russ & Daughters Café on Orchard Street, opened in 2014.

of the kvetching Jewish countermen to retire and he replaced them with two Dominican cousins, Herman Vargas and Jose Reyes, who'd been working in the kitchen peeling onions and pickling herrings. "It was a bold move: placing Latinos behind the smoked fish counter in a traditional Jewish appetizing store had never been done before. This was cutting edge," Federman wrote in his 2013 memoir, *Russ & Daughters: Reflections and Recipes from the House That Herring Built.* Both Vargas and Reyes still work at the store and they've even become fluent in Yiddish. As they

When Russ & Daughters was immortalized in the 2008 PBS documentary *The Jews of New York*, Tupper told GrubStreet.com what motivates him, which has made him a folk hero in the New York food world: "We're perpetuating and cultivating the culture of Jewish experience," he said. "And whether we're religious and go to temple is independent of the fact that we're providing an experience of the Jewish–immigrant era of New York. It's really important to maintain what it was like and what it is like."

BY DAN SHAW

YOUNG SHIKSA GIRL

Growing up in Borough Park in Brooklyn during the 1950s as an Italian-American in a predominantly Jewish neighborhood felt a little like being a fish out of water for me. There wasn't an Italian neighbor in sight, except for my great-uncle who lived next door.

I have very fond childhood memories of all of those great Jewish bakeries in that area, especially the bagel bakery on 16th Avenue and 47th Street. My mother would always send me there to pick up bagels and bialys for the family. I would ride my bike to 16th Avenue and to this day I can still recall the wonderful scent of onions from the freshly baked bialys laid out on large bins throughout the store. There was another great bakery on 13th Avenue near our home where we would stop to pick up Charlotte Russe after a day of shopping.

Being a Catholic, many of my Jewish neighbors would ask "that young shiksa girl" to come to their home and light their stoves after sunset on Friday evenings for Shabbos dinners. Boy, have times changed! Can you imagine anyone asking a 10 year-old girl to come to their home after dark to light an oven today?

It wasn't until after I was married that I was really introduced to Jewish food. I was first introduced to the typical Seder dinner by family friends Dottie and Ted, who lived in Greenwich Village just a block away from my apartment on 9th Street. I spent countless family dinners in their company at that apartment. Dottie would make the best chopped liver. It was light and airy. To this day, it's the best I've ever tasted.

To this day, I'm immediately transported back to those wonderful days of my childhood and young adulthood whenever I smell onion bialys or see a tray of freshly baked bagels or taste a delicious chopped liver or gefilte fish. This "young shiksa girl" can never get enough of great Jewish food!

CAROLINE HIRSCH
Founder and owner, Caroline's on Broadway,
the New York Comedy Festival

MY FAMILY, ME, AND JEWISH FOOD

Our food was love and prosperity!

MOM & DAD: My mother did not enjoy cooking. Even though she was a really gifted cook, the only thrill she got out of it was people enjoying it. Her chicken soup was Lipton in a package, which was very odd for a Jewish family. The things my mother could make, she made beautifully. She loved when people loved her cooking. And that may seem stereotypical, but we ate well in the house. The refrigerator was always stocked with delicious things.

My mother made excellent blintzes; it was one of the really skilled things she made very, very well. The secret was the skins: she made them extremely soft and very thin, so they were not thick and doughy. They just were enough to capture the filling, usually a kind of pot cheese, farmer's cheese with some cinnamon. It definitely was sweet, not savory. My father was thin and kind of muscular. He never ate a green in his life. He thought it was for cows.

ME: I never had a fresh vegetable as a child. I didn't know that peas didn't come out of a can until I was a teenager. I actually preferred the taste of it. Not any more. Except for canned baked beans—that was another very Jewish thing. Heinz vegetarian baked beans, which was the natural companion to Jewish deli.

One of the greatest roles I've had as an actor was playing God in the Hebrew National hot dog commercial for 5 years, until I saw the same commercial with a different God. They got a cheaper God. They were paying me too much!

A shrimp cocktail was a thrill. I consider that Jewish food, and lobster. Jews love lobster and shrimp so much that Israeli scientists are working on a way to "kosherize" it by gluing scales onto it or something. Chinese food I consider Jewish food too of course, that's about it, you know.

ROBERT KLEIN
Comedian; actor

CHINESE GUY:

"You know, we have the world's oldest culture. It goes back 4,000 years!"

JEWISH GUY:

"Sorry, we have that beat! Our culture is 5,000 years old!"

CHINESE GUY (mouth agape):

"Wow! What did your people eat every Sunday for 1,000 years?"

A little song,
a little dance,
a little seltzer
down your pants.

"Chuckles Bites the Dust" episode,
THE MARY TYLER MOORE SHOW

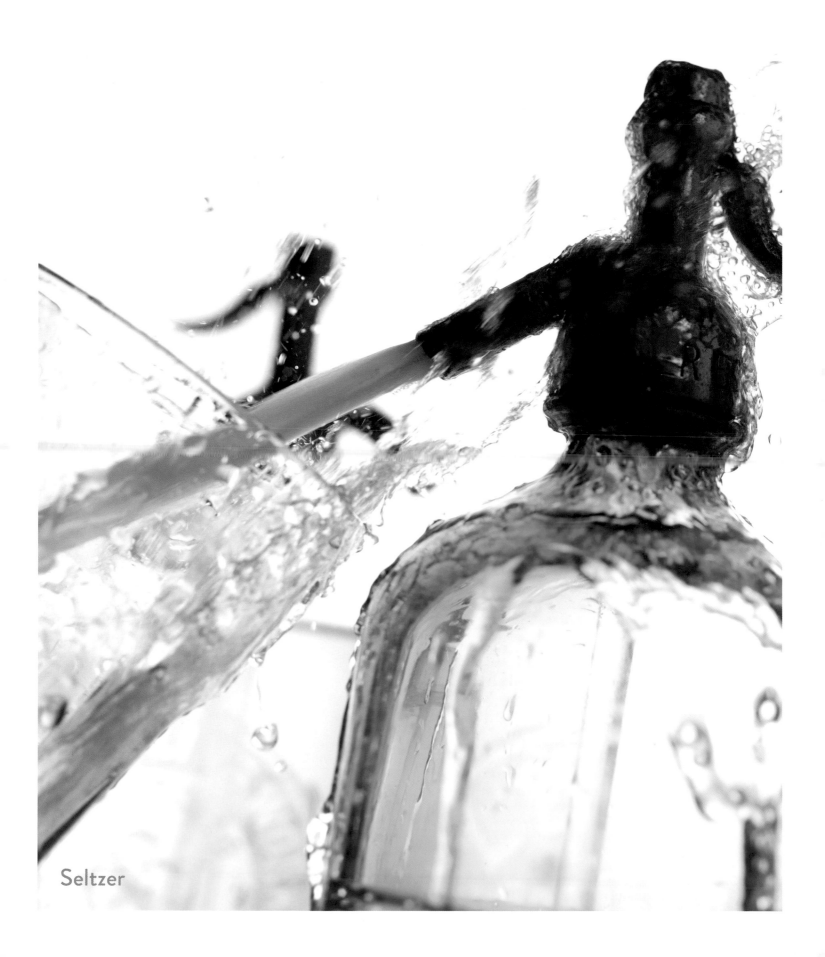

Seltzer

HAMOTZI LECHEM MIN HA'ARETZ

"Who brings forth bread from the earth."

Cara De Silva, age 7.

I can still see myself, a little girl, begging my father to help me open the bakery door. Behind it lay my favorite place in the world. Other children were impatient to enter, too, but their pleas were for cakes and cookies, while I yearned only for bread. There were real bagels, small and hard, without a blueberry in sight, pletzels, bulkas, bialys, onion rolls, but, most of all, there were loaves—challah, pumpernickel, rye, and, most delicious of all, corn rye, especially dense and fragrant. Each was a bakery offering that had come to New York with the Jewish immigrants who packed the city. And to me, they were heaven.

Nothing since has ever matched those first loaves of my life, great examples of the bakers' art, of Jewish tradition being kneaded with well worn hands. My passion for them only grows. But, ultimately, bread, in general, also engaged me. Whether in the United States or around the world, I began to explore, from Navajo fry bread to pain au levain. And I became deeply enamored of the great artisanal breads that have surrounded us in the last decades. But, most important, I now understand the particularly beloved breads of my youth, and all others, too, not only as food, but as culture, a symbol, a metaphor. Although not made of gold, they are a form of alchemy.

My view began to broaden when I first read Jean Giono's *The Baker's Wife* and when, later, I discovered MFK Fisher. Her words, "There is communion of more than our bodies when bread is broken and wine drunk," are always with me. And it grew even more when I read the Bible, with its wealth of references to bread. It expanded, too, when I fell in love with Isaac Bashevis Singer's near saintly baker in *Gimpel the Fool*. And as for the words of Robert Browning, the philosemitic Victorian poet, how much they enlarged my vision. "If thou tastet a crust of bread, thou tastet all the stars and all the heavens," he wrote. Exquisite. Yet surely those words would have been still more extravagant had he been able to feast even once in the style of my grateful family—on corn rye with sweet butter, a sprinkle of kosher salt glistening on top.

CARA DE SILVA

Writer; award-winning journalist; lecturer; food historian; author/editor, *In Memory's Kitchen: A Legacy from the Women of Terezin*

Nothing since has ever matched those first loaves of my life, great examples of the bakers' art, of Jewish tradition being kneaded with well worn hands. . . Although not made of gold, they are a form of alchemy.

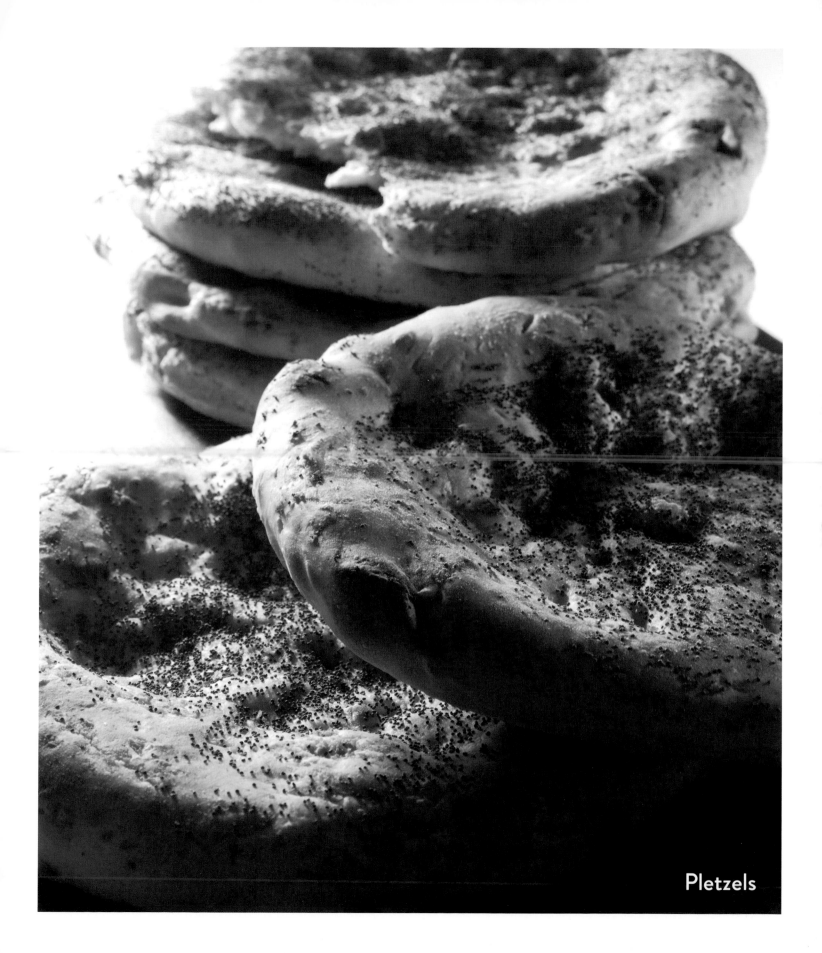

Pletzels

STUFFED DALMA

Growing up in Brooklyn there wasn't much to do. The two best things were the subway that took me to New York City and the astonishing number of delicatessens. It felt like there was one on every corner in those days, places you could get the most unbelievable pastrami and knishes—back then we took them for granted.

When I moved to the City I was 20, and as fate would have it I lived on West 71st street near the fabulous Fine & Schapiro on 72nd street. I had just begun working in the fashion business and one night when I had a cold I stopped in to get some of their famous matzo ball soup. I was waiting on line when I spotted the queen of the runways at that time, a beautiful Brazilian supermodel named Dalma Collado—who one would never expect to see at the counter of a Jewish deli. It was like spotting an exotic bird in with the pigeons. I thought to myself, "How is anyone so thin eating pastrami and cream soda?" We had recently been introduced at a fitting at Perry Ellis, who I worked for as a gofer and so I never expected the fabulous Dalma to remember me—but she did. She was in a full-length mink coat and dark glasses waiting to take home her dinner. Just a nod from her was enough to make my heart stop but then as she was leaving with her parcel she approached me and I held my breath, I couldn't imagine what she might say. She leaned in and in her exotic Brazilian accent whispered, "Don't tell!"

I got to know Dalma very well in the years that followed. She modeled for me a lot when I started my company. And, although she probably never knew this, every time I saw her I thought of that night at Fine & Schapiro. A funny association for a supermodel: chicken soup and pastrami.

ISAAC MIZRAHI
Fashion designer

Dalma Collado on the cover of *Brazilian Vogue*.

TRADITION!

Ma! Which one's the tall one again?" my brother asks as my dad carves his way through the annual holiday traffic on Brooklyn's Belt Parkway, "Betsy, Michael. Her name's Betsy. Oh wait, no it's Robin. Robin's the tall one," my mother debates with herself, as we slowly inch our way from Long Island to New Jersey for our family's Passover Seder.

I hear this over the resolute sound of Zero Mostel singing "Tradition!" on my headphones, as the tape rotates around my cassette player. See, my love for both theater and irony started at about the age of 12.

Tradition indeed. The annual "cousinfest," brings together my father's family from around the country and some years even the globe, when my "creative" cousin, the ex-hippie Robert, attends from Germany. He's always been my favorite.

The family is there. The religion is there. The tradition is there. Oh wait, is it? Did Uncle Kenny bring the matzo balls? Are they hard or soft? Is there really any question?

Truthfully, for all that makes us different, it's the food that brings us together—rather, closer. The melting mouthful of brisket, the spicy bite of horseradish atop a loaf of gefilte fish, the sweet spoonfuls of charoset, the savory potato kugel, and the delicious taste of success and unsaid competition.

"Shh. . .Take a piece of Irene's brisket, not as chewy as Alice's." "Aunt Sylvia made another pan of matzo balls, if you prefer the soft over the hard," we giggle because, G-d forbid you prefer soft matzo balls.

Yes, our famous G-d has made his way in here. And there, as my Uncle Ray walks us through the Seder and each page of the Haggadah. Throw in the food, with love—it works like the charoset to bond our tribe together as "family," all to be renewed next year, for good measure.

STEPHEN SCHONBERG
Theater critic and founder, Center on the Aisle

SPEAKING OF FOOD

I'm Jewish, but I did not grow up in a kosher home. Bacon and ham were frequently on the menu, my brothers and I loved cheeseburgers. But in recent years, as lactose intolerance progressed toward dairy allergy, I came to appreciate kosher food in a whole new way.

My non-religious kosher affinity started when I worked as a senior aide to Sheldon Silver, the Speaker of the New York State Assembly and one of the country's most prominent Orthodox Jewish elected officials. Shelly was a great boss—smart and kind. Most of the time, our offices in the State Capitol in Albany were extraordinarily busy, but during rare quiet moments he gently answered my questions about the rules of kosher. He quickly came to understand why I was so enamored of kosher parve goodies—they most definitely did not contain dairy products.

Shelly had an appreciation for good food and loved sharing it with others. When we visited his Lower East Side neighborhood, he made sure I knew where to get the best bialys. He took great delight introducing me to the pleasures of cholent. After meetings, he always saved a few kosher parve rugelach for me.

Of course, it wasn't just me. On one occasion, Shelly met with a professional athlete whom I later spotted leaving the Speaker's office with a bagel with lox and cream cheese that Shelly had made for him during their meeting.

Birthdays in our office were always celebrated with Carvel ice cream cakes. (Who knew Carvel was kosher?) Alas, I could never partake. When my birthday rolled around, Shelly and the rest of our staff surprised me with a giant sheet cake from Albany's one and only kosher bakery. I found out later that he had gone out to get it himself—a 20-minute trip each way, on a day of back-to-back meetings and appointments—because he knew that was the only cake I would be able to eat.

DAN WEILLER
Director of media relations and communications,
New York State Thruway Authority

FAUX KOSHER

The Passover dishes—mint-green glass—were pretty, as were the separate cabinet meat and dairy sets—ivy-patterned I recall. All this kosher-kitchen fuss so my grandmother could occasionally join us for Sunday lunches. She wouldn't visit otherwise, which would have distressed my father, the coddled baby of eight children.

My comfortably middle-class family was comfortably conservative. My siblings and I endured five years of He-

> We traipsed through New England . . .where breakfast included certifiably sinful bacon and eggs.

brew school and were duly Bar/Bat Mitzvah-ed. Sweetly old-fashioned, tartly new-styled Mom was a first rate if unimaginative cook. Like most of her generation, she prepared virtually every meal for her husband and kids—including the lunches brown-bagged for school. Except for the semi-regular Saturday night Chinese dinners: scrumptiously verboten shrimp, lobster, or pork. When the red and black restaurant décor was traded for take-out, this exotica was eaten off paper plates with plastic forks. More extreme cheating was conducted out-of-state: when we weren't spending summer vacations with our people in the Catskills, we traipsed through New England stopping at high-gentile Howard Johnson's where breakfast included certifiably sinful bacon and eggs.

When Grandma passed away at age 89, these half-hearted formalities were dropped. The three sets of dishes shrunk to one, the kosher butcher lost our business, and no private plague rained down on the Mandelbaums of Jamaica Estates. Now if I had only reserved those green-glass dishes for my own kitchen shelves.

RONALD MANDELBAUM
Vice president, Photofest NYC

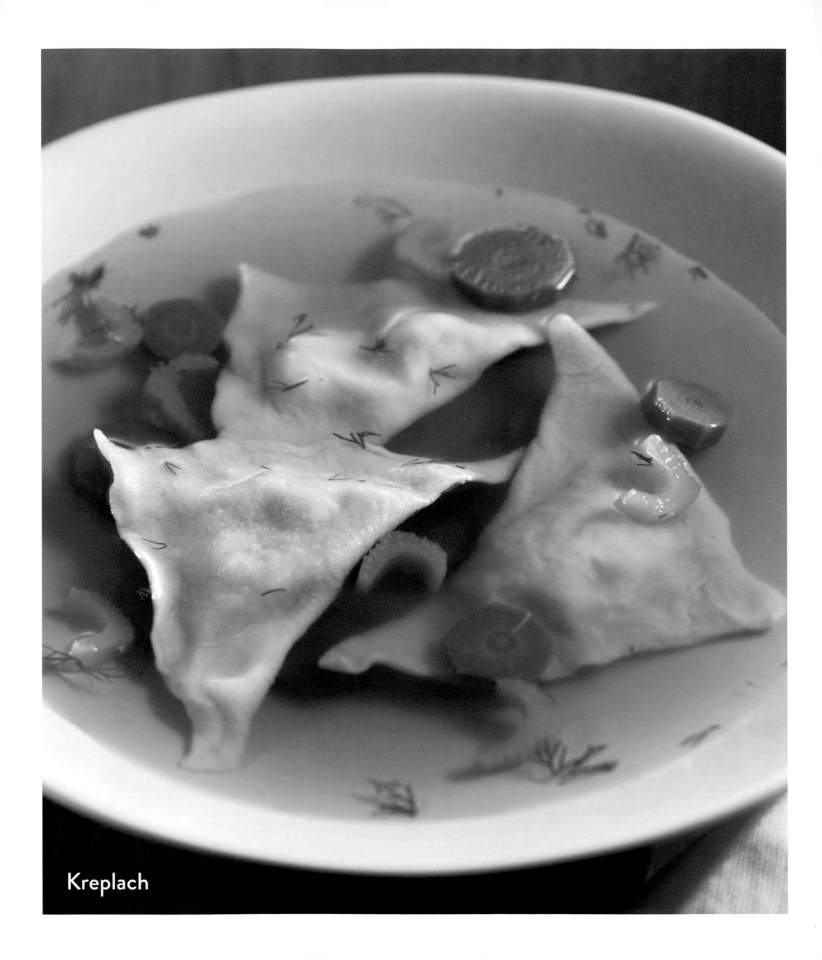

Kreplach

KREPLACH

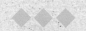

DOUGH
1 egg
roughly ⅔ cup of flour
¼ teaspoon salt

FILLING
any cooked meat leftover
(⅓ pound meat is sufficient)
½ teaspoon onion juice
finely chopped celery
schmaltz to hold meat together
salt and pepper to taste

To make dough, beat egg slightly. Add salt and enough flour to make a stiff dough.

Knead well on floured board. Invert bowl over dough and let stand, covered, ½ hour.

Roll out as thin as possible. Dough should not be sticky but not too brittle.

Cut dough into squares.

To make filling, grind meat very fine, add other ingredients, season to taste, and mix well.

Fill and pinch ends together.

Cook in boiling salted water for 15 minutes.

Drain.

Worries go down better with soup.

Grilled Sweetbreads

SAMMY'S ROUMANIAN
SWEETBREADS

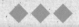

¾ pound sweetbreads

Cut open into 4 or so pieces.

Add kosher salt to taste.

Grill turning over a couple of times, until it becomes white with black grill marks.

Serve with lemon wedges, to taste.

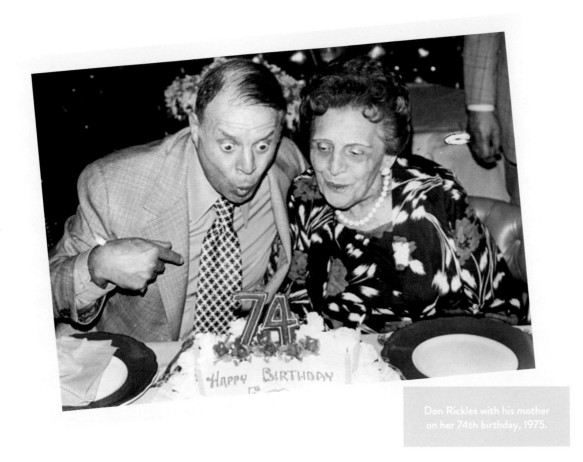

Don Rickles with his mother on her 74th birthday, 1975.

I'LL GET TO THE PUNCH LINE

My Mother (rest her soul) made the best chopped liver this world has ever known. Of course there were consequences. . . a disease called heartburn! In those days I lived in New York and when you belched the wind picked it up in California!

I've always believed that Jewish mothers had the gift when it came to Jewish food. Who knew from kasha varnishkes, homemade kreplach, and brisket cooked with such caring, and a special chopped salad my grandmother called forshpeis.

I have to leave now, I'm going to dinner at a Rabbi's house to see what he has come up with! Bye.

DON RICKLES
Comedian; actor

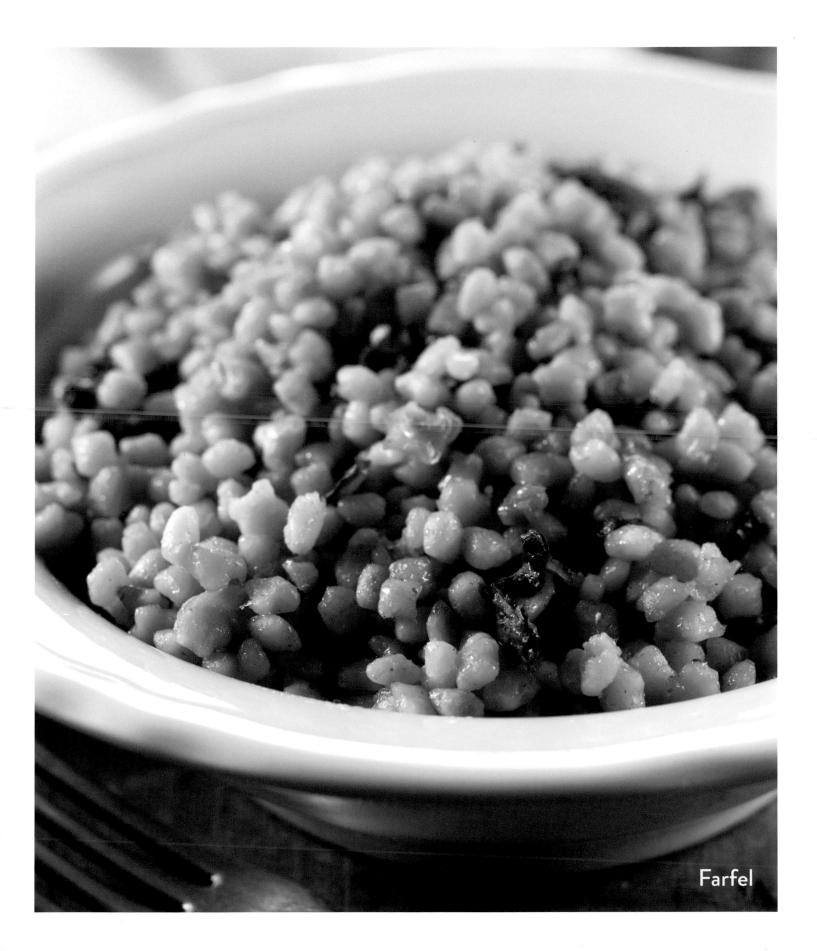

Farfel

RATNER'S GEFILTE FISH RECIPE

STOCK
Fish bones and heads,
removed from fish

3 quarts water

4 carrots, sliced

1 large onion, sliced

1 cup sliced celery

½ cup chopped parsnips

1 tablespoon salt

FISH
2 pounds deboned yellow pike

2 pounds deboned carp

2 pounds deboned whitefish*

4 eggs

6 slices challah

1 large onion

½ cup water

¼ cup oil

1 tablespoon salt

1 teaspoon white pepper

lettuce

horseradish (optional)

In a large kettle combine all stock ingredients and bring to a boil. Reduce to a simmer.

Grind or finely chop the pike, carp, and whitefish several times with the onion and challah. Beat in water, pepper, salt, eggs, and oil. Mixture should taste peppery.

With wet hands, shape 1 cup of the fish mixture into an egg-shaped ball. Drop into simmering stock. Repeat using remaining fish mixture.

Cover and simmer for 1 ½ hours. Remove fish and place in shallow bowl.

Top with carrots from stock.

Strain stock over fish. Chill.

Serve on lettuce topped with some of the jellied fish broth and carrots. Serve with white or red horseradish.

*Instead of 2 pounds each of the three listed fish, 6 pounds of any assortment of them may be substituted depending upon their availability.

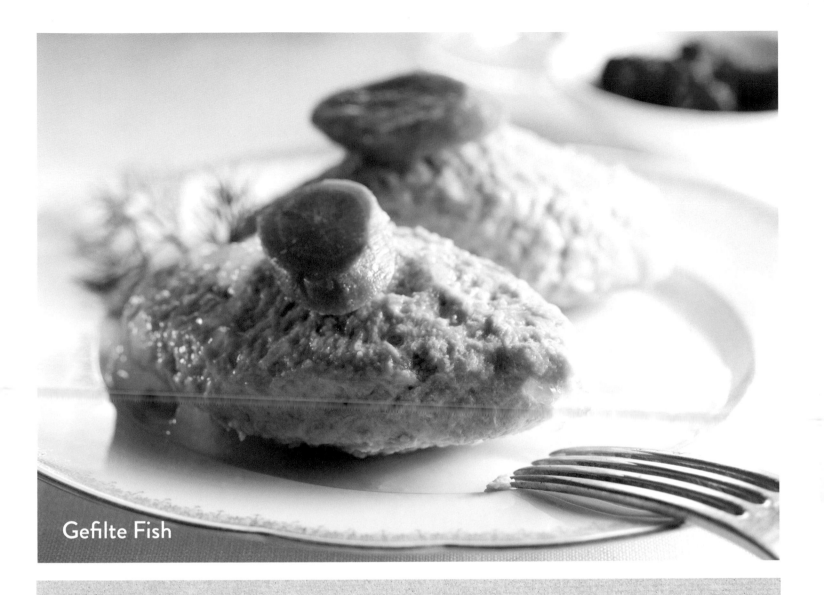

Gefilte Fish

Q	A
How can you tell the gefilte fish from the other fish in the sea?	The gefilte fish is the one with a slice of carrot on its back.

A CHOLENT STORY

I was released from uterine confinement on January 6, 1932, at 183 Clinton Street. In attendance, besides my mother, was my grandmother who knew how to catch and clean the new arrival, and then remain as an assistant to help stabilize the very complex terrain accompanying birth in Orthodox Jewry. Arrange for the bris; assure mikvah attendance; pass judgment on the Yiddish and Hebrew names to extol our forefathers, with care to integrate into current society. These were the obligations of midwives (no certificate necessary) in the teeming Yiddish society of Lower East Side. No announcement of this momentous event was proffered either to the *Daily Forward* or the *New York Times*.

My father, who was not enthralled by Lower East Side life was nowhere to be found, but did submit an English name that would forever disassociate birth in that domain from even societal births. "Lets name him Miles," he said. "It seems to be a name that has made my family's shoe stores successful." Hence, Miles in English, Mordechai in Hebrew and Motche in Yiddish. Simple, no? With a last name Galin, often pronounced Gallon, he set the course for an infinite protocol of responses in school and elsewhere; how many Miles do you get per Gallon. So be it.

Of course I never knew my name was Miles until I entered public school approximately a half decade from birth. I spoke only Yiddish; very few around me spoke anything but Yiddish and even the street signs were in Yiddish. At Yeshiva, we spoke Yiddish, Hebrew, or English, the latter being very difficult to speak, understand, or use. Though my parents spoke English fluently, I lived with my grandmother (my mother was ill for a prolonged period due to a genetic gastrointestinal abnormality), her husband, a Rabbi who studied and never worked, as well as an enormous assortment of local cousins and family immigrants that she brought here from Poland. One large bed, one pot belly stove, one ice box, and one toilet in the hall. A very intimate life.

I was the baby of this menagerie and followed grandma, the sweetest and gentlest person imaginable, like a puppy. I went with her to the live chicken market where she chose the beast for the sabbath meal. After the shoichet appropriately assisted in the animal's demise, we (yes, we) would pluck the chicken feathers. This ultimately became my job. A small boy, with tiny fingers, can do a yeoman's job in removing feathers and not leaving residua in the skin. My frequent presence in the live chicken market and the adjoining butcher shop ingratiated me into their world. I took advantage (under instruction) of this benevolence to often ask (in Yiddish) for "some liver for the cat." Indeed, we did have a cat, but the cat never saw the liver. Money was tight and my grandmother knew God would forgive a little white lie.

Though chicken was the Shabbos staple, once a month we had cholent. This incredible dish of meat, beans, and who knows what, was a ceremony unto itself. Ours was a religious home, no turning on lights or initiating cooking on the Shabbos to name just some of the many rules that engulfed my life. But for cholent, there was a path. My grandmother would prepare a large pot with its mysterious content, and bring it to the baker whose ovens were never turned off. He did not light his ovens on the sabbath; they were always on. I could not lift this pot but it was my job on Saturday morning to recover the goods that had been cooking from early Friday morning. This was done with our buddy, appropriately termed the Shabbos goy (sabbath non Jew), who accompanied me to the bakery, hoisted the pot into a cart, carried it to our building and up the stairs to the fourth floor, the location of our domicile. The post Sabbath prayer luncheon attracted a myriad of family, friends, and encroachers. Yet, there always seemed to be enough. Lots of camaraderie, "gemutlichkeit," and a union of good will. Cholent was not just a food, it was a culture unto itself.

DR. MILES GALIN
Eye doctor; scientist

When it comes to
Jewish food
I dream about it,
I don't eat it.

❧

BETTE MIDLER

Vegan

CHOLENT

2½ pounds chuck roast, brisket, tip of rib,
or other pot roast trimmed of visible fat

6 small "new" potatoes

1 cup dry baby lima beans,
sorted and rinsed

1 cup dry white beans,
such as navy beans
or great northern beans,
sorted and rinsed

⅔ cup barley

2 large onions, finely chopped

3 garlic cloves, minced

water

2 tablespoons oil

1 bay leaf

1½ teaspoon paprika

½ teaspoon black pepper

½ teaspoon ground ginger

Soak beans overnight; drain.

Heat oil in an ovenproof pot. Cook onions and stir until beginning to brown.

Add and brown meat on all sides.

Add soaked beans, barley, garlic, spices. Put potatoes on top with enough water to cover.

Over medium heat, bring all to boil, then cover tightly and put in preheated 250° F oven—bake for 1 hour.

Lower oven temperature to 225° F and bake overnight (12–20 hours).

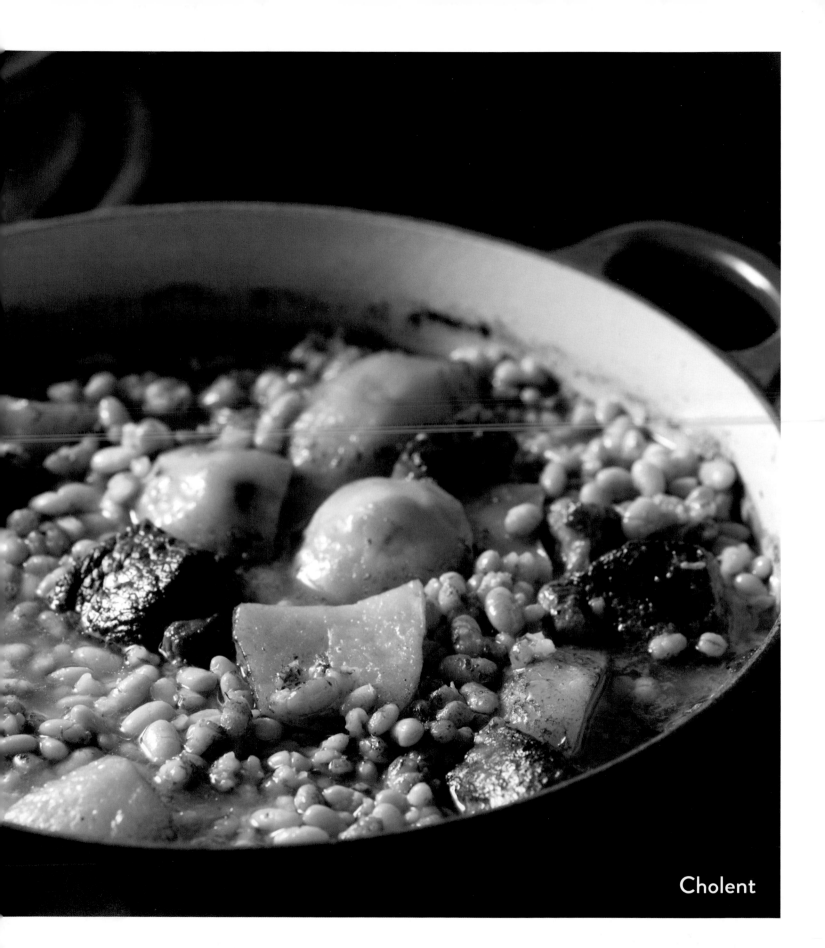

Cholent

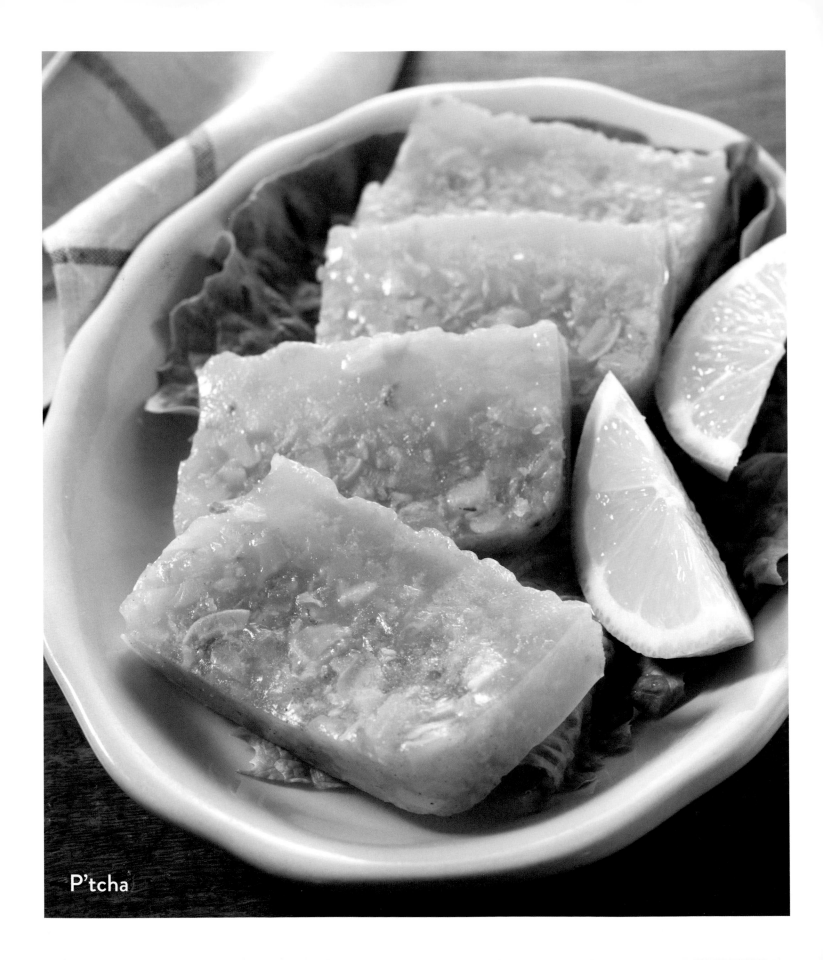

P'tcha

ARTHUR SCHWARTZ'S P'TCHA

◆◆◆

Makes 6 to 8 servings

Most people remember p'tcha, if they remember it at all, as jellied calves' feet with chopped raw garlic and, in some versions, slices of hard-cooked egg or chopped egg embedded in the firm gelatin—just to make it look a little better. Among the senior set it has a cult following. Tell a hipster it's a garlicky aspic made with calves' feet and he'll think it's the latest food trend.

In the following recipe, chopped fresh parsley is a contemporary touch to make the jelly more appealing in looks as well as flavor. If, however, in your memory, p'tcha is not p'tcha if it doesn't look like a brownish, suspiciously quivering brick, leave out the herb.

P'tcha was likely a hot soup originally, a broth with the richness (and protein) of gelatin. Who in the tenements of the Lower East Side, or, back in the old country, in the shtetlach of Poland and Russia, had the refrigeration necessary to make the broth gel? I give you the choice—hot or cold.

BROTH
2 calf's feet and/or knuckles (about 3 pounds)

2 medium onions, quartered

2 or more cloves garlic, coarsely chopped

10 cups boiling water

2 tablespoons white distilled vinegar, or more to taste

1 teaspoon salt, or more to taste

¼ teaspoon white pepper, or more to taste

GARNISH
2 hard-cooked eggs, sliced

3 egg yolks for thickening hot broth (optional)

1 cup finely chopped flat-leaf parsley

finely minced garlic to taste

1 lemon, cut into wedges (optional)

Have the butcher saw the calves' feet and/or knuckles into about 2-inch pieces. Wash them thoroughly: Put the pieces into a large bowl, pour boiling water over them, let stand a few minutes, then drain. Scrape the skin with a sharp knife until it is smooth. (Sometimes, these days, the calves feet are already well cleaned.)

Place the calves' feet in a 4-quart pot with the 10 cups of boiling water, the onions, coarsely chopped garlic, salt, pepper, and vinegar. Over high heat, bring to a boil and continue to boil until the meat and gristle begin to separate from the bones. This will take about 3 hours. You will probably have to add more water to keep the feet covered in water, but it is supposed to reduce. Strain the liquid, saving both liquid and solids.

Pull the meat from the bones and cut it into small pieces. Taste the broth and adjust the salt, pepper, and vinegar to taste.

To serve hot, combine the meat and broth and return to boiling. Remove from heat and add as much chopped raw garlic as you like. Do not simmer the broth after adding the garlic.

Serve the hot broth with meat and garlic garnished with chopped fresh parsley, in soup bowls. Or, beat the 3 egg yolks together in a mixing bowl, then ladle some of the hot broth into them. Then pour this mixture into the broth. Do not allow the broth to boil after adding the raw egg. Another way to serve the broth is with chopped hard-cooked egg, instead of the raw egg enrichment.

To serve cold, which is more often how it is done, arrange the pieces of meat and gristle in a deep Pyrex dish. Add chopped garlic to taste. Add parsley, if using. Pour in liquid and refrigerate. Before the gelatin firms completely, place slices of hard-cooked egg over the top. Or, alternately, chop the hard-cooked egg and add it to the broth.

In either case, hot or cold, p'tcha can be served with wedges of lemon.

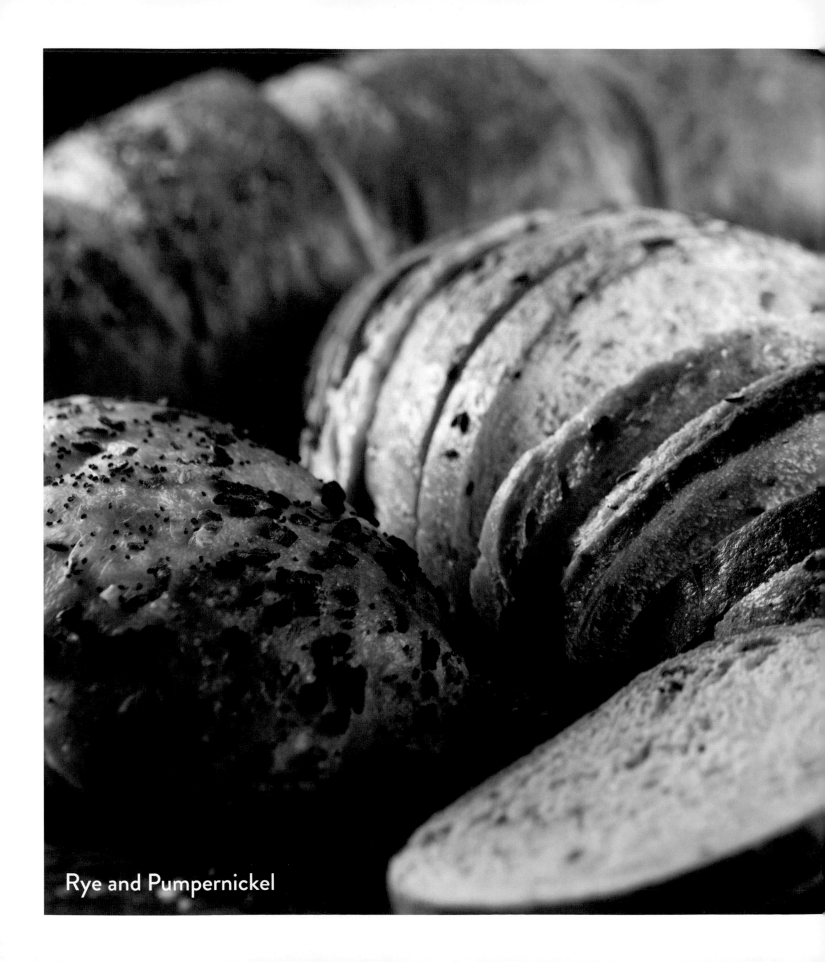

Rye and Pumpernickel

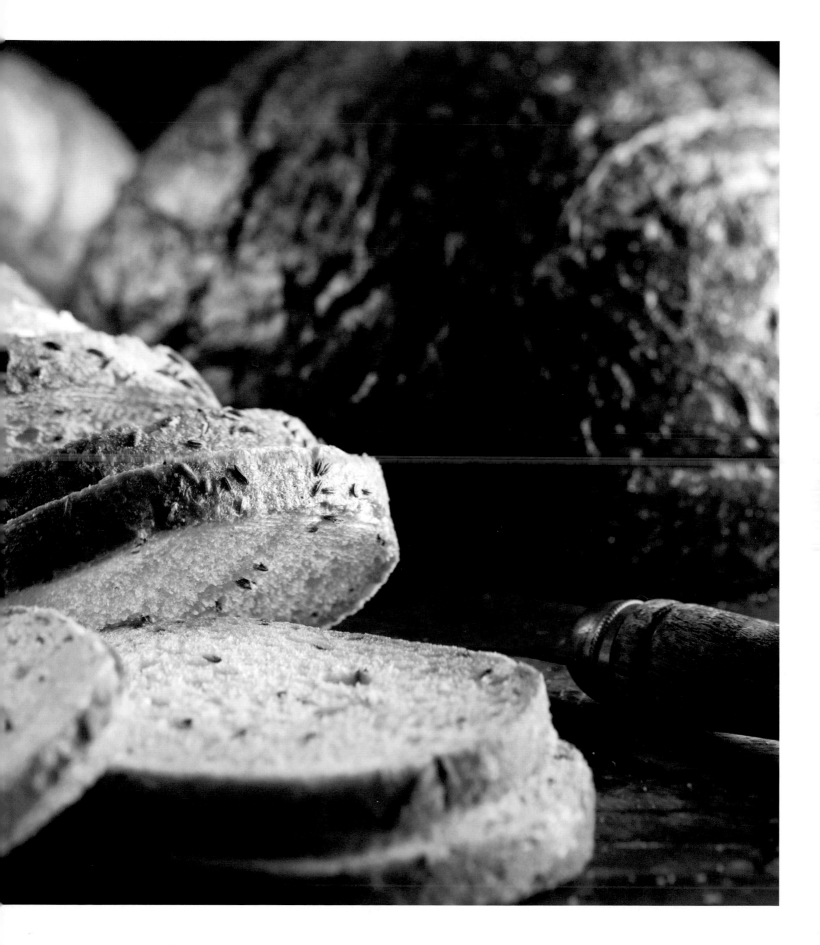

THE EGYPTIAN ONE-EYED SANDWICH

A Sunday morning in New Jersey. My brother and I wake to the strains of classical music piping from an old tube radio that sits on top of the fridge. Sitting at the yellow Formica kitchen table, we watch as my father, wearing only his underwear, enters in a series of mad pirouettes, dancing the female lead from Swan Lake.

If we're lucky, he'll make his famous Egyptian One-Eyed Sandwich. We're allowed to participate in the first step—he folds a slice of bread in half, holds it to my mouth and says "Bite!". My teeth snap down, pulling away some dough and leaving a perfect hole in the center.

Then, the fun begins. Zoom! Dad flings the bread from the table into a heated frying pan. It lands with a splat! in the sizzling butter. He grabs a spatula and holds it to his mouth, crooning into the "mic" as he dances toward the stove. Whoosh! The toast is flipped heavenward, turning over mid-air while my father chases after it with the pan until it lands back in the butter. Executing a perfect arabesque, he gravely bows to the waiting egg before carrying it, like some precious relic, to the stove.

Crack! goes the egg as Dad empties it into the hole. The white runs delicately over the bread, reaching the butter and remaining just long enough to crisp around the edges. Meanwhile, the yolk peers up at us, already beginning to harden just enough to be edible.

My father grabs a kitchen towel, throws it over his forearm, places the sandwich on a plate and serves it with a flourish. My brother and I stare at the single eye, peering at us like some demented monocle, as Dad explains that this was the favorite dish of Egyptian princes when we were slaves in the land of Egypt. And now, thanks to America, we are no longer slaves, and we eat like princes.

JANIS IAN
Singer-songwriter

DELI MACHER

Well, to begin, of course I have great feelings about Jewish food in general, but I am the premier delicatessen fan in the history of Jewish food. If "deli" was an Olympic sport, I'd be a gold medalist. I have been to delis all over the U.S., Great Britain, France, you name it. . .wherever there are Jewish delis, I've been there. In America, in particular in the last 30 years, there are less and less delicatessens. You've still got a handful of spectacular delis in New York—Katz's, The Pastrami Queen, the re-opened 2nd Avenue Deli, etc.—some kosher and some kosher style, and they're so crowded, you can't find a seat.

I've visited delis in Cleveland, Ohio and I've visited delis in Houston, Texas. Los Angeles has several Jewish delis that are good, but not up to real New York standards.

I'm an incredible fan of corned beef, pastrami, salami, and I love all the side dishes. The special holiday foods are spectacular too. Farfel is a favorite. It's terrific before Passover, during Passover, after Passover.

I love all the things people don't eat anymore because they aren't good for you. Jewish food isn't healthy but I'll be honest with you, stuffed derma (kishka)—it's just out of this world. And to be honest, to love all this food, or just the food of my heritage, is one of the single most delicious and satisfying culinary experiences you can have.

Good Jewish cooking doesn't run in my family. Unfortunately, I never knew my grandmother. And my mother, God bless her, was perhaps the worst Jewish cook in the history of food. I loved her, but she had no clue about cooking. So when it came to the Jewish holidays, she would buy whatever she needed to put out a meal, and we ate it, but my dad, thank God, he and I were the delicatessen kings. Every Sunday, that was our life—corned beef, pastrami, kishka, salami—we loved it and we bonded over it.

FREDDIE ROMAN
Stand-up comedian

A man stormed into Goldstein's Bakery

and confronted Abie.

"Do you know what happened to me?"

he demanded.

"I found a fly in the raisin bread I bought

from you yesterday."

Abie gave a palms-up shrug and replied,

"Nu, so you'll bring me the fly

and I'll give you a raisin."

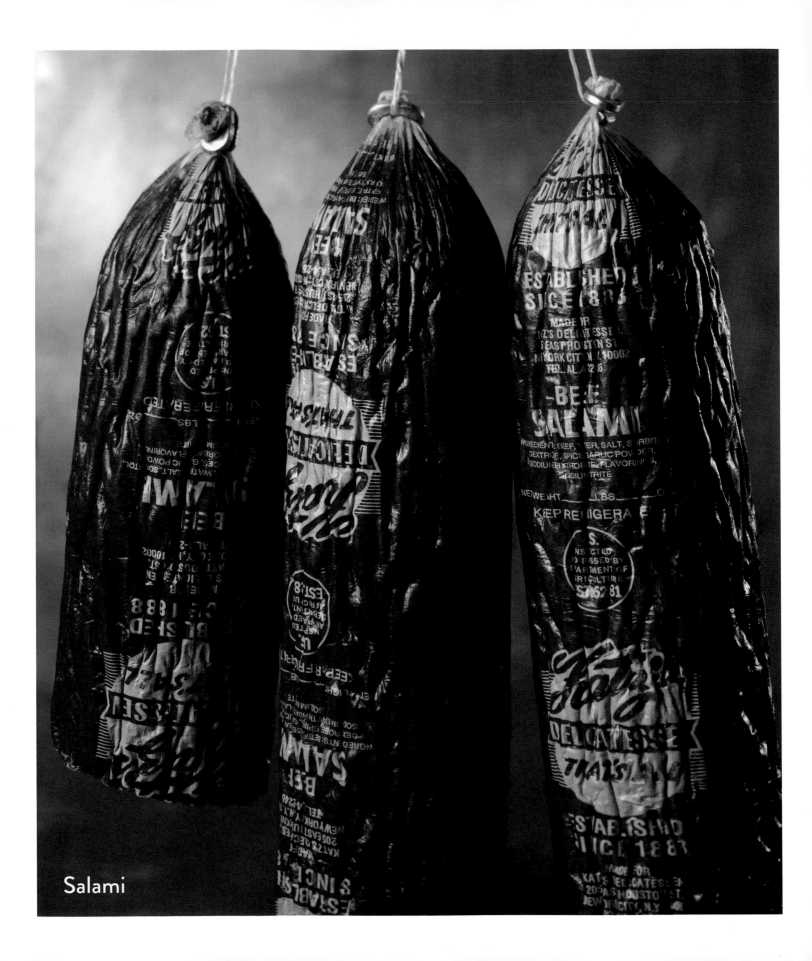

Salami

THE CASE OF THE MISSING SALAMI

For almost 40 years, six of us (now down to five after the loss of Joel Siegel) have had lunch together every Wednesday—all Jews except Jerry Della Femina, who knows more Yiddish than the rest of us combined. It's all raucous fun, mostly lots of jokes (more repeated than new since we can't recall them from week to week). We've shared triumphs and tragedies and above all we've cared for each other and missed each other whenever one of us (too often me) can't attend.

During one of my frequent reporting trips to the Middle East—this one during the 1982 Israeli incursion into Lebanon—Joel, then ABC's TV and film critic, decided I needed a taste of home. As a serious Jewish gastronome, Joel knew that it is virtually impossible to get decent deli in the Holy Land. So he set off to consult with Milton Parker, legendary owner of the Carnegie Deli. After what Siegel later described as an "intense Talmudic discussion," it was agreed that corned beef and pastrami might not travel well over 5,000 miles. But a giant salami? Well, that could last forever.

Having failed to hear from me for over a week, Siegel called, distraught. "What gift boychik?" I asked. "A shanda," Joel screamed. "I'll get to the bottom of this." A day later Siegel instructed me to get to Jerusalem's central post office as fast as I could, which, salivating, I did.

After several clerks shook their heads, a supervisor appeared. As best as I can conjure the conversation after 32 years, it went something like this:

"So, you're the guy the Carnegie sent the salami to?"

"What I've told your underlings, yes."

"And you know we can't get such quality here in Israel?"

"Doesn't everyone?"

"Exactly."

After some moments of silence—I had missed the ominous implication—the postman continued: "You think the Carnegie can send a salami to Jerusalem and you can actually receive it?"

"Isn't that what the mails are for?"

"The mails are for mail, not for salami."

"They aren't?"

"No."

"So?"

"We ate it."

"You ate it?"

"And we thank you for it very much."

Leaving me with my mouth agape, he ambled off, turning back at the door to his office. "Welcome to the land of the Jews," he said, smiling. "Shalom."

MICHAEL KRAMER
Journalist; playwright

Have you heard the term "a nickel a schtickle" — how salami was sold.

Katz's Delicatessen

Katz's waiters, 2014.

There was a time when delis and cafeterias were as common in Manhattan as Starbucks are today. Katz's, on the corner of Houston and Ludlow Streets, evokes this bygone era. It is a hybrid time capsule—a sprawling restaurant where you wait on line at the counter to order your food before carrying it on a tray to a table (although there are a few seats with waiter service for those too frail or impatient to participate in this century-old rite.)

Asking the countermen to make your sandwich is an essential part of the Katz's experience. The men who make the sandwiches kibbitz with their customers, a skill as essential as being able to slice corned beef and pastrami with a knife because Katz's signature is a sandwich made of meat cut not too thick, not too thin, and never on a machine. "It takes two months to train to be a counterman," explains owner Alan Dell, who grew up in this Lower East Side neighborhood and taught music in the public schools before going into the deli business some 30 years ago. "We're not the original owners, but we consider ourselves the fourth generation, carrying on a 125-year-old tradition."

The ordering of sandwiches is ritualistic. Upon entering, you are given a chit that you hand to the counterman to tally your purchases, which you present to the cashier on your way out the door. After selecting, say, a corned beef or roast beef rye, he'll cut you a couple of slices to taste, placing them on a small plate on the chin-high counter to make sure the meat is to your liking. "People in the know ask for their pastrami juicy, which means not too lean and not too fat," explains Dell. It's customary to tip the counterman a couple of dollars for this gemutlichkeit gesture as he prepares your meal.

Katz's is always bustling these days, but it wasn't always so. "Fifteen years ago, when this neighborhood was dicey, we closed at 8 p.m.," says Dell. Since then, the Lower East Side has become a hipster hood and tourist destination, and now Katz's stays open 24 hours on Fridays and Saturdays, a soul-satisfying way to end an evening of clubbing or to begin a day of sight-seeing at nearby attractions like the Tenement Museum, which is a must-see if you want to understand the history of this neighborhood and its crucial role in the history of the city.

Ironically, Katz's old-fashioned approach is thoroughly contemporary—artisanal food from the best ingredients made fresh every day. "We make everything ourselves, except the bread because of union rules," says Dell, explaining that the deli's 100 employees are all union members, which is appropriate because the modern labor movement was born in this neighborhood where many of the immigrant residents worked in sweatshops. "We don't put the pickle barrels on the sidewalk anymore, but otherwise we stick to tradition." But there are a few exceptions. "We now serve a Philly cheese steak that is better than anything you can get in Philadelphia," says Dell. "And we serve cappuccino. My grandfather would wonder what that is!"

Dell is passing the torch to his son Jake whose Bar Mitzvah party was held at the deli. Katz's thriving mail-order business dates back to World War II when worried Jewish mothers could "Send a salami to your boy in the Army," which has been Katz's slogan ever since. The Dells contemplate opening franchises for the diaspora of New Yorkers who now live in places like Arizona and Florida, so they might find a taste of home away from home. But for true deli connoisseurs, the corner of Houston and Ludlow Streets will always be a holy land.

BY DAN SHAW

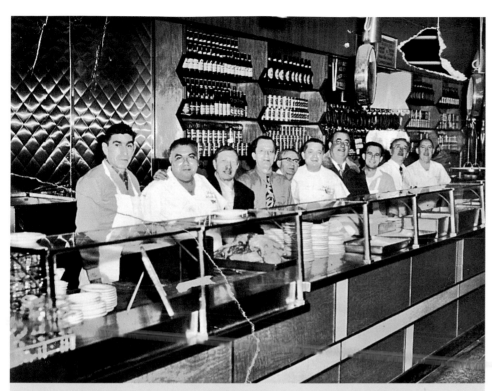

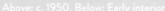
Above: c. 1950. Below: Early interior

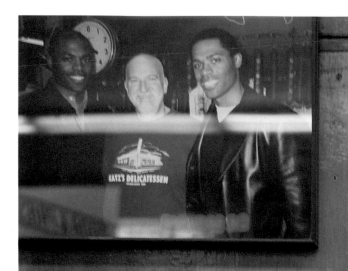

POLICE COMM. BRATTON

Don Francisco

MICHAEL RICHARDS

WAITER SERVICE Only 8

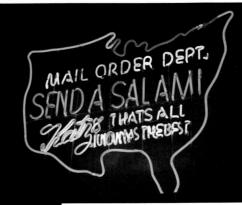

In a restaurant,
choose a table near a waiter.

This little nugget is attributed to the legendary

HENNY YOUNGMAN,

who is said to have walked into the Friars Club

every day for 50 years and asked for

"a table near a waiter."

A TONGUE STORY

Not once did the thought of what I was eating enter my mind. Not even when I was tucked into my favorite place, between the kitchen table and the stove, watching Mama put that tapered grayish piece of meat into a pot, add onion, bay leaf, and peppercorns, and cover it all with water.

Mama always said, "I hate to cook." I never could understand why my mother, who always prepared such wonderful meals, would insist that she hated cooking. I realize now that cooking nourishing meals for our family of four was taxing because Mama had to spread the meat dollar and so cooking was a job. And she wasn't the only one. Interesting food was often stretch-the-dollar food. That was just the way it was in those days.

Stroganoff—what is it? Stew with mushrooms and sour cream. Pot roast—a tough cut of meat cooked for hours with vegetables and served in small portions with a starch—noodles, rice, potatoes. All filling and all inexpensive. Kishka—intestine filled with starch, garlic, and parsley. And tongue in a sweet and sour raisin sauce. All memorable. All delicious. These are the foods of our ethnic heritage.

I still love tongue, but now, viewing this Lower East Side delicacy through the eyes of my children, who shuddered when they recognized what I was cooking and were shocked that I served it to them, I try not to think about it's origins. But still I can't resist the taste. So tender, so unique.

And so when alone, without a raised eyebrow in attendance, I head to Katz's and order tongue on rye, and a Cel-Ray tonic. And then I dip into the bowl of sour pickles and pickled tomatoes that the waiter places in the center of the table and anxiously await my treat.

LYDIA ROSNER
Author, A Russian Writer's Daughter

PICKLED TONGUE

4 pounds beef tongue

3 cloves garlic, minced

½ cup warm water

2–3 teaspoons mixed pickling spices

2 tablespoons salt

1 tablespoon brown sugar

1 tablespoon saltpeter

Mix salt, pickling spices, sugar, and garlic together. Rub into the meat thoroughly.

Place in a crock or glass bowl. Dissolve the saltpeter in the warm water and pour over meat. Cover tightly and place in refrigerator.

Turn meat every other day. Leave in icebox for 1 week.

To cook, place in cold water to cover.

Bring to a boil and throw away the water.

Repeat this process three times.

After changing the cooking water three times, cover with cold water again, bring to boil and cook until tender.

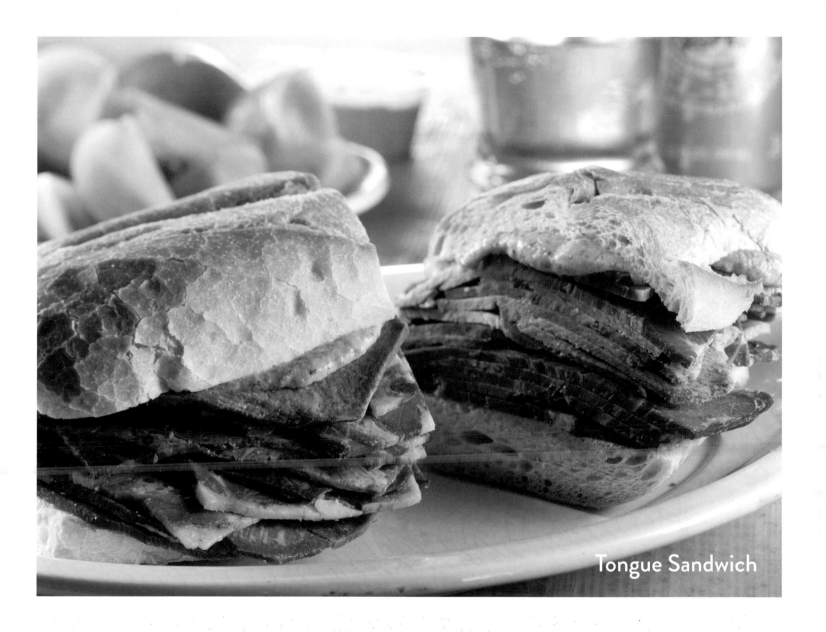

Tongue Sandwich

Why spoil a good meal
with a big tip?

OF DADS AND DELIS

There are tip cups on the counter now, jammed with bills, but that's not the way it always was.

Back many years ago—50 in pastrami years—when you went into Katz's on Houston Street getting a sandwich required different skills. I should know: My dad started taking me there and teaching me the fine art of delicatessen when I was just a kid.

Going to Katz's in the 1950s and 60s was a ritual in our family, which, legend has it, has the words "So many meals, so little time" embossed on the family crest.

We often stopped at Katz's on the way home to the Bronx after visiting my father's parents in Brooklyn. . .that is when we didn't stop at Nathan's at Coney Island. Sometimes we just went to Katz's without the obligatory family function, though at this point in my life, it's a little blurry.

No matter, the ritual was the same. Dad would park the car on one of the narrow Lower East Side streets and the four of us—including Mom and my older brother Steven—would head for the corner of Houston and Ludlow. Then as now, each person got a ticket as they walked into the door, the difference being that back then the printed prices had some relationship to what sandwiches actually cost.

There was waiter service back then too but not for us. We went straight to the counter and ordered our sandwich directly from the slicer behind the station: pastrami on rye with mustard and full sour pickles. . .as if there were any other correct way to do it.

And then came the technique that set us apart from the

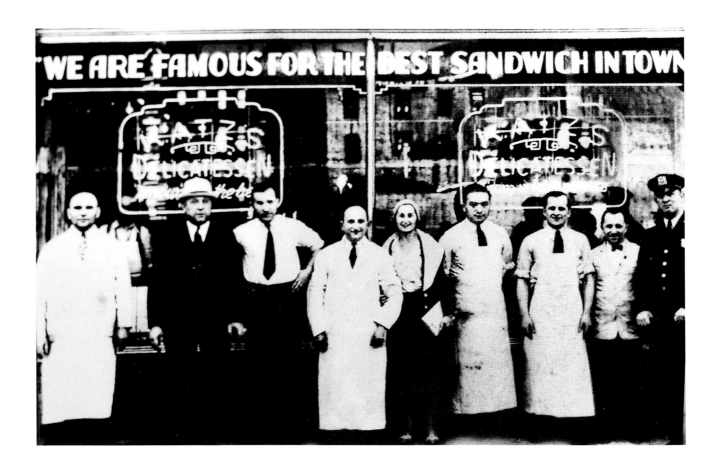

rubes and tourists. My dad took out a quarter and holding it next to the paper ticket, tapped gently it on the top of the glass counter. The slicer behind looked up, knowingly nodded and that was it.

The fix was in.

Said ticket with said quarter were handed over to the slicer and the former, though not the latter, was soon returned. When our sandwiches appeared, they were thicker, juicier and accompanied by more sour pickles than anybody else in the entire restaurant. Perhaps in the entire city of New York.

It was all in the wrists, my dad subsequently taught me, and over the years I mastered the fine art of tipping the slicer to always come away with something a cut above normal.

One quarter eventually became two and as Katz's enjoyed its pastrami renaissance over the past decade or so, coins gave way to dollar bills. The subtlety of the tap was replaced with the more blatant handing over of paper currency, now further commercialized by cups and jars with the word "tips" boldly emblazoned on them.

But the principle remains the same and if you want a great sandwich, it's still the only way to go.

And go I do, once or twice a year as my nuclear stress tests and EKGs allow, but each time I think back to how it used to be and the warm memories of family.

Many kids learned how to play baseball or do long arithmetic from their dad. Mine taught me how to order deli.

WARREN SHOULBERG
Editorial director, Progressive
Business Media

Katz's Deli, 2014.
Opposite: Storefront, 1932.

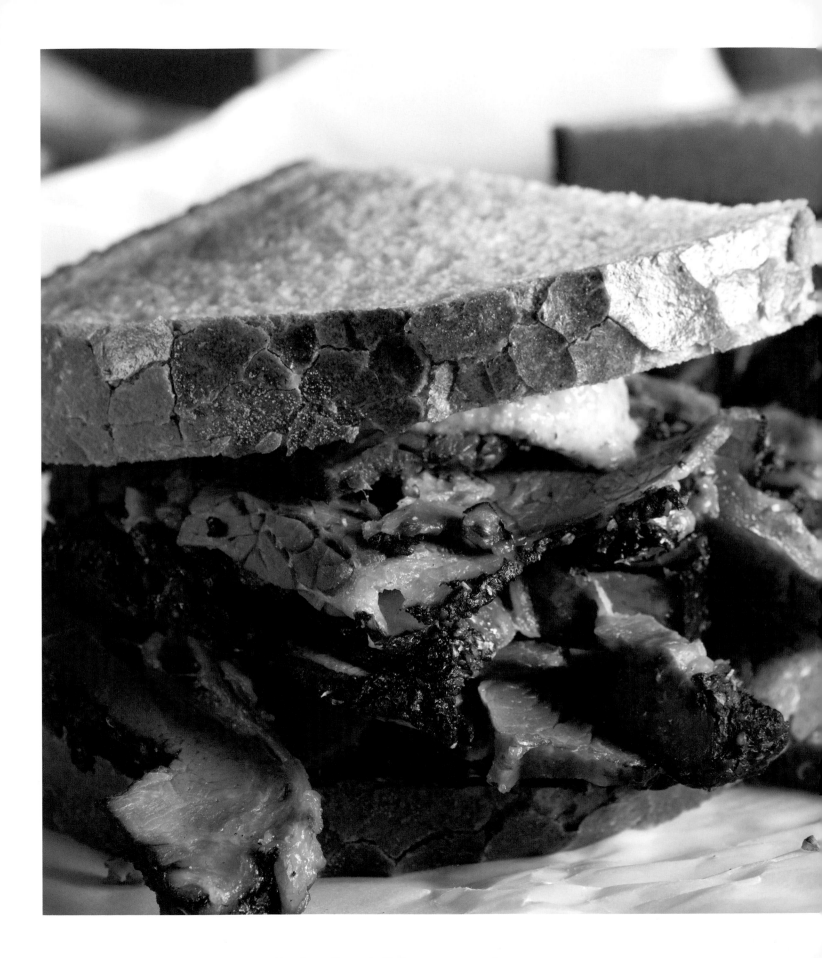

Sidney Kosner, 1929.

Pastrami Sandwich

PROUST ON RYE

The only surviving relics are two match-books for sale on eBay for a couple of bucks. One, from the 1940s, black with gold lettering, reads: J.H. Gert-ner Jr. Restaurant & Bar 168 Fifth Avenue at 22nd St. Like Proust's madeleine, that matchbook summons up a lost world for me. In those days, men often worked a half-day on Sat-urdays, and lucky sons got to visit them at their offices before lunch and spend an afternoon together exploring the city.

My father, Sidney, was the New York sales rep for J. Pritzker, a New England manufacturer of men's and boy's glossy leather jackets and other outerwear, as it was called. His office was at 200 Fifth Avenue, at 23rd Street, just a block north of Gertner's, an otherwise unexceptional businessman's place that for me was pastrami Valhalla.

Our routine never varied. My father would be ready when I showed up around noon. He'd lock up the office, which was supposed to look like an English hunting lodge, and we'd walk through the echoing corridor to the elevator, stroll through the big lobby out to Fifth, and turn right. At Gertner's, we'd slide into a booth, and the big moment would come: I'd order the pastrami on rye and a Dr. Brown's Cel-Ray or a ginger ale. He'd have a corned beef sandwich and a beer, or, if he was in an especially good mood, a J&B on the rocks.

Almost instantly—at least in memory—the crusty waiter would ap-pear with my still steamy pastrami, delicately rimmed with fat, embedded in two slices of chewy, seeded rye bread with a slice of sour pickle and a side of thick-cut french fries. Then he'd slide my father's corned beef on rye in front of him in an identical oval white plate with a green border. The sharp deli mustard was waiting in its crock.

There's no evidence that Gertner's pastrami was any more extraordi-nary than the brined, spiced brisket served up by uncounted Lower East Side delis and others around New York. If *New York* magazine existed at the time and handed out pastrami laurels, I doubt that Gertner's would have rated. Yet, 65 years later, I can still taste that sandwich from those delicious afternoons with my father.

EDWARD KOSNER
Former editor, *Newsweek*, *New York* magazine,
Esquire, *The New York Daily News*

Any time a person goes into a delicatessen
and orders pastrami on white bread,
somewhere a Jew dies.

MILTON BERLE

Two Chinese men are walking
out of Katz's Delicatessen.
One says to the other,
"The problem with Jewish food is that
two weeks later you're hungry again."

AN UNMOVABLE FEAST

Jewish deli is a passion pit.

When you embark on a creative journey—filmmaking, painting, whatever—you cross into a territory where, if you're honest, what you don't know is greater and larger than what you do. I'm somewhat stubbornly on my own Jewish ramble, leaping instinctually from rock to rock—from studying sacred music at the Academy of Jewish Religion and the Jewish Theological seminary to my Talmud study group to—and through—my films, *A Cantor's Tale* and *The Klezmatics—On Holy Ground*. Only now, it seems, I've landed on the real Plymouth Rock, so to speak—food.

There's that old turnip: "They tried to kill us, we won, let's eat." But the domain is so much larger. "We just lost a loved one—let's eat." "A baby was born—let's eat." A Bar or Bat Mitzvah—let's eat." "I've just had a hip replacement—let's eat." "I miss you—let's. . ."

Food traditions and rituals belong to every tribe. My mom's kitchen, of course, reigns supreme. Nobody holds dominion over her brisket, or cranberry sauce, l'olam va'ed. But I've also been treated to delectable ethnic meals and consummate hospitality in St. Petersburg, Russia; Maun, Botswana; and the Deheishe refugee camp skirting Bethlehem, the Holy Land. So what is it then that has food passion, if not obsession, so hard-wired into the Jewish DNA?

When it comes to matzo ball soup, kugel, a tongue or pastrami sandwich, the oh-so halakhically challenging Reuben. . .we enter the aforementioned unknown territory, where the welter of mouth-watering victuals subsumes the rational. Jewish deli is a relative latecomer to ethnic cuisine, sprung from New York's Lower East Side in the mid 19th century. But it needs neither détente nor reconciliation. Jewish food is facts-on-the-ground, non-negotiable, borders etched in garlic and spicy brown mustard, with Deli as its eternal capital.

ERIK GREENBERG ANJOU
Producer/director, *Deli Man*

HOT DOG!

For what it's worth, my great-grandfather was Harry M. Stevens, and he created the hot dog. He was the legendary food concessionaire who ultimately fed the masses at Yankee Stadium, Ebbets Field, The Polo Grounds, etc. At the suggestion of one of his four sons, he famously married the frankfurter to the bun so they could offer warm food on cooler days. It was always kosher too. Cartoonist Tad Dorgan gave the "hot dog" its name because he couldn't spell "dachshund" when illustrating wiener dogs.

The Stevens clan was "geven mer goyish vi goyish," more gentile than gentile. Harry M. was the American Dream manifest, a self-made English immigrant who settled in Niles, Ohio where he was a steel puddler and itinerant book seller until he saw a good idea: selling baseball programs that were accurate and that he could sell advertising on ("You can't tell the players without a scorecard!") and bottles of cold soda pop, creating the necessity for the drinking straw so you wouldn't miss any action.

I grew up in Michigan. I don't think I met anyone Jewish until boarding school, but more than 30 years ago I took one home to meet my mother. We're still together, and he makes a mean kugel.

I lived on the St. Clair River. Condoms floating downstream were called whitefish. I have come a long way but never past that.

W.M. HUNT
Photography strategist

O. HENRY ON HOUSTON STREET

When I was a girl growing up in Detroit, New York was the Old Country, the origin of my species. Tradition, religion, and history coalesced there. Exciting, deeply evocative, near mythical New York City was an inexhaustible wellspring of Jewish culture for me. And all that nostalgia, family connection, and sense of belonging was tied up with New York food.

My father was raised in Brooklyn and educated at City College. His parents were immigrants from Eastern Europe who launched their American lives as teenagers on the Lower East Side. My father headed out to the auto plants of Detroit in 1948 with a left-wing posse of idealists, and he stayed. Yet he remained a New Yorker, sentimental about the world he'd left behind. And he made sure we experienced his New York on our annual car trips "home."

The Jewish frankfurter was on his New York map. Many was the time when our family would arrive in Brooklyn after a two-day drive east and search for a meaty snack, lest we land hungry in East New York, where my grandmother waited with vats of soup and trenchers of pickled brisket. Dad cruised out Flatbush Avenue, maneuvered side streets, plunged into the shadows beneath elevated trains, followed his nose. I recall steamy storefronts. Deli men handed franks from the grill through little sliding windows, literal holes in the wall.

There were hotdogs in Detroit, but New York pups were different. These grilled beauties, festooned with tart sauerkraut, tucked into warm rolls, dripped pungent brown mustard. When you bit in, the crisp casing popped, joyfully spurting salty, garlicky juice. That old-time natural casing is likely illegal now.

We sampled frankfurters all over the city. We strolled Coney Island off-season, through wind and rain, and always stopped at Nathan's Famous. We visited great-aunts in the Bronx, cousins in Queens, comrades in Washington Heights. Each street corner seemed to have its Jewish deli, with brown Formica counters, cracked red vinyl banquets, linoleum floors, and glassed displays bedecked with chains of garlic wursts. We tested the swings in WPA-era playgrounds, gawked at the Empire State Building. Frankfurters appeared when needed like another landmark.

Undoubtedly, our favorite vendor was Katz's on Houston Street. In the 1960s and 70s, the Lower East Side still tasted Jewish, with fading signage in Yiddish and shops selling hosiery and pocketbooks and feather pillows and phylacteries, but it was changing. Katz's was a stalwart, a million years old, rundown and not too clean (especially the bathroom), purveying its magnificent frankfurters and knobelwurst and knockwurst "specials." It had atmosphere, history. My grandfather must have known this place, going his rounds as a young man trying to make way in the New World.

The place never changed. You got your paper ticket at the door and your family fanned out in disciplined formation, grabbing trays, waiting for washed glasses, claiming a table. Like military strategists, one waited for the french fries, one ordered the franks, another balanced cans of Dr. Brown's. The counter men marked the tickets. You lost your ticket on pain of death. (Waiter service was available, at tables along the wall, but this was incomprehensible to us, and so boring.) And after your meal, stuffed as a sausage ready to burst, you gathered everyone's greasy tickets, to pay on the way out. The cash register, as I recall, wore this sign: "Red Yiddish Zug Gornisht" (Speak Yiddish Or Nothing). Why would anyone want to be anything but a New York Jew?

For me, being part of all this by birthright was the point. In the Midwest, I equivocated. In New York, I thought I had an idea of what being Jewish might mean: Yiddish in a shop window, a gravelly accent that dropped its Rs, the immigrant strivers of the past, discussions that really mattered, library books on the subway, bargains on Orchard Street, socialists huddled over cracked plates of delicatessen. Katz's was emblematic. The Jewish identity and history I felt >

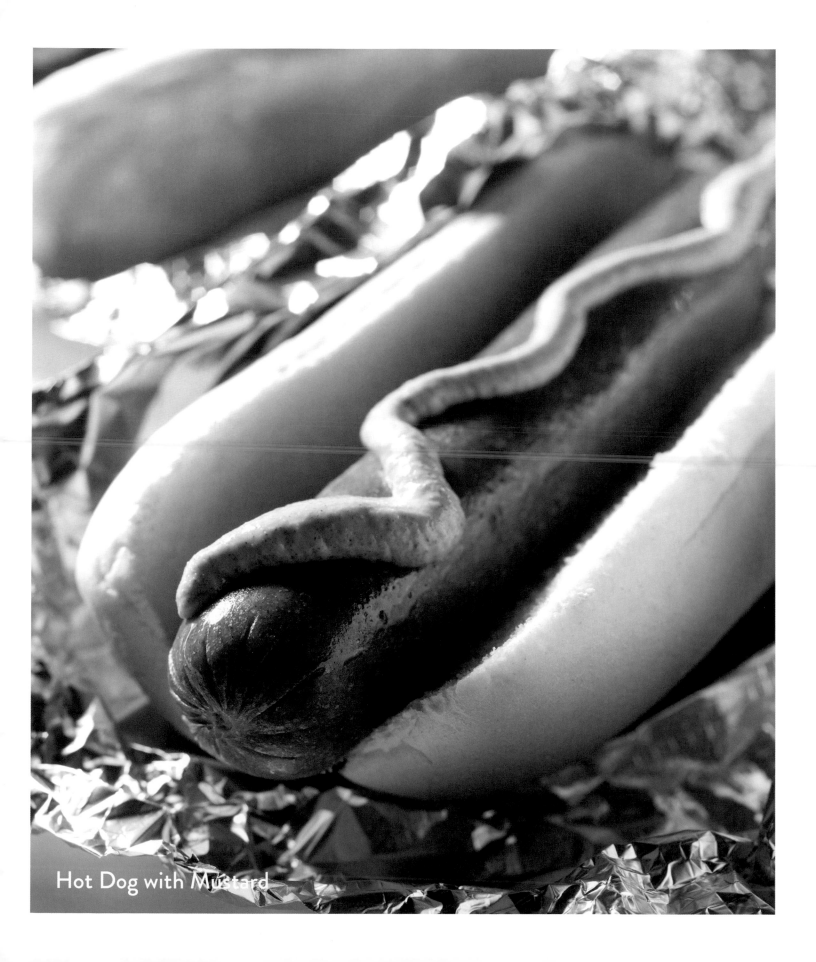

Hot Dog with Mustard

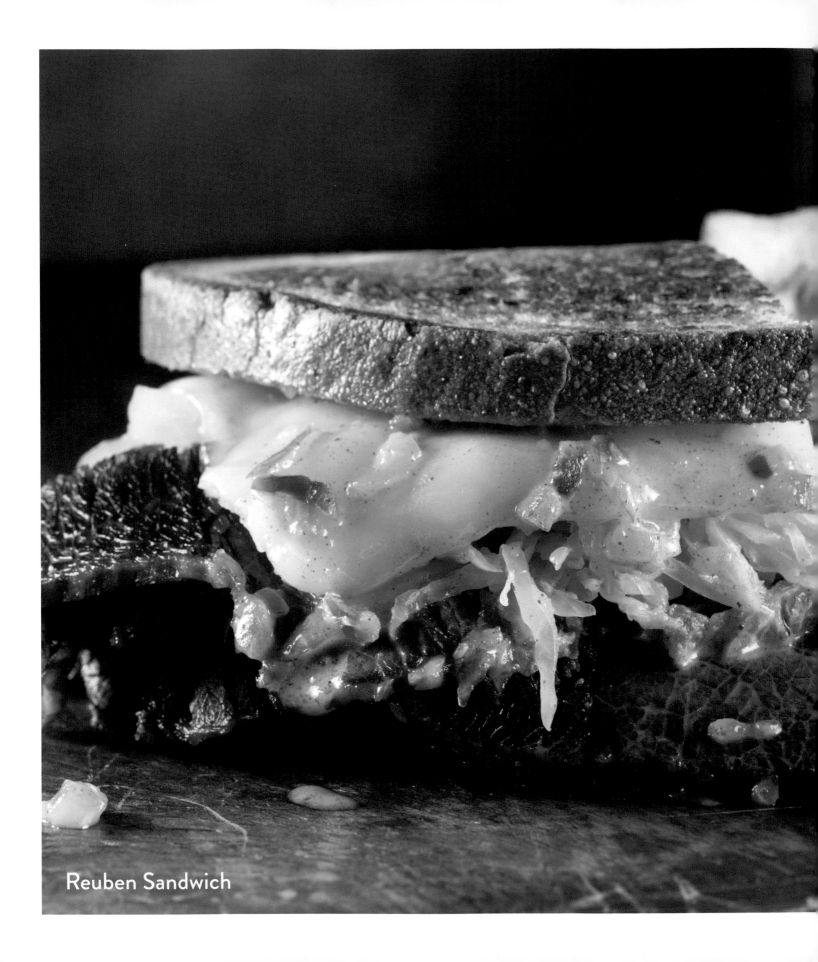

Reuben Sandwich

KATZ'S REUBEN

¾ pounds Katz's pastrami

2 slices traditional rye bread

3 slices Swiss cheese

a handful of juicy sauerkraut

homemade Russian dressing

Slap a handful of sauerkraut on a hot pan. Don't be afraid to go all out—no one ever died from an excess of kraut.

Lay the Swiss over the sauerkraut and slowly melt it to gooey glory.

While the Swiss is melting, hand-carve some pieces of our juicy pastrami into thin slices. Inhale deeply. Try to stay conscious despite the delightful wave of smoky aromas.

Drape those slices over a fresh piece of rye bread—treat yourself to a little extra if you're in a meaty mood.

Pour the sauerkraut and cheese over the freshly cut pastrami slices. Resist the urge to consume immediately.

Smear some Russian dressing over that other slice of rye. No skimping.

Slap the dressing-coated slice over the kraut and cheese, slice that puppy in half, dish out the napkins. Take a moment to appreciate your hand-crafted creation—but only one moment. Who would have the self-control to wait any longer to sink their teeth into this delicious work of art?

there tantalized me like the scent of franks on the grill. New York was not just Old Country, but promised land.

In my 20s, I made my move. By then I came for other reasons. Sure, I wandered the Lower East Side on Sundays, spending my first paychecks. But as much as the cobble-stoned past might have drawn me away from Detroit, I sought a New York future. I worked and played, married and reproduced, planned and sorrowed and built. As life was happening, I found myself looking for a different kind of religion, one that could guide me, not just connect me to the past. I wanted to know what lay beneath the culture, wit, community, the food that had formed me, to learn what it offered for the future.

I suppose I followed the logic of those flavors, primal memories, connections. The path led me in unexpected ways. Back when I strolled Orchard Street holding my father's hand, I never expected to embrace religious observance or tile my path with Mosaic Law. But here it is. I'm on the path. I take dietary cues from ancient mindfulness. So I don't, these days, put great store in the spiritual value of "Jewish tastes," though I still love a grilled frankfurter.

No longer is Katz's the magnetic pole that drew me to my New York past. In the ironical compass spin of life, I can no longer eat there. As it turns out, Katz's isn't kosher.

ELIZABETH EHRLICH
Writer

IF FRESSING WAS AN OLYMPIC SPORT

am a champion eater. Really, I should be a 300 pound shut-in with swollen ankles resting in a kiddy pool, and it's only through sheer luck that I'm not because I can really pack it in. (Sheer luck and great tits hide most sins, right?) All of my good friends and my great loves throughout my life have joined me in eating, drinking, and laughing until we're nearly fainting with pleasure. And of course, all good memories from my childhood revolve around food.

My romance with Jewish food—smoked fish, pastrami, dried fruits, fancy nuts, and pickled anything—began at around 6 or 7 years old when my mother's sisterhood group arranged a walking tour of the tenements and shuls of the Lower East Side.

Growing up in suburban Philadelphia, we had good—really, more-than-good—deli. We had Hymie's and Murray's, almost across the street from one another where we lived, and you declared your allegiance to one camp and stayed put. We were a Murray's family. I loved the cabbage soup, the blintzes, the cold, thinly sliced corned beef.

So. . .then came this trip to New York. My mother insisted that even though we were traveling by bus, we dress up. Memory tells me there was a coat with a fur collar. I can also recall the small, cramped, dark rooms and the low buildings with Hebrew lettering on the facades that were in stark contrast with our huge, soaring synagogue back home. But what I really remember was the shpatziring around Delancey and Orchard Streets, looking at handbags and brassieres and luggage, stopping in at Russ & Daughters for dried apricots, dried pears, dried

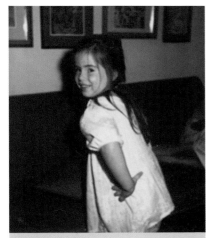

Cute as a hamantaschen at age 4.

cherries, and pickled herring that we ate with our hands right on the spot. We had lunch at Katz's—I had never seen such huge sandwiches with such thickly sliced warm meat. I ate plate after plate of full sours. My mother bought me a battery powered, red plastic "Big Apple" coin bank that featured a worm which popped out and wiggled around when you dropped in your change, and I played with this all night at the table at Moshe Peking, where the group ate before boarding the coach for the ride home. I can still see all those Yiddish mamelahs, full bellies, snoring lightly in the dark on the way back to Philly, overloaded shopping bags at their feet and spicy, exotic smells in the air on that overheated bus.

Now I was ruined. I still enjoyed my food at Murray's, but clearly we were missing out here in the burbs. This might have been my first inkling that New York City—specifically, downtown New York City—was to be my home.

And for nearly 20 years, it was. I never lived more than a 10-minute walk from the heart of the Lower East Side and my posse and I ate heartily. Bialys, hamantaschen, lox, pastrami, rye bread, halvah, sour tomatoes, babka were all brunch staples or late night snacks (we were young, there were no gyms but we walked everywhere and no one was even close to needing Lipitor). The food was intoxicating by virtue of the memories it stirred up and the experience was made all the more haimish because you dined with your proverbial mishpocha. You were surrounded by Jews. Katz's wasn't serving chicken salad or putting cheese on its sandwiches back then. Everywhere you looked, there were familiar looking, familiar sounding people—like those people at the next table who were arguing over who would pay the check. They could've been stand-ins for my nana Bea and great-uncle Harry.

Everyone loved going to The Lower East Side for a nosh. My ex-husband's best friend from childhood would head straight to Katz's from the airport whenever he flew in from points exotic and unknown (he was a cameraman who worked on the first series of *Survivor* shows). Quite

frankly, I thought he was an asshole when we first met, until once, when he arrived from Katmandu. He had dysentery and he hadn't slept or showered in days. But he still needed a pastrami sandwich and a hot dog, stat. I took him right to Katz's and then he went to the doctor for meds. This was when we became friends.

Still, no one loved The Lower East Side more than Al Levine. He was a textiles executive when I was a reporter covering that beat for a trade newspaper. Al was somewhere between 70 and 200. When he played at industry golf outings, he wore knee high argyle socks that matched his polo shirts. He wore a carnation boutonnière in the lapel of his suit and always told the young women who were just married or newly pregnant in his office that if they named their progeny "Alvin," after him, he'd pay for the kid's college education.

Al loved to go to Peter Luger, where he had one of their private label credit cards that allowed him to put the meal on his tab. One day, he asked me to lunch. Peter Luger, but of course.

Al had a cream colored Eldorado with red leather interiors and drove it at about 15 miles per hour. The car was wider than my first apartment. We were making our way towards the Manhattan Bridge from my office in Chelsea, when suddenly he pulled over in front of Katz's.

"Listen honey, we'll be at the restaurant in a few minutes, but, I'm wondering, since we're passing by, if maybe we shouldn't get a little something to hold us over before we cross the bridge? A snack. Are you in the mood for a hot dog?"

All hail. I had met my match.

ABBE ARONSON
Publicist; grande dame, *Abbe Does It*

I'll eat bacon,
but bacon with a glass of milk—
I'll faint.

LARRY KING

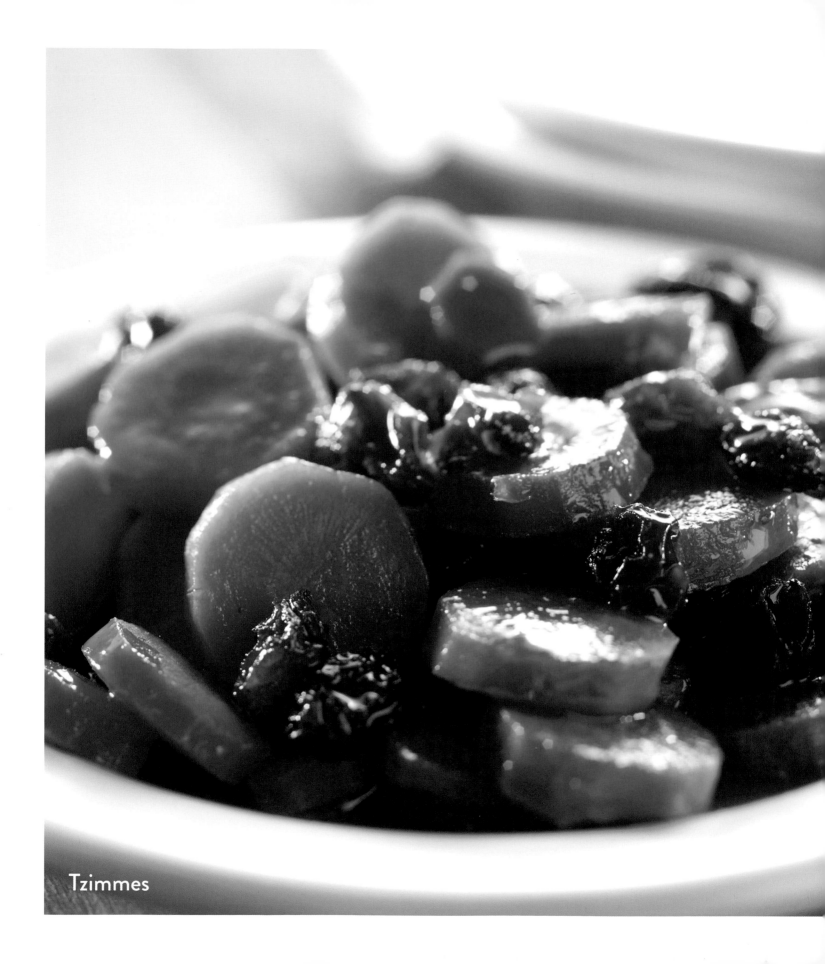

Tzimmes

Molly Jacob Rezny and Bella Jacob, 1975, Brooklyn, New York.

MOLLY REZNY & BUBBE BELLA'S
TZIMMES RECIPE

Makes 6 servings

4 large carrots, peeled and sliced in rounds

⅔ cup raisins

3 tablespoons honey

3 tablespoons fresh lemon juice

2 tablespoons butter (Bella used 2 tablespoons of schmaltz)

2 tablespoons brown sugar

salt

pepper

In a large saucepan combine all the ingredients. Bring to a boil over medium high heat.

Reduce the heat, cover, and simmer until the carrots are tender, about 20–25 minutes.

Remove the cover from the pan, turn up the heat, and cook the carrots until most of the liquid has evaporated and the sauce has thickened, about 4–6 minutes.

Young Joshua Bell.

MARROW MINDED

Growing up, it was always a special treat when my mother would make a bone-in roast for holidays and special occasions. The house would fill with smoke as she seared the meat under a high burner to create a charred appearance and crisp outer texture along with a medium rare inside. However, it was not really the meat itself I looked forward to, it was what was inside the bone.

Along with my two sisters, I would anticipate the soft, warm "mush" that my mother would carve out of the circular bone and divvy to each of us, one at a time, on a small piece of challah topped with a dab of salt. We each would be allotted, at most, a teaspoon of the bone marrow that would melt in our mouths. We coveted our individual morsels for the delicate texture and the decadently fatty taste. To think some people actually throw away this part!

To this day, I continue to search out the finest restaurants that serve this delicacy. Both the presentation and taste contribute to this special culinary experience. I have introduced many friends to this unique food choice who might have scoffed at the idea at first but who are now as "marrow minded" as I am.

JOSHUA BELL
Violinist

SAMMY'S ROUMANIAN SKIRT STEAK

1 large skirt steak

kosher salt

ground pepper

minced garlic

Take 1 large skirt steak. Pull the fat off both sides. Trim the remainder of the fat.

Pound it out. Tenderize the meat with a metal meat tenderizer.

Add kosher salt and ground pepper.

Put steak on the grill turning once or twice.

Cook to desired doneness, and schmear with garlic.

Garnish with caramelized onions on top, if you like.

PHOTO COURTESY OF THE BELL FAMILY

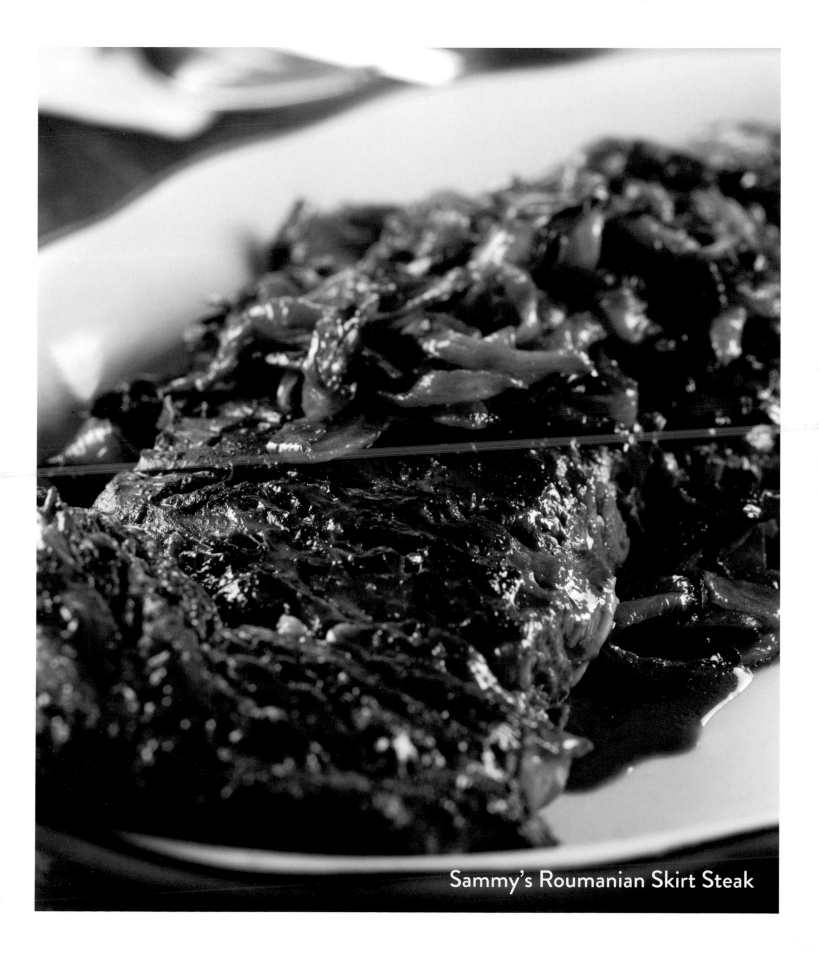

Sammy's Roumanian Skirt Steak

Zolstu vox
vie ein tzible
mitten kop in drerd.

May you grow
like an onion
with your
head in the ground.

Sable

A woman walks into a butcher shop.

Woman:

"How much are your

chicken livers?"

Butcher:

"$8.00 a pound."

Woman:

"At the butcher across the street,

they sell chicken livers

for $6.00 a pound."

Butcher:

"Then why don't you go there?"

Woman:

"They're sold out of chicken livers."

Butcher:

"When I'm sold out of

chicken livers,

I sell them for $6.00

a pound, too."

JORDAN SCHAPS' GRIBENES

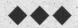

Anyone can make gribenes. I started at home as a twelve year old. It's hardly worth a "formal" recipe.

All you need is a raw chicken (better two, or three) minced garlic, chopped onion to taste, and a good heavy saucepan.

Pull/cut off all the fat from the chicken. Pull off all the skin, (You can buy chicken fat and skin at a really good butcher. My favorite is Hudson & Charles in the West Village.) Cut the skin into 2-inch triangles.

In the saucepan, throw in the fat, and start heating it up—moderate heat. When it gets going—nice and hot and the fat starts to sizzle and render and turn to liquid—toss in the chicken skins, onion, and garlic. Instead of stirring, just tilt the pan around, so it all starts "meeting," or you can use a wooden spoon to stir. Watch the heat, so as to cook hot, but not burn.

When the fat is rendered golden, the onions brown a bit, and the chicken skins curl up medium brown, take off the heat, and let it cool to room temperature. Strain the golden chicken fat (now schmaltz), and put the crispy skins on a paper towel.

Put the golden schmaltz in a covered container in the fridge, or freezer, and the gribenes in a bowl. Voilà, or Huzzah!

The gribenes can be eaten like "Jewish popcorn," or used in countless Jewish recipes. The schmaltz can also be used in numerous recipes, but my favorite is schmeared on a nice piece of matzo. Perhaps life shortening, but heavenly.

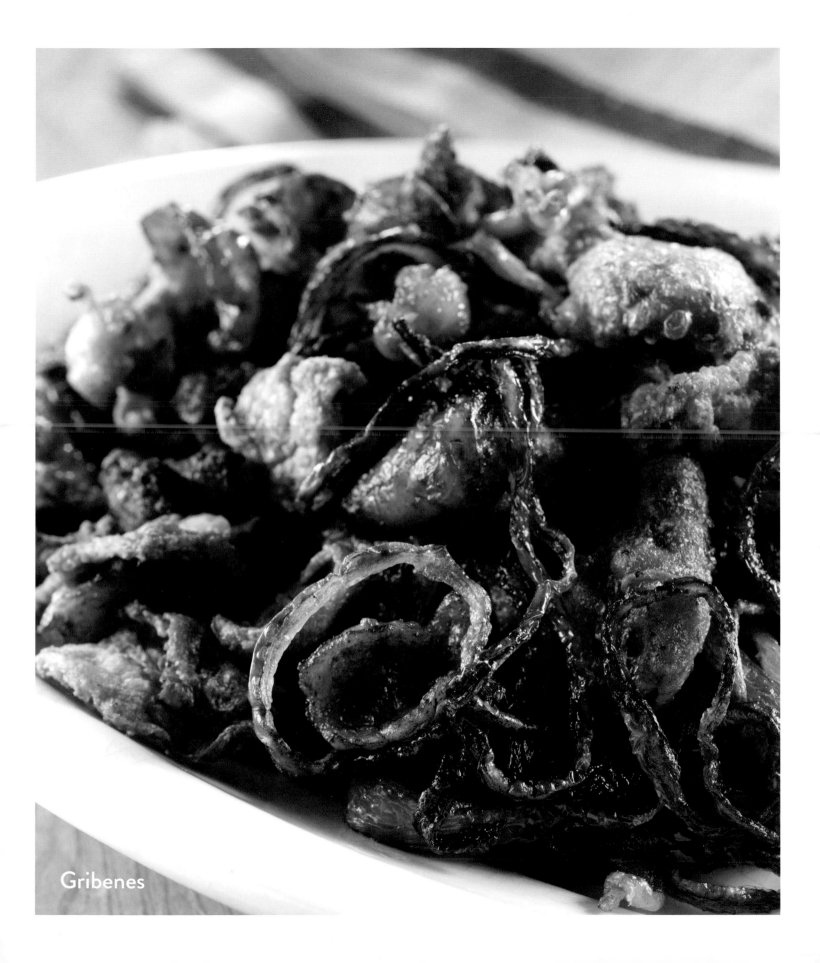

Gribenes

Kasha Varnishkes

RENEE SILVER'S FAMOUS KASHA VARNISHKES (THE KIND THAT MAKES JOAN RIVERS PLOTZ!)

◆ ◆ ◆

1 pound bow-tie pasta

3 cups coarse grain kasha

3 large onions, chopped

½ cup oil or schmaltz

Sauté chopped onions in ½ cup of oil until soft and golden brown. Set aside.

Boil 1 box of bow-tie pasta in lightly salted water until cooked. Set aside.

Bring 6 cups of salted water to a boil. Add in 3 cups of kasha. Bring back up to boil.

Cover pot and reduce heat to simmer. Cook for approximately 8–10 minutes, until water is absorbed and kasha is soft but still holds its shape.

In a large bowl combine onions, kasha, and bow-tie pasta.

Add salt and pepper to taste.

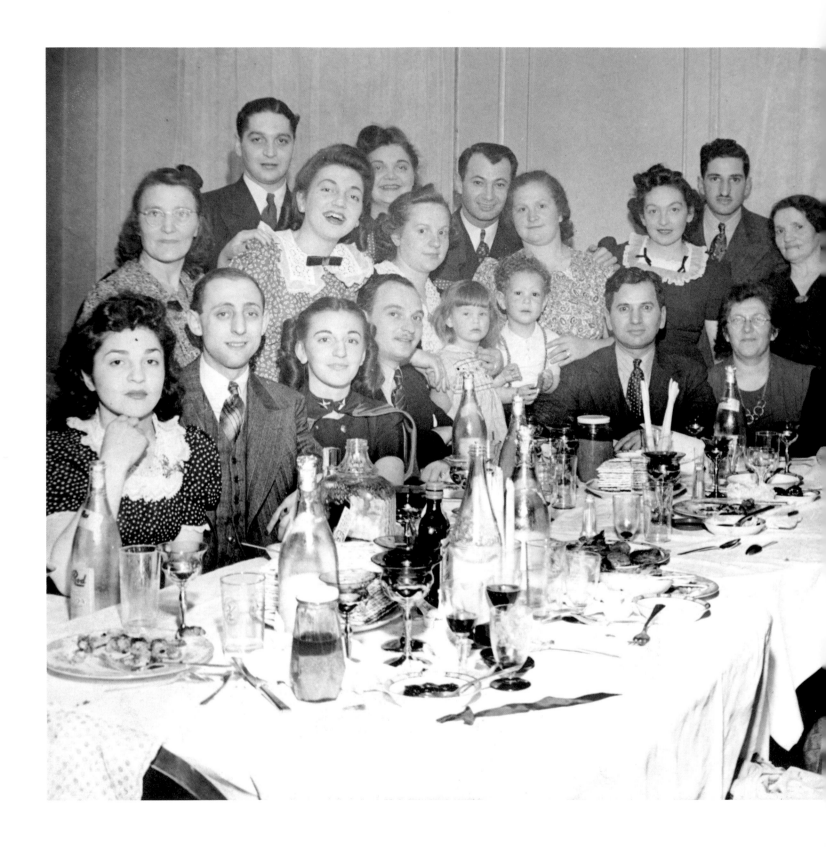

FAMILY RECIPE

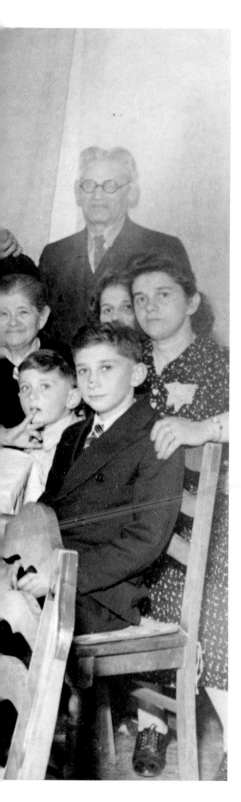

Some of my happiest memories are sitting in the back seat of our 1977 Chevy Impala with my brother and sister as our family would drive to Brooklyn every other Sunday to visit my grandmother, Bertha. Coasting over the Verrazano Bridge, waving to the Statue of Liberty first, and playing "Spot the Jews" (a game my mother made up to see if we could identify other Jews in their cars on the Belt Parkway). When we finally got to Grandma's house, my siblings and I would race from the car and down the stairs to her basement apartment on East 18th Street in Sheepshead Bay. No sooner did the door open than our senses were overcome with the delightful smell of Grandma's matzo ball soup. It was never easy waiting for dinner to start eating it, and grandma knew this, so she would give me a bissel of soup to eat in the kitchen, warning me that it was very hot. The matzo balls were just the right density: not too hard, not too soft. And the little square noodles were always al dente, and topped with a few boiled carrot slices in a light and salty broth. It was heaven in a small orange bowl.

Years later, when I was in college, I began to think back to the old days in Brooklyn, and I called my grandmother to see if she would share what I assumed was an old family recipe, handed down from mamelah to tatelah. I opened a notebook and took out a pen, as she began to dictate the recipe to me over the phone: "My Jeffelah, you go to the store and you buy a box of Manischewitz Matzo Ball mix and you follow the instructions on the box. It's easy."

Oy.

JEFF KAGAN
Cofounder, NYC Gay Hockey Association

Above: This color photo of me and my grandma Bertha was taken in front of the house I grew up in— in Old Bridge, New Jersey (where I live now!). That was 1969.

Left: Passover Seder, 1942 in Brooklyn, New York. My grandmother Bertha in the center in the white, floral dress, with my grandfather Harry's arm around her, and their son, my uncle Harvey, standing in front of them (when he was three years old). My father wouldn't be born for another two years. This picture is so important to me because so many of the people I love are all in the same room enjoying a traditional meal together. These faces bring back countless memories, some good and some bad, but together, they make me think of one special word: home.

THE GREAT MATZO BALL BATTLE—1972

Let's get this straight—my mother Gerry was not a great cook. She was a career woman who married young and never really felt the need nor had the time to become domestic. That said, everything changed when it came to Passover. She was insistent on proving that she had what it took to make the traditional dinner with style, on the second night of the holiday every year. My aunt Birdie always got the first night and here is where the fun began.

My mom was a bit of wild card. Her parents divorced when she was four—so she was sent to live with her Dad's sister Birdie. Mom was a tomboy and Aunt Birdie did her best to convert her into a perfect, young Jewish lady suitable for a very well-heeled man. And then on a trip to the Catskills, mom met my dad who was a busboy at the resort (are you thinking *Dirty Dancing* yet), fell in love, got married at 19, and moved to New Jersey. Aunt Birdie was horrified but accepted the situation and continued to train Mom on all things related to being the perfect Jewish bride—including giving her access to all the secret family recipe tips.

Here's the thing—we weren't really that Jewish. Mom's free spirited religion tips included: God is everywhere consider your room your temple; fashion is one of the most important aspects of the High Holidays; and pork roast was a delicious, successful alternative to pot roast.

Okay, back to Passover. The year was 1972. I was ten.

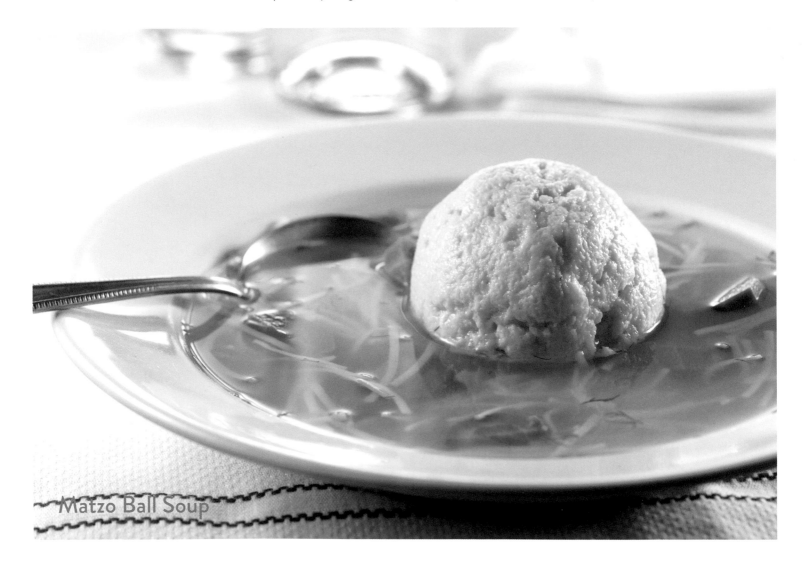

Matzo Ball Soup

There was always a lot of anxiety that built up the week before the holiday and it seemed to come down to two things—the matzo balls and the chopped liver. Whose were better: Mom's or Aunt Birdie's? Of course, the rivalry was sort of weird since Aunt Birdie trained Mom—but Mom was very competitive so would study recipes and try new takes throughout the year for the big two-night competition. We were probably the only family having matzo balls and chopped liver at least once a month throughout the year. Aunt Birdie was also amazingly competitive and had her own secrets. For instance I fell in love with her Russian dressing which was the right mix of one part mayo and two parts ketchup, but it had to be blended perfectly before it could be spooned over the crunchy iceberg and celery salad that opened every meal.

That year things were really getting hot in the kitchen. The year before, Aunt Birdie's light, fluffy matzo balls were the sure winners to Mom's smaller, firmer balls. So this was going to be Mom's year. Night one: Aunt Birdie's house, matzo balls served with the rich salty and stocky chicken soup, each bowl also included a whole cooked carrot. As the guests indulged in their first bites the sighs of satisfaction were obvious. Uncle Morty sang out that these were by far the best matzo balls ever. I could actually see my Mom getting tense as she knew she would have one chance tomorrow night to take the title back.

Night two: our house, the setting was extreme 70s modern—think pink shag carpet, dining chairs with a plaid pattern covered by plastic seat covers and a holiday table which I was responsible for setting. I loved shining the silver but we will save that for another story. All the same players came to the dinner with the addition of Grandma Freeman (my dad's 86-year-old Romanian mother—who had long given up cooking for her nightly bingo and egg salad sandwich outings). Mom had been in the kitchen all day perfecting everything. For appetizers chopped liver and gefilte fish were served and the critics were unanimously pleased—the night was going well. The tension mounted as the matzo ball soup was served. The balls were big and bouncy and the soup had an orangey-golden hue. Instead of

a full cooked carrot, Mom opted for shredded carrots and celery along with chunks of chicken, which filled the bowl beautifully. Spoons hit the bowls and there was a distinct silence. Aunt Birdie appeared to be edgy. And then, all at once my dad Sol, my uncle Hank and my aunt Selma enthusiastically called out the soup and the matzo balls were the best they had ever had. My eyes filled with tears as the table all agreed and started asking my mom

Andrew and his Mom, Geraldine (Gerry) having their first dance at his Bar Mitzvah—at the Richfield Regency, Verona, New Jersey. The colors were brown and peach. March 23, 1975.

numerous questions about what she had added to the recipe to create this sublime deliciousness. Though defeated, Aunt Birdie rallied as well and gave Mom a big hug and told her she was very proud. Mom, who happened to look exquisitely beautiful that night in a tweed purple pantsuit (that I selected but I will save that for another story, too) was sly with her answers. When the crowd persisted, she simply answered a little bit of this and a little bit of that.

For years after, Mom's matzo balls and soup were never disputed and became legendary in our family. In 1980, when I was 18 my mom developed cancer and made her last Passover dinner. It was the year she finally revealed the secret ingredient for both the matzo balls and the soup—when my sister-in-law Heidi pleaded with her she simply smiled, winked, and whispered—ketchup.

Heidi now makes the matzo balls each year at Passover and I am pleased to tell you Mom's legacy will live on in our hearts and stomachs forever.

ANDREW FREEMAN
President, Andrew Freeman & Co.
Hospitality and Restaurant Consulting

Four Jewish matrons were going to a matinee.
They stopped in to a famous
Jewish restaurant for a pre-theatre lunch.
After giving the foursome menus,
when the waiter came back
and asked to take their order,
the grande dame of the group put her hand
on the waiter's arm and said,
"Waiter, we're going to the theatre
and don't want to be late."
To which the waiter replied,
"Would madam like the check now?"

2ND AVE DELI
MATZO BALLS

Makes 12 to 14

1 ⅓ cups matzo meal

4 large eggs

⅓ cup schmaltz

1 tablespoon plus ¼ teaspoon salt

1 tablespoon baking powder

¼ teaspoon pepper

Fill a large, wide stockpot ¾ full of water, add 1 tablespoon of the salt, and bring to a rapid boil.

White water is boiling, crack eggs into a large bowl and beat thoroughly. Beat in schmaltz, salt, pepper, and baking powder. Slowly fold in matzo meal, mixing vigorously until completely blended.

Wet hands, and folding the mixture in your palms, shape perfect balls about 1 ¼ inches in diameter (they will double in size when cooked). Gently place the matzo balls in the boiling water, and reduce heat to simmer. Cook for 25 minutes. Remove with a slotted spoon and place 1 or 2 in each bowl of soup. Serve immediately.

Q

What do
you get
when you cross
LSD
with a
matzo ball?

A

A trip
to Tel Aviv.

2nd Avenue Deli

From the first day it opened in 1954, the 2nd Ave Deli was steeped in history. Although it was then just a ten-seat luncheonette on East 10th Street, the tiny restaurant was much more than another soup-and-sandwich shop. It was Abe Lebewohl's paean to the Old World, his pledge to recreate a taste of home for Eastern European Jews who'd lost their families and food culture in the Holocaust.

New York was then a city rife with kosher delicatessens, but Lebewohl's passion made his place different. Born in Lvov, Poland in 1931, he had emigrated from a displaced person's camp in Italy to the United States with his parents and brother after World War II—the only members of their extended family who'd not been killed by the Nazis. His appreciation for being alive manifested itself in the zeal with which he ran his restaurant. Every pastrami sandwich and bowl of chicken soup came with a side order of gratitude, every meal a cause for celebration: l'chaim! Customers did not necessarily know Abe Lebewohl's story. They did not need to be Jewish nor have Eastern European roots to appreciate the warmth of his welcome or the honesty of his cooking. The only requirement for enjoying a meal at the 2nd Ave Deli has always been a hearty appetite.

By the 1980s the deli had expanded several times, with 250 seats as well as a thriving take-out and catering business. It had become a New York institution—one of the city's most unlikely destination restaurants. While it had a large menu with serious entrees like brisket, goulash, roast chicken, and stuffed cabbage, the main draw was still soup and sandwiches, which continue to be served in a style that makes customers feel like they're guests at a banquet.

After placing their orders, diners are given individual bowls of crunchy, vinegary health salad and fresh pickles. While it's hard to argue with former *New York Times* restaurant critic Mimi Sheraton's assessment of the mushroom barley soup—"a creamy, bracing antidote to midwinter snow and wind"—it is the matzo ball soup that is the 2nd Ave Deli's signature. It is served in a wide, shallow bowl with the noodles, carrots, and a matzo ball arranged around a tin cup of clear broth, which the waiter or waitress then ceremonially pours into the bowl at the table. The matzo ball is always soft, savory, and sumptuous. The secret ingredient is schmaltz, which is to Jewish cookery what butter is to the French and olive oil is to the Italians. It is the timeless taste of shtetlach and tenements, which has been elevated to an artisanal ingredient by the Lebewohl family. "As Abe used to say," recalls his brother Jack, who now runs the restaurant, "a matzo ball without schmaltz is an assimilated matzo ball!"

The deli's location in the East Village on Second Avenue, which had been the Broadway of Yiddish theater in the early 20th century, was important to Abe, who turned the sidewalk in front of the restaurant into the Yiddish Walk of Stars—Manhattan's version of Hollywood's Walk of Fame. Alas, Abe was robbed and brutally murdered on an East Village sidewalk in 1996 as he walked to the bank after work to deposit the day's receipts. To most New Yorkers, it seemed unlikely that the 2nd Ave Deli could continue without Abe as its guiding spirit.

But his younger brother Jack, along with his widow Eleanor, and daughter Sharon, agreed that the only way to honor Abe's memory was to re-open the restaurant after sitting shiva. They would maintain his vision and uphold his standards. They would face more challenges, including a rent increase that forced the restaurant to close its East Village doors in 2006, and re-open a year later on East 33rd Street, which seems like an unlikely location but turned out to be fortuitous. "We're around the corner from

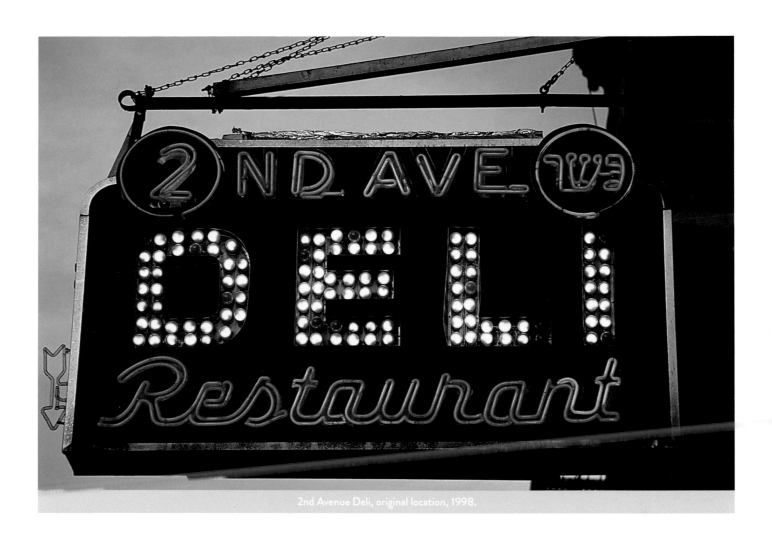

2nd Avenue Deli, original location, 1998.

PHOTO © DAN HELER, 1998

Yeshiva University's Stern College for Women," says Jack, "and close to hospitals with hungry doctors, nurses, families, and patients craving chicken soup."

Today, you walk into the 2nd Ave Deli and the mingled aromas of pastrami, corned beef, chopped liver, coleslaw, rugelach, and fresh rye bread transport you back to a New York City that now exists mostly in memory. The restaurant is open seven days a week, and only closes on Rosh Hashanah, Yom Kippur, and the eight days of Passover. You never have to ask for Russian dressing—mother's milk for generations of New York Jews—to go with your sandwich, because a glass container of it is always on the table along with a container of spicy mustard. You will inevitably order too much food, and you will probably finish it all because, well, how could you not?

You don't have to worry that the 2nd Avenue Deli may go the way of legendary New York eateries like Schrafft's and Horn & Hardart, because Jack's sons, Jeremy and Josh, are committed to keeping the restaurant alive (and, what's more, they own their building and have opened a second restaurant on the Upper East Side). One of their innovations is offering a free treat to all customers after their meals—a kosher egg cream (Bosco and seltzer, but no milk) served in a shot glass. No doubt Uncle Abe would approve. Sounding like Tevye in *Fiddler on the Roof*, Jack explains that the Lebewohls have a covenant with their customers to preserve the flavors of their forbearers and a cultural heritage. More than anything, the family is motivated by a single, eternal concept: Tradition!

BY DAN SHAW

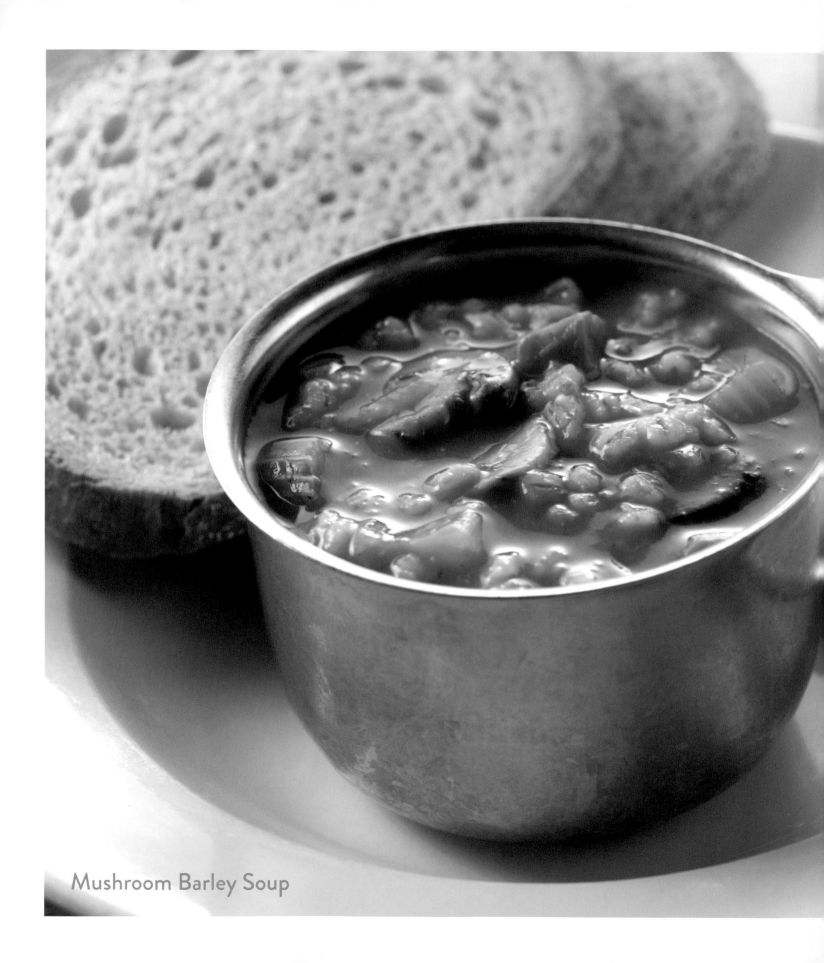

Mushroom Barley Soup

2ND AVE DELI MUSHROOM BARLEY SOUP

◆ ◆ ◆

½ pound barley

1 pound scrubbed, fresh mushrooms,
sliced into pieces ⅛-inch thick

5 large pieces dried mushroom
(preferably shiitakes)

3 cups chopped onion

1 cup celery, chopped into ½-inch pieces

¾ cup carrot, chopped into ½-inch pieces

½ cup parsnip, chopped into ¼-inch pieces

10 cups clear chicken soup or stock

3 tablespoons corn oil

2 tablespoons finely chopped or crushed fresh garlic

salt
(depending on how much salt is in the chicken stock you use;
if it's salty, you may not need any)

¼ teaspoon pepper

Place barley and chicken soup in a large stockpot. Bring to a boil, then reduce heat and simmer for 1 hour.

While the soup and barley are cooking, heat corn oil in a large skillet, and sauté onions on high heat for 5 minutes, stirring occasionally.

Add fresh mushrooms, and continue to sauté, stirring frequently, until everything is nicely browned. At the last minute, add garlic, and brown quickly.

With a slotted spoon, remove contents of skillet to a bowl, and set aside.

Meanwhile, soak dried mushrooms in hot water for 15 minutes to soften. Chop into ½-inch pieces, and set aside.

Add onion-mushroom mixture, dried mushrooms, carrots, celery, parsnips, salt (if needed), and pepper to the soup. Simmer for 1 hour and 15 minutes.

Why does man kill?
He kills for food.
And not only food:
frequently there must be
a beverage.

WOODY ALLEN

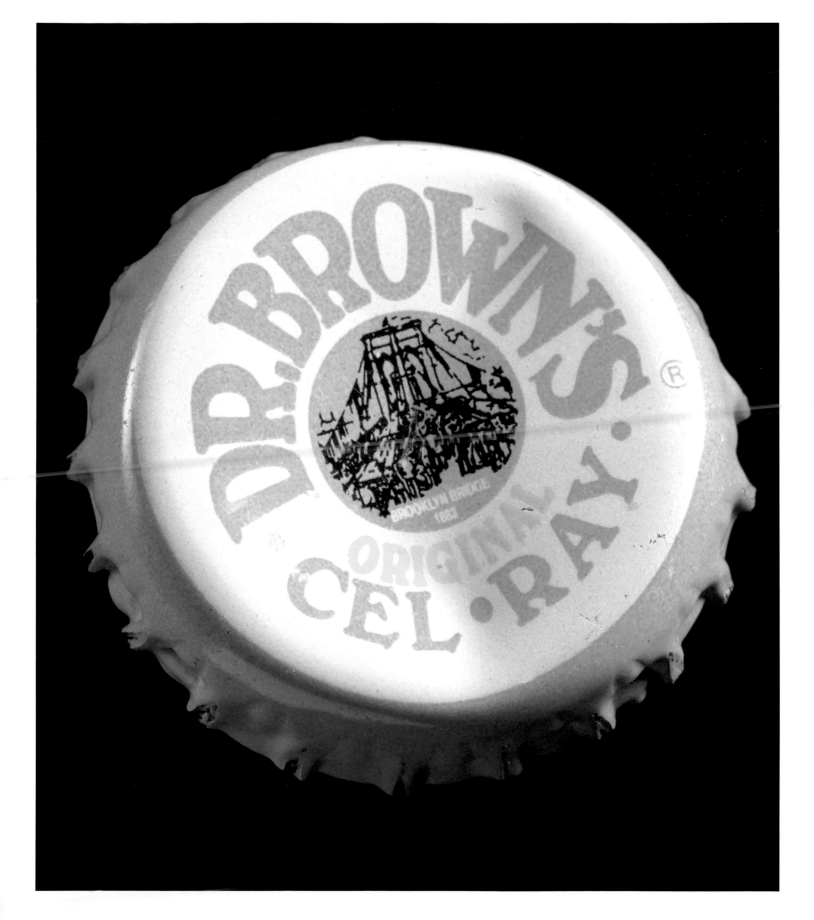

DR.BROWN'S® ORIGINAL CEL·RAY·

BROOKLYN BRIDGE
1883

Borscht

ARTHUR SCHWARTZ'S BORSCHT

Makes about 8 servings

Clear borscht, served very cold, is a great refreshment in the summer. My father would drink it straight from a jar in the refrigerator, downing it with the refrigerator door still open. I can still hear my mother yelling, "Close the refrigerator door, Larry," from the next room. Sometimes my mother would serve it in a soup bowl, with a big dollop of sour cream and a boiled potato.

3 pounds beets, washed, peeled, and halved

1 onion, coarsely chopped

10 cups water

⅓ cup lemon juice or ½ teaspoon sour salt

3 tablespoons white sugar

1 tablespoon salt

sour cream (optional)

boiled potato (optional)

In a 5-quart pot, combine the beet halves, onion, water, and salt. Bring to a boil, uncovered. Simmer briskly for 1 hour, or until the beets are very tender.

Remove the beets with a slotted spoon and cut them into julienne strips. Strain out the onion. Return the beets to the pot with the beet juice. Add lemon juice or sour salt, and the sugar. Return to a simmer and cook 30 minutes longer.

Taste for sugar and sour seasoning, adjusting to please your palate.

Chill very well. Serve cold in a glass or in a bowl with a spoon. If served in a bowl, you may add a boiled potato and a big dollop of sour cream. If served in a glass (or in a bowl), blend about 2 tablespoons of sour cream into every cup of borscht.

THE LAST BRISKET

As Abie lay in his bed, he contemplated his impending death. Suddenly smelling the aroma of roast brisket, his favorite food, wafting up the stairs, he gathers his remaining strength and lifts himself from the bed. Leaning against the wall, he slowly makes his way out of the bedroom, and with even greater effort, gripping the railing with both hands he crawls downstairs.

With labored breath, he leans against the door frame, and gazes into the kitchen. Were it not for death's agony, he would have thought himself already in Heaven. For there, on the kitchen table, was the biggest roast brisket he had ever seen.

He couldn't help thinking, was this already Heaven or was it one final act of love from his devoted wife of 65 years, Bessie, allowing him to leave this world happy man?

With one great final effort, he throws himself towards the table, landing on his knees in a crumpled posture. His parched lips parted, the wondrous taste of the succulent meat already in his mouth, seemingly brings him back to life. His aged and withered hand trembles as it grasps a carving knife laying next to the platter when it is suddenly smacked with a spatula by his wife.

"Don't touch that, Abe!" she shouts,

"THAT'S FOR THE SHIVA!"

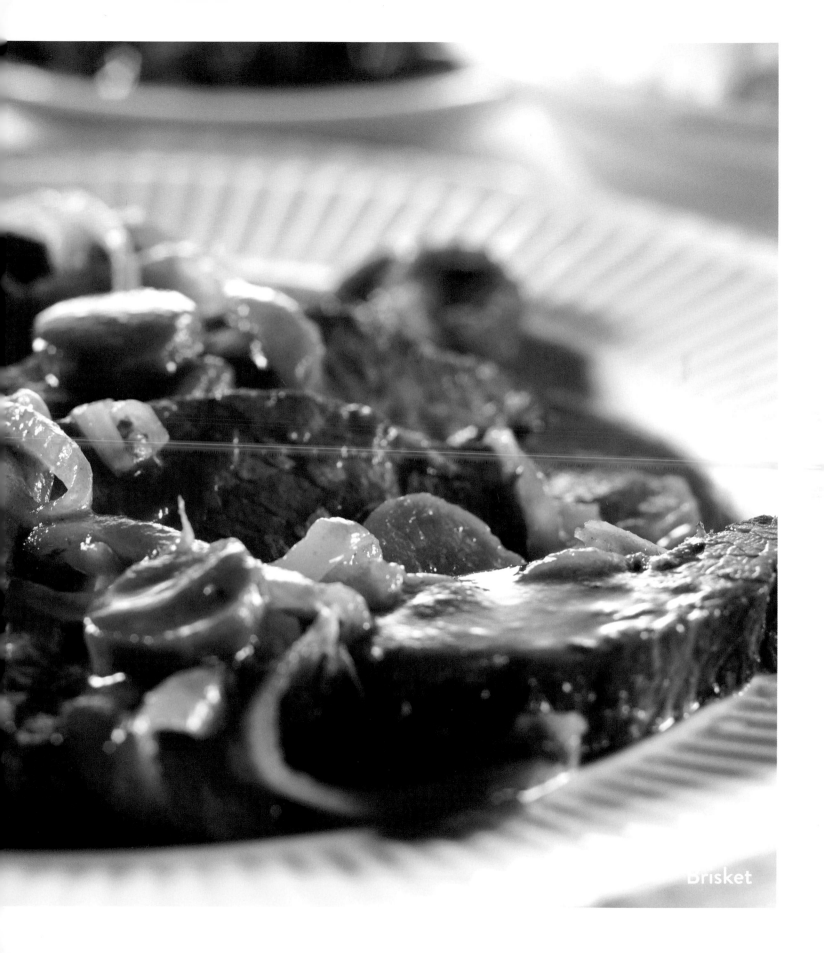

Brisket

MARILYN'S LEGACY

Some of my fondest memories growing up were helping my mother prepare for Passover. With my sister Toby by my side, we would begin our yearly ritual at the dining room table polishing the silverware. Next up was setting the table, making the matzo balls and brisket. To this day I continue to make her famous brisket and without fail, everyone who tastes it wants a copy of the recipe. On the days leading up to Passover I am bombarded by phone calls from my friends with questions on the finer details. Made with ketchup, a can of beer, onion soup mix, prunes, and golden raisins, my smile is that much bigger on Passover thinking about the families sitting down to enjoy my mother's brisket.

HELENE JACOBS FINE
Jewish mother

PASSOVER — APRIL 1960

1639 Carroll Street, Brooklyn. Apartment of Pearl and Josh Abelow. Guests Marilyn, Manny, Helene, Toby Jacobs, Joan, and (not pictured) Herb Abelow.

MARILYN'S BRISKET WITH PRUNES AND RAISINS

1 brisket of beef, about 4 pounds, lean and trimmed, sprinkled with salt, pepper, paprika, and garlic powder

6 medium carrots, peeled and cut in half, crosswise

6 small whole onions

6 ounces pitted prunes

½ cup yellow raisins

1 can (12 ounces) beer (any kind)

1 envelope onion soup mix

¼ cup brown sugar

3 tablespoons ketchup

In a heavy skillet, brown brisket on both sides. Remove and place in a 9 x 13-inch roasting pan. Arrange prunes, raisins, carrots, and onions around meat.

In a small mixing bowl, combine soup mix, sugar, ketchup, and beer. Stir to blend. Pour this over meat.

Cover pan tightly with foil and bake at 350 degrees for about 3 hours or until meat is fork tender. Allow to cool.

Place in refrigerator overnight. Skim congealed fat. Place meat on a cutting board and slice thin against the grain. Place back in the pan, cover with foil, heat oven to 350° F, and bake 30–60 minutes to reheat.

GETTING MY JEW ON

grew up in Riverdale, an upwardly mobile section of the Bronx. When you were a Jew and started to get some money you moved there or to Long Island. I suppose some folks went to Jersey, but since their driving was so bad we never saw them again. The neighborhood had a couple of decent deli's, a couple of good Jewish bakeries, and appetizing stores. Those were stores where you went to get lox, whitefish salad, herring, and other Jewish culinary delights. A good mushroom and barley soup, chopped liver, chicken in the pot, potato kugel. Yummy stuff. The place I liked had the first fruit leather I have ever seen, as well as marshmallows sandwiched between two dried apricots. There were about four bagel stores, God forbid you should run out. Also, you could get halvah from the giant wheel, cut with a wire, like cheese.

My mother was a pretty dreadful cook. The food that she would put out at dinner time was, in the words of my people, a shanda. Although I had no idea at the time that I would have a career in food, I was well aware that she—as Woody Allen describes in *Stardust Memories*—put the chicken and everything else in the deflavorizing machine. We had, on any given day, a scary half head of brownish iceberg lettuce, many bottles of no-cal soda, a few squares of that bizarre cheese in the little foil packages, and frozen TV dinners. Ouch.

Dinner during the week was always the same; a meatloaf that smelled just like the dog's Ken-L Ration, shoulder lamb chops baked beyond recognition, filet of sole rolled around canned spinach, and the dreaded pot roast. The pot roast was possibly the worst thing I have ever eaten. It was hard, impossible to slice, had no flavor, and it was big, so it made repeat appearances on "leftover" nights. The potatoes and carrots that went with it were canned. Honestly, until I went to college, I don't think I had any contact in my home with a fresh vegetable.

Every dinner party had the same two hors d'oeuvres. Those tiny little "cheese" squares and my mother's signature offering.

It started with a Ritz cracker. On top of that cracker was a circle of bologna, cut into shape with a shot glass. That was topped with a circle of American cheese. On top of that, to gild the lily so to speak, was ketchup. Under the broiler it went, and when the cheese looked a bit melted, it went on a tray and was forced on terrified guests.

Not everyone likes to cook, and my mother hated it. She was a terrific woman; a teacher of both 5th grade and Spanish, she had a decent sense of humor and she was

> My mother was a pretty dreadful cook. The food that she would put out at dinnertime was, in the words of my people, a shanda.

smart. Cooking was not her thing, and that's okay.

Looking back, my love of good food blossomed at the homes of friends. Upstairs in my apartment building, my friend Cheryl's mom made things like leg of lamb with asparagus and real whipped potatoes. My friend Beth's mom made amazing corned beef and cabbage. Even my friend's crazy trampy mother made the most amazing stews and roasts. I was the person who could not wait to get back to college to have good food again!

But the best place to eat, from when I was about five to fifteen, was at my friend Marcy's house. Marcy lived in the building next door and her mom Gert was a terrific home cook. Nothing fancy, just wholesome flavorful food. Gert made the most wonderful side dishes, with fresh vegetables, and she baked cakes that were better than from a bakery. You could smell the food as soon as you got off the elevator, sometimes even in the lobby. I loved it there; it was a refuge for me.

LAURIE WOLF
Author, *The Portland, Oregon Chef's Table*

ROYAL CHINA

Florence called my mother and practically begged her and my father to come for dinner. "Quick, Edna," she said. They just bought a new set of dishes and wanted to "break them in." "Very special plates," she explained.

So they went to the fancy 15th floor to Florence and Charlie's apartment. They could see the dining room table was set for four. Their sterling from England glistened, on folded linen napkins from Portugal. Florence always told the countries of origin to my parents when she made a new purchase—as if it made any difference to them.

But there it was: the fancy apartment in the fancy building, the fancy table with silver and linen, and on the table—SPARKLING, EXQUISITE, BEAUTIFUL blue and white dinner service, from Denmark.

"These are the same dishes the Queen of England has," Florence told my mother. Edna thought, "I'd be more impressed if the Queen of England told her friends she has the same dishes as Florence Trilling in Chicago."

Anyway, Florence started plating out boxes of food from Ashkenaz, a famous Romanian-Jewish restaurant in the neighborhood.

When they finished my mother said, "Flora, let me help with the dishes." "Oh no!" she blurted. "I don't want anyone to touch these dishes. We have a middle-aged couple that does them."

The evening progressed nicely, with canasta, coffee with coffee cake—not served on royal-wear. But my mother couldn't let go of what Florence had said about a middle-aged couple coming in to do the dishes. It just wouldn't leave her mind. As my parents were leaving, Edna pulled Florence aside, "You have a couple come in in the middle of the night to wash your dishes? That's incredible! Who are they? How did you find them?"

"We found them here. They're here all the time, me and Charlie."

RAYMOND L. LEVIN
Art dealer

THE LAST CHALUSHKA

My grandmother could cook. Sylvia Lutvak, my dad's mom, was famous in the Bronx and Queens, and probably well into Connecticut for her chicken soup. Her kreplach were like no other. Her chopped liver was nonpareil. But nothing, absolutely nothing could beat her chalushkas.

And among her remarkable skills was that you could put her in any kitchen, stocked in any which way, and the food would end up tasting exactly the same. She could be at our house on Long Island, and without any special preparation, her vegetable soup tasted like the vegetable soup she made on Pelham Parkway in the Bronx. Or at Aunt Harriet's house in Brooklyn, her kasha varnishkes tasted just like they always would. The miracle of Nanny.

But for me, Nanny's stuffed cabbage was a thing of beauty. Meat and rice wrapped in cabbage. But there was something about the sauce. . .a simple brown sauce, sweet, under the tang of the cabbage. Layers of flavor to make a grown man weep.

Once, she gave an entire dinner's worth of chalushkas to my brother, who froze them (he was in college at the time) and he would constantly brag that he still had more to go. And I was jealous like I'd never been. Then he was boasting that there was only one left.

And then she died. Not suddenly, exactly, but it came swiftly, and while we all had time to say good-bye to her, my brother Larry couldn't bear to defrost what we believed was her last chalushka. Only then, with the last frozen chalushka defrosted, would she really be gone.

Larry moved over the next twenty years, probably five or six times, and that frozen chalushka always went with him, from freezer to freezer. Finally, he had to dispose of it. He said, when I called him to say I'd be writing this piece, that he knew that she would have been horrified by the freezer burn, if nothing else.

STEVEN LUTVAK
Broadway composer, *A Gentleman's Guide to Love & Murder*

DELANCEY STREET OR SCHIFF BOULEVARD?

Thirty-something years ago, I contributed the restaurant reviews to a new kind of guidebook, supposedly the first to be organized by neighborhood, street by street, with detailed, color-coded maps, which were to be the most revolutionary part of all. Or so said the guide's creator and publisher, the legendary graphic designer Richard Saul Wurman.

My job, along with all the other writers and critics, was to pinpoint and number our entries on maps of the streets, which were to be provided by the Access offices in Los Angeles. Professionals all, the New York City writers reviewed the maps. It took only a few days for all of us to call LA to find out why Delancey Street was labeled Schiff Boulevard.

Jacob Henry Schiff was born in Germany into a promi-

Arthur Schwartz, age three.

nent banking family. He emigrated to the U.S. just after the Civil War and increased his family's fortunes many fold on Wall Street and in business, eventually becoming the foremost Jewish leader of his day. Indeed, the years 1880 to 1920, the year Schiff died, used to be called "the Schiff period" of American-Jewish history. Not only was he a great philanthropist and the patriarch of one of the city's premier German-Jewish families, he was also vocal about the atrocities of Tsarist Russia against the Jews, and was an early supporter of Zionism. He supported the educa-

tion and assimilation of the Eastern European immigrants who came later at the end of the 19th century and into the early 20th, the people who settled into the tenements of the Lower East Side. One of his beneficiaries was the Henry Street Settlement, a social service agency that continues to provide services to New Yorkers—now of every race and religion. (By the way, his granddaughter, Dorothy Schiff, was the owner and publisher of the *New York Post* from 1942 to 1976.)

Clearly, Jacob Schiff is worthy of a street name. But, when Access was being written, Schiff Boulevard was merely one of the many honorary street names New York City bestows on citizens of note, including policemen and firefighters who have heroically lost their lives on the job. No one on the Access New York writing team had ever heard of Schiff Boulevard. It was, after all, indicated by only one tiny street sign on the traffic median of what is really Delancey Street. I went downtown to see it for myself.

So what was up with Schiff Boulevard on our maps? Seems the Los Angeles designers copied a map that used "Schiff Boulevard" as the preferred name for Delancey Street as an intentional error, to catch copyright infringement. Our maps were quickly changed.

To the city's betterment, Schiff Boulevard is now Schiff Mall, a much more befitting honor to the man. The "mall" is the planted median strip that separates east and west flowing traffic along Delancey from the Bowery to the Williamsburg Bridge. Does it make Delancey fancy again, as it was when Lorenz Hart wrote the famous lyric? Not really, but as part of New York City's Greenstreets program, Delancey Street now has leafy trees, tulips and daffodils that bloom in the spring, roses that flower in the summer, and evergreens all year. Thank you, Mr. Schiff.

ARTHUR SCHWARTZ
"Walking Google of Food Information;"
food editor & critic; radio commentator;
cooking school founder (Paestum, Italy);
author of seven cookbooks

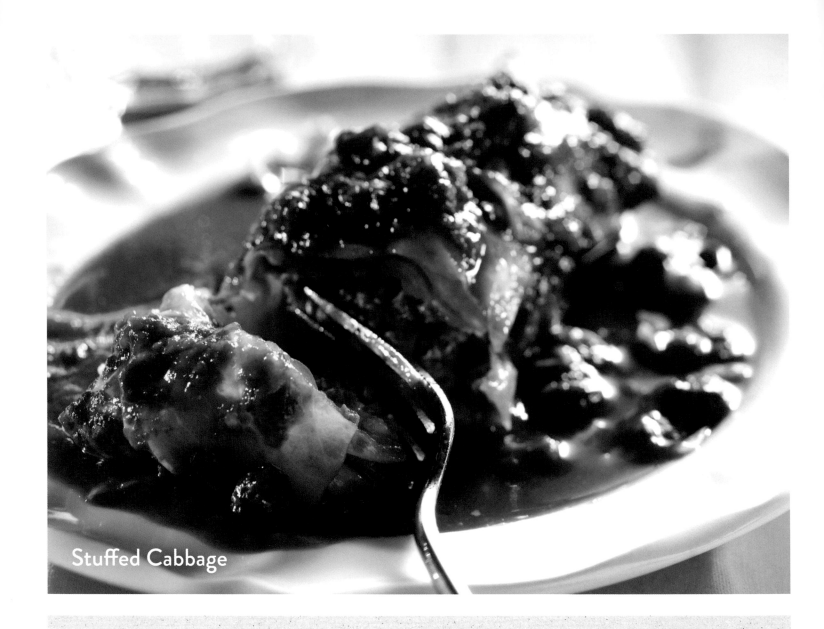

Stuffed Cabbage

The food is cooked in a POT
and the PLATE gets the honor

◆◆◆

You can call them holishkes, or holipchess, or halubchas, golubtzes, or prakkes. It's stuffed cabbage all the same, one of the most beloved dishes in the whole Jewish-American repertoire, made from Germany and eastward through Poland, Ukraine, and Belarus, south to Hungary and Austria. However, the idea of stuffing a cabbage leaf most likely comes from the Ottomans, who, after all, controlled parts of Eastern Europe for a couple of centuries. At any rate, most stuffed cabbage today is made with a sweet and sour tomato sauce, with or without raisins or other dried fruit, which is the taste from the Pale. Hungarian, Czech, Slovak, and Romanian cooks, on the other hand, usually keep the tomato sauce strictly savory, sometimes with a touch of sour from sauerkraut. German Jews often make brown gravy. Ginger snaps, which season as well as thicken the gravy, are an American addition, but the taste of ginger is from the old country.

1 4-to-5-pound head green cabbage

MEAT FILLING

2 pounds ground chuck or ground neck and tenderloin

2 eggs, beaten together

⅓ cup long-grain rice, parboiled for 3 minutes

1 cup fresh bread crumbs from challah
or 2 slices quality supermarket white bread (with crusts),
processed into crumbs in a blender or food processor

1 6-ounce onion, grated on the coarse side of a box grater

2 ¼ teaspoons salt

½ teaspoon freshly ground pepper

SAUCE

1 28-ounce can imported Italian tomato puree

1 medium onion, finely minced

⅓ cup dark raisins

2 tablespoons vegetable oil

⅓–½ cup dark brown sugar

¾–1 teaspoon sour salt (citric acid crystals),
or the juice of 1½–2 lemons

1 teaspoon salt

6 ginger snaps, soaked in ½ cup water (optional)

To blanch the cabbage, select a pot that will hold the whole head of cabbage almost submerged in water. Fill halfway with water and bring it to a rolling boil.

Meanwhile, with a small sharp knife, cut the core out of the cabbage. When the water is boiling, put the cabbage in the water. Using a two-tined kitchen fork, hold the cabbage in one hand and with the other peel off the outside leaf. Return the head to the water for another few seconds, and remove the next loose leaf. Continue until the leaves become too small to easily stuff. You should have 12 to 15 leaves that are big enough to use.

Shred the remaining cabbage and make a layer of it on the bottom of a large, wide casserole pan that will hold the cabbage rolls in one layer.

Cut the white central rib out of each cabbage leaf.

To make the meat filling, in a large bowl, add all the ingredients together and mix very well.

Use ¼ to ⅓ cup of meat mixture for each leaf, depending on the size of the leaf. Place the meat along the uncut green end of the leaf, shaping it into a thick oblong patty. Roll the meat in the leaf, tucking in the sides of the leaf to completely enclose it. If you have a little extra leaf, cut it off. Place the stuffed leaves, seam-side down, packed fairly tightly, on top of the shredded cabbage.

To prepare the sauce, in a small saucepan, heat the oil over medium heat and sauté the onion until beginning to brown, about 10 minutes. Add the tomato puree, brown sugar, sour salt, salt, and raisins. Bring to a simmer and simmer 5 minutes.

Pour on the prepared sauce. Shake the casserole to encourage the sauce to seep to the bottom. Cover with foil if using a roasting pan or lasagna pan or baking dish.

Preheat the oven to 325° F. Bake for about 2 hours. If using the ginger snaps, after about an hour of cooking, spoon some of the sauce out of the baking pan and blend with the soaked snaps. Add enough pan sauce to make the ginger mixture liquid enough to blend easily into the remaining pan sauce. Shake the pan to blend.

Serve hot. Stuffed cabbage reheats beautifully. Some would say it improves.

SWEET FAMILY TIES

When I started Erica's Rugelach & Baking, Co., it was with little more than a taste memory of my beloved great-aunt Pearl's buttery hand rolled rugelach. Wild blueberries and raspberries grew around her Catskills bungalow during the summer and we'd go on a picking parade. On those days she'd cook up a storm—roast chicken, chopped liver, cholent, stuffed cabbage and derma, blintzes, blueberry pies, and her version of rugelach from leftover pie dough. It could be 98 degrees in that kitchen. She'd still bake and hand roll little triangles of delicate dough with jam, nuts, raisins, and fragrant cinnamon to the wonder of Jascha Heifetz soaring through the Beethoven Violin Concerto.

It was 1969, I was 11, dying to go to the Woodstock Festival with my uncle Irv. My mother pulled the plug on that unlived adventure, so instead I got to hang with my great-aunt Pearl. When I'd roll a good crescent rugelach, she'd smile and say, "Shayna punim."

Ultimately, I studied classical guitar and voice and in 1981 graduated from Queens College. I made a B-line for Brooklyn and for the next eight years, taught music, wrote, waitressed, and sometimes performed at weddings where I sang my best Barbra Streisand version of "Evergreen." Invariably, there was a chopped liver swan centerpiece. I don't know what came first, my passion for food or music—the two always seem to go together.

Fed up with the life of a freelance musician, I began Erica's Rugelach & Baking, Co. in 1989, with a fierce determination to eclipse every rugelach already out there and create the quintessential New York rugelach. It's 25 years since I hired my first employee, when we rolled test batches to Pink Floyd's *Dark Side of the Moon*. I wonder what great-aunt Pearl would say?

ERICA KALICK
Owner, Erica's Rugelach & Baking, Co.

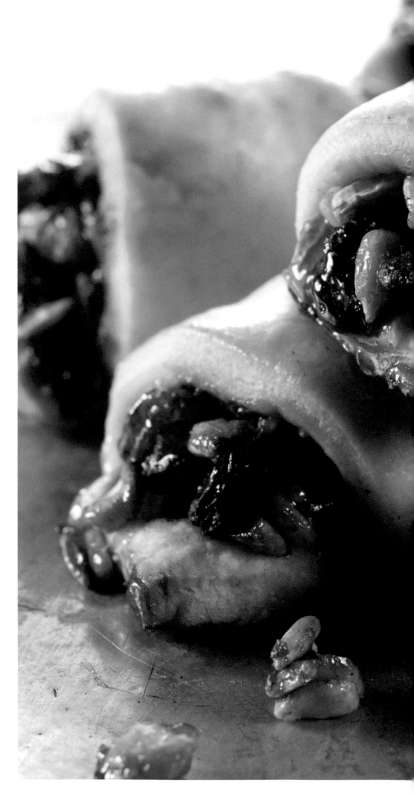

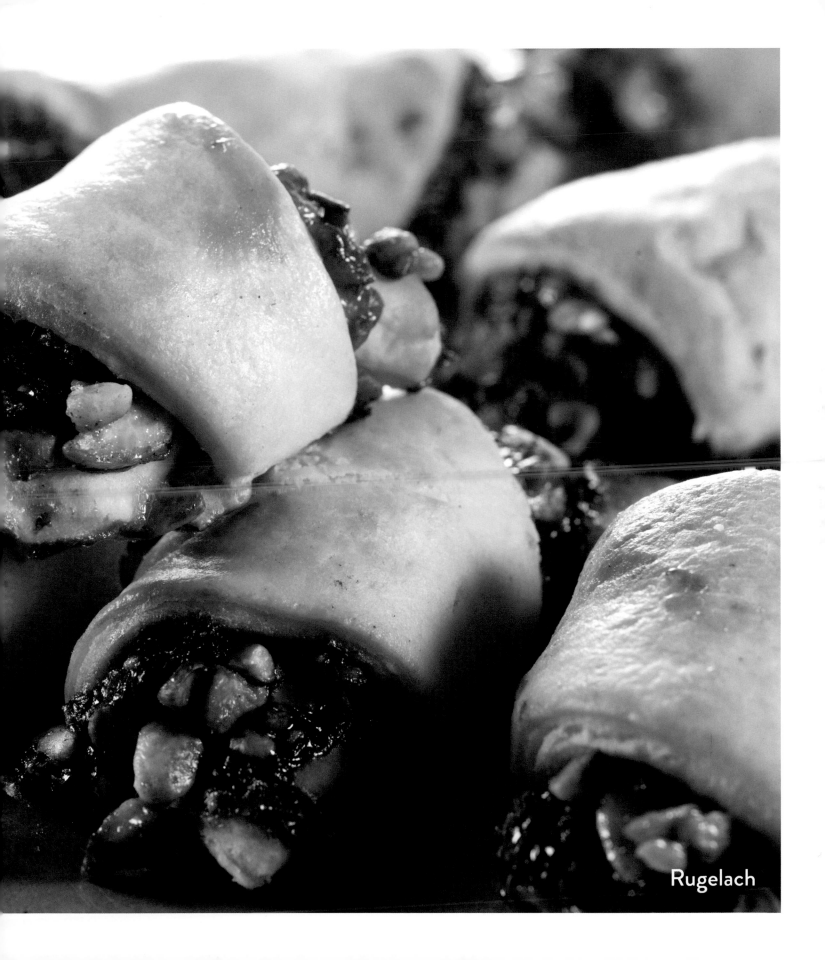

Rugelach

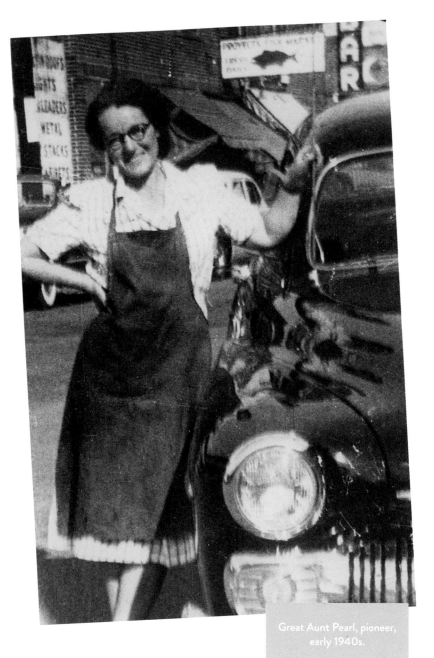

Great Aunt Pearl, pioneer, early 1940s.

AUNT PEARL'S INSPIRED OLD-FASHIONED RUGELACH RECIPE

◆ ◆ ◆

INGREDIENTS

2 cups flour

1 cup unsalted butter

8 ounces cream cheese

½ cup raisins

½ cup chopped walnuts
(any good quality nut will work)

⅓ cup sugar

1 tablespoon cinnamon

fruit preserves to taste
(optional chocolate chips to taste)

Combine flour, butter, and cream cheese. Mix well; form into 4 balls. Wrap each ball of dough in parchment paper or saran wrap. Refrigerate overnight.

Combine, sugar, cinnamon, raisins, and walnuts for the filling. On a marble pastry slab (cooled) roll out each ball into a circle ¼ inch thick and about 12 inches in diameter. If making a fruit version, spread jam over the rolled out circle. Then sprinkle with filling. Cut each round into 16 wedges (or 8 wedges if you prefer a larger rugelach) and roll into crescent shapes.

Bake in a 375° F oven for 15–20 minutes.

FROM DAIRY TO DELI & ALL THE DELICIOUS DELIGHTS IN BETWEEN

Alan Katz with his father Jerry, The Granit Hotel, Catskills, New York, 1965.

was born and lived for the first part of my life in Brooklyn (then Long Island, Spring Valley, Fort Lee, and the UWS—never far from a decent deli). My family kept kosher and I never saw my grandparents (Russian immigrants) eat a non-kosher ANYTHING during my entire life.

If we went out to eat with them, it was for deli.

My grandfather ran a small Credit Union on the LES, steps from Delancey Street, Guss's Pickles, Ratner's, and Economy Candy. They were all regular stops on my hit parade.

His organization held its annual meeting at Ratner's and I'll never forget the little white monkey dish/bowls placed on every long table that we would now fill with M&M's or mixed nuts for snacking. . . but not these tables. In the 60s, they were filled with arbes (warm chick peas), which my father would promptly shower with pepper and proceed to devour as we would so many peanut M&M's or Swedish Fish today.

When we did go "out" for deli, my grandfather would order the corned beef plate. Not a sandwich, a plate, with bread on the side. He would take out a tiny manila envelope and slide out one medium sized pink pill, "for the fets (fats)," he would say. While I never saw him have any other kind of alcoholic drink, this meal was always washed down with a bottle of Miller High Life.

While I now eat almost everything sold at a Deli, my early years consisted of either a hot dog or a salami sandwich, both topped with a blasphemous squirt of ketchup. Years later I learned the joys of mustard and felt so grown up.

Those years consisted of learning the proper way to slice any and every cut of meat (including tongue), cheese (a nice piece farmer's cheese), and to serve/make a proper mayo based potato or cole slaw salad at *the* deli of supermarket delis, Waldbaum's of Hillcrest, in Spring Valley, New York.

And now I will digress to one of my favorite treats sold at delis and the famed Economy Candy (where my father would go and stock up after the meetings, a wonderland of every "candy store" brand sold in bulk and at actual size!) the Joyva chocolate covered delights. Sure there was, and is, my mother's favorite, halvah, but for a young tyke it was all about the chocolate covered grahams, the chocolate covered jelly grahams, and the no longer available. . . chocolate covered wafer cookie.

They were kept behind the counter at most delis, in huge square boxes stacked and separated by a black, shiny, thin cardboard divider. They were sold by the pound and were never a given. It was a treat that good behavior and finishing my lunch or dinner earned.

Don't get me started on what that cookie was like with a nice cold egg cream (another day, another story about Dave's—did I mention for my 25th surprise birthday party Juan, the egg cream maker, brought the famed syrup and catered the party?), or my sister's love for the Charlotte Russe, with the yellow sponge cake bottom, sweet whipped cream piled high, and corralled by a white cardboard collar, with a glistening cherry on top.

Sure, you can still find the Joyva Jell Ring (and sometimes the Jell Rectangle), the plain and cherry Marshmallow Twist, but that elusive creamy/crunchy choco covered wafer cookie? Like the chance of finding a good deli outside the chosen few? History.

So, thanks Katz's (no relation), Epstein's, Cresthill, Ben's, 2nd Ave, and Waldbaum's. . .to name a few, it's been an adventure.

ALAN KATZ
CMO, DuJour Media Group
Former publisher *New York* magazine, *Cargo, Vanity Fair, Interview*

EGG CREAM

When I was a young man, no bigger than this
a chocolate egg cream was not to be missed
Some U-Bet's Chocolate Syrup, seltzer water mixed with milk
you stir it up into a heady fro, tasted just like silk
Egg Cream
You scream, I steam, we all want egg cream
You scream, I steam, we all want egg cream

Now you can go to Junior's, Dave's on Canal Street
and I think there's Ken's in Boston
there must be something in LA
But Becky's on Kings Highway, was the egg cream of choice
and if you don't believe me, go ask any of the boys

You scream, I steam, we all want egg cream
You scream, I steam, we all want egg cream

The only good thing I have to say about P.S. 92
was the egg cream served at Becky's, it was a fearsome brew
For 50 cents you got a shot, choco bubbles up your nose
that made it easier to deal with knife fights
and kids pissing in the street

You scream, I steam, we all want egg cream
You scream, I steam, we all want egg cream

So the next time you're in Brooklyn, please say hello for me
at Totonno's for Pizza and ice cream at Al and Shirley's
But mostly you go to Becky's, sit in a booth and say hello
and have two chocolate egg cream, one to stay and one to go

You scream, I steam, we all want egg cream, ah
You scream, I steam, we all want egg cream
You scream, I steam, we all want egg cream

LOU REED

KATZ'S DELI EGG CREAM

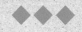

Jake Dell, owner

Alright, so the perfect Katz's egg cream is really simple. The oldest recipe in the book for egg creams is a little Fox's U-Bet chocolate syrup—although if you're kinda a chocolate wuss you can use a little vanilla syrup instead, but let's be honest, chocolate egg creams are infinitely better in my humble opinion—fill that up about an inch or so. Put an equal amount of milk in there. Top it off with a little bit of seltzer and as you're pouring the seltzer you stir vigorously and that'll get you the nice head on top. Voilà you have the perfect egg cream.

Chocolate Egg Cream

BUBBE AND A BISSEL

My Bubbe Esther made the best cookies! My Aunt Francine so wanted the recipe but Bubbe never wrote anything down—for a good reason; she didn't know how! She was Russian. She couldn't read or write Yiddish or English but could speak both fluently. I recall when she didn't want me to understand something she would speak to my father, her son-in-law, in Yiddish, I got conditioned to think that "Jewish" was something "naughty."

In shul, she knew all the prayers but couldn't read a lick of it. She could sign her name but I am surprised (now) that she never bothered to learn how to read or write. She shopped, cooked, sewed, and cleaned all day as I recall. She called anybody who was funny, "Charlie Chaplin" and she referred to the Three Stooges as the Three Meshuggahs.

One day my Aunt Francine (my mother's sister) decided to get the recipe for her sugar cookies. These were thick as I recall, and round. They were kinda yellowish on the outside and kinda white on the inside. So as my Bubbe is putting this together, my Aunt has paper, pen, various spoons, and measuring cups.

Bubbe cooked with her hands: a pinch of this, a fist of that, etc. My Aunt would then put the same amount in Bubbe's hands or fingers and then dump it into a spoon or measuring cup so she could list it. Bubbe worked fast and her daughter causing her to repeat her actions didn't slow her down.

Finally, it was all in the bowl. My Aunt, exhausted, checked what she wrote while my Bubbe started adding things! "Ma, what did you add?! I need to add it to the recipe." And she said, "A bissel of this, a pinch of that. . ." It hadn't looked just right to her so her eyes told her what to add. My Aunt never got it right. . . but I'll always remember eating those cookies in her kitchen on Friday nights. Delicious memories. . .

BOB GREENBERG
Comedian; actor; friar

A SWEET TASTING VIOLIN

My enduring love for rich, delicious tasting desserts started in childhood. I developed a sweet tooth when I first moved to the United States to study at Juilliard. I wasn't aware of fountain drinks or even assorted fresh pastries while I was growing up in Israel. Something as common as ice cream was so rare back then that it was only served on special occasions.

In Israel, my family didn't go out to eat. For dessert, my mother used to bake a two-layer cake with yellow cake, chocolate butter cream filling, and chocolate butter cream frosting on top—it was delicious.

My mother's cake was probably the reason why I wandered into Cake Masters on the Upper West Side. Cake Masters made cakes for Liberace, President Kennedy, and Elizabeth Taylor and was known by its slogan, "where baking is an art."

Cake Masters made the best seven-layer cake that I ever had. It tasted just like my mother's! Their seven-layer cake was layers upon layers of yellow cake and butter cream frosting. Each layer had a nice soft texture and wonderful taste. I still remember how they used to sell it by the slice with each slice separated by wax paper. Cake Masters was close to my parents' home so I would stop by again and again and again. (Coincidentally, many years later I found out that my wife, Toby, who also lived on the Upper West Side loved their seven-layer cake too!!)

We didn't have soda fountains back in Israel either. I remember going to my first soda fountain on the Upper West Side. I quickly fell in love with milkshakes: chocolate malteds and chocolate frosteds.

Years later my sweet tooth made the headlines! Nestlé presented me with a violin made out of Kit Kat bars after I hosted the PBS concert series, "In Performance at the White House" with First Lady Nancy Reagan. I'm telling you, it was the most delicious tasting violin that I ever ate!!

ITZHAK PERLMAN
Violinist; conductor

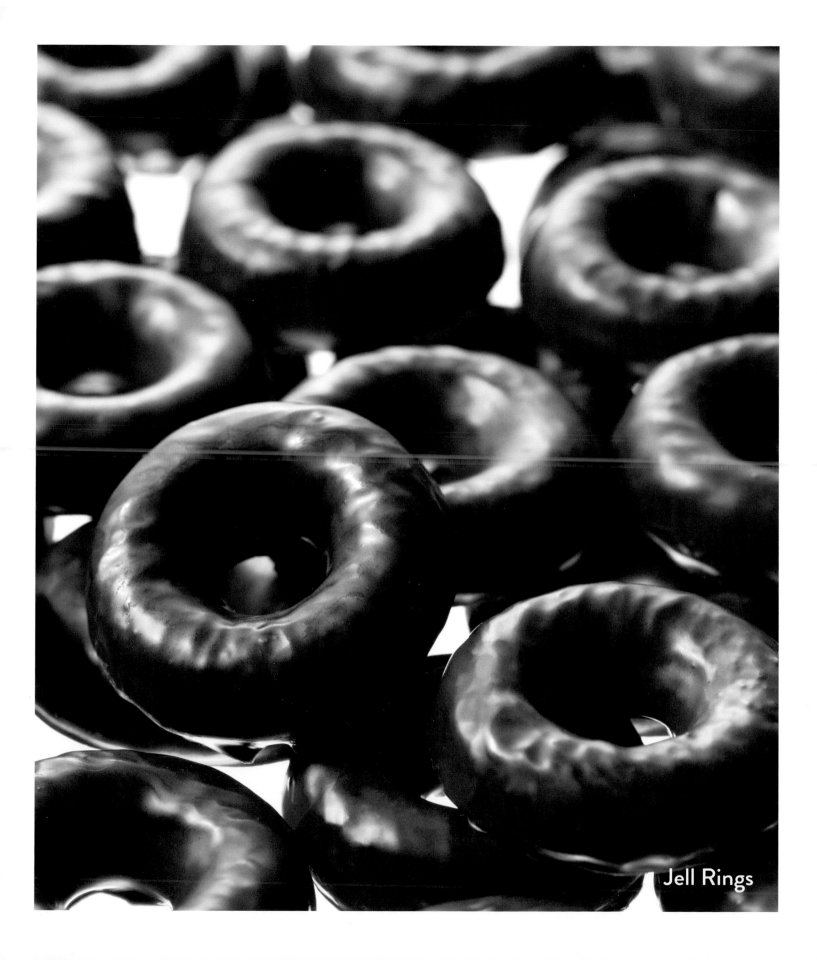

Jell Rings

Nik-L-Nip

A man is walking down the hall of a hotel.

He hears a Jewish woman

in one of the rooms, moaning,

"Oy, am I thirsty, oy am I thirsty!"

He forces the door open,

and sees the woman.

lying on the bed in a near faint.

He makes repeated trips

to the bathroom

bringing her cups of water.

At last, she revives and thanks him.

He leaves, closing the door behind him.

As he continues down the hall,

he suddenly hears the woman, again.

"Oy, oy, oy!"

He runs back to the room, forces the

door, and says to her,

"Are you OK?"

To which the woman replies,

"Oy, was I thirsty!"

Economy Candy

You know the scene from *The Wizard of Oz*, where the house crash-lands from the cyclone? It's filmed in sepia tone. When everything is still, Dorothy gets up and wanders to the house door, slowly opens it—and—she sees Munchkinville in Oz. The movie turns into color; technicolor colors so dazzling they outdo nature—a magic place of color and delight. That's what it's like opening the door of Economy Candy. It's dazzling!

I only know the Lower East Side of my parents' and grandparents' day through those ubiquitous vintage black-and-white photographs. Though now fashionable and galleryized, the Lower East Side is still black-and-white, sepia at best, but not Economy Candy.

Also—DO NOT get into a "remember the (insert candy name here) contest" with Jerry Cohen owner of Economy. Milk Duds? Got 'em. Mason Dots? Got 'em. And Juju bees, and Sen Sen and Blackjack gum, and all varieties of Bonomo Turkish Taffy (that's BON-o-mo, not Bo-NAMO). Pez, remember Pez? Rock candy, sugared fruit slices, Jordan almonds of every imaginable and UN-imaginable hue—even purple. The visit is a trip. The candy—better!

Jordan Schaps: Tell me about Economy Candy. How?

Jerry Cohen: Back when the days of pushcarts and wagons used to roll in the streets, my father used to be outside peddling the candy in the snow, in the rain—and torrential rains we used to have. We started back in 1937, our wagons outside in the streets on the corner of Essex and Rivington. It would take us about an hour and a half just to set up the store and milk boxes and crates and wood, setting up everything, putting out our nickel Hershey Bars, six for a quarter and the rings of string figs for 39¢. . . I mean everything that was around was in my father's store on the corner. Back then there was no Costco, there was no Walmart, there was no Target. You came down to the Lower East Side to do your shopping and you came early in the morning and you left late at night and you went home loaded. Then, as it progressed, I was born in 1954, and he needed more help. So we've been in the store since then. I traveled along. I did my thing, running around until I was 19 and my father said, "You're a bum. You're not doing anything. It's time for you to get back into the business and let's work." And I've been here since, and I'm going on 60. I taught my son the business, which is good. My son just took over the business too, so we're in the third generation, still going strong. Still the same old merchandise. Still the same old customers, but it's wonderful and we're happy and the customers are happy.

JS: Why candy? Why did your father pick that?

JC: In the olden times, candy stores were the easiest things to open. There were eight candy stores down here, maybe ten, at the time. There was one on every corner because it was easy to open. It was easy to do and you just did it. You put out the stuff and it sold. Everyone wanted candy. Believe it or not, there was enough business for everybody. Nobody stepped on each other's feet. Everybody worked together. It was nice.

JS: There's something about being in the candy business, it's a happy business.

JC: People ask me when they come here, what do we sell? I sell happiness.

JS: Why is candy an essential part of the whole Jewish gestalt?

JC: From what I remember, as Jews growing up, we always had it rough. It was really rough for us. It was rough being a Jew. What do you need? You need candy. You need sweets to help you along in life. A little piece of butterscotch candy, the root beer barrels, anything that would make our lives a little bit sweeter. Hamantaschen, that we had. Sweet candy. Jelly apples. Anything to do with sweets. It's the Jewish heritage.

JS: Has anyone asked you for a candy that you didn't know of, or have?

JC: No. Growing up in the business since birth, I know every candy. I have so many cavities, it's just. . . I've had everything. Every Monday was great, because all of the salesmen would come down. They would bring down all the new candies that they had. Hershey or Nestlé or Cadbury would come down to us and say, "Hey Moishe," my father's name, "what do you think of this?" "That's a piece of garbage!" He would tell them exactly what to do, how to refine it and bring it to market. They would bring him some test candies and we'd try them out on the Lower East >

Side. Before Hershey was Hershey, a multimillion-dollar company, they were small. They needed the vendors like us. We had what the customers wanted. They had to come to stores like ours to sell their goods. They needed the input also. They needed the old time knowledge of the interaction with customers face-to-face. The best way was on the Lower East Side where everybody expresses their opinions.

JS: No secrets.

JC: No secrets down here. New York is New York.

JS: What's the oldest candy you have?

JC: Sometimes a very bad salesman would come in. You know, they would say how come you still have my candy? I would say, you're a bad buyer. We used to have so much of that candy we bought. . . It was about 60 years ago and it's still downstairs. The oldest candies are Mary Janes, Tootsie Rolls.

JS: About how far back do they go?

JC: About 1909, 1910, when they first started. Tootsie Roll was the first and Mary Janes, the old sour balls. They're the old type of candy.

JS: What's the newest?

JC: The newest are Sour Patch Kids; all of the take-offs of the games, Hello Kitty and Mario.

JS: That evolves into a candy?

JC: Any cartoon character can become a new candy.

JS: Is there such a thing as candy fashions or candy trends?

JC: Everything now is people making their weddings and Bar Mitzvahs color coordinated, so what's coming out now are single colored M&M's, single colored Jelly Bellys and all this and it's wonderful for me, I love it. When they come in it's a beautiful sale and we have the largest selection in Manhattan of all the single colored candies. They come in with their vases, and we help them and guide them along. They say thank you because we're saving them so much money instead of hiring a specialist.

JS: Who picked the name Economy?

JC: We never found out. My father doesn't remember, even though he's 97, he doesn't remember. He's still alive.

JS: No kidding. Mr. Economy.

JC: Mr. Economy. Still alive.

JS: What's your favorite candy?

JC: I don't stop eating candy. I love candy. I love my Hershey Good Bars. I was just away for two months down in Florida. The minute I came back in, I had to have my hamantaschen, I had to have my chocolate covered macaroon, and I had to have my graham cracker, the Good Bars, I mean I haven't stopped eating. It's quality control. I make sure everything is fresh.

JS: It's a responsibility?

JC: It's my responsibility.

JS: You do a lot of shipping also.

JC: Well, a lot of our customers moved out. They're not in the neighborhood anymore. And they still want to have it, because they know it's fresh. They know the quality is there and they love us. They want to keep our store going and we ship everywhere. We ship all over the country and even to Venezuela; we do Bar Mitzvahs and things like that.

JS: Where's the farthest in the world that you've ever sent to?

JC: Australia.

JS: Tell me a great story. Who's your favorite customer?

JC: There are great stories, but I don't remember them. We have a lot of people that come in, we have actors and we leave them be. They come in with their kids and they don't want to be recognized. The late Philip Seymour Hoffman, he was in here with his kids. Mary Kate Olsen. Everybody comes in. The only one I did get mad at was a comedian who came in here. I can't think of his name. From Canada. He came in with his hockey stick. I was telling him my jokes and he wouldn't laugh at me. So I threw him out. His name just baffled me for a minute—Mike Meyers.

JS: I never liked him.

JC: He's all right. He came in and I was telling him some good jokes and he wouldn't laugh, and I said, you know what, you better leave.

JS: He left?

JC: He loosened up a lot.

JS: What's with the hockey stick?

JC: He's from Canada. He wanted me to notice, so he came in with a hockey stick and a red jumpsuit.

JS: What's the worst thing that happens?

JC: When I catch people stealing. When I catch kids stealing and people that are well-to-do. And they say, "You can afford it. You're busy." And it just bothers me, because you know I'm working hard and it's a family business. I tell them to take the stuff out of their pocket and they're looking at me and they're calling me names. Why? That's what bothers me the most.

JS: Does your wife have any participation in the business?

JC: Oh yeah, it's a family business. Even my son, when he was three, four, he was working on the register on a milk box there, doing math and working. This is a family business. This is what you do. You can't help it. We sent him to University of Pennsylvania, Wharton School. He went to the best school. He was in the top of his class. I wouldn't have taken him unless he went to Wharton to get into Economy Candy.

JS: That's very funny!

JC: It's good. We've had our problems here in the 60s, the 70s, and the 80s. The whole neighborhood of the Lower East Side wasn't the greatest. You couldn't walk down here, because of drugs and the neighborhood was pretty seedy, but we stuck it out and now there are more hotels and upscale bars. It's wonderful, the neighborhood changed. A lot of tourists come in here. Every guidebook you pick up says wonderful things about us. You should go down and visit us. We get a lot of comments on Yelp and everything else. It's amazing.

JS: So you're a tourist destination.

JC: We're a tourist destination now. The Tenement Museum loves us, because they come over to us and we donate a lot of candy to them and everything else, and it's just wonderful, to keep the Lower East Side going and flourishing. The thing is, I used to come in with my dad, because he was a workaholic. That was that generation. I always wanted to be like my dad and it was hard, because he would come home late at night and leave early in the morning. When I didn't have school, I would get dressed early in the morning and go to the door and stay by the door, dressed and ready to go to work with him, because I wanted to be with him for

the rest of the day.

JS: Do you know any of the other LES family businesses?

JC: We know each other from business. We would do anything for each other. Pick up the phone, whatever. . . We would do anything to help each other's business thrive and get along, because once again, it's us. There's no one else that can help you. If we can't help each other. . . We're all together in this. It's one. If one falls, the others will fall. But we each go together to Yonah Schimmel's, Katz's, Economy Candy. People come down to the Lower East Side, >

why? To see these places.

JS: Okay, I'm going to ask you something, and it's coming from my point of view. Candy forever. But I'm wondering what is happening to gribenes and flanken? Is this going to die out?

JC: You know the people will be if they eat too much of it. Cholesterol is going. We all kibitz around and you talk about going to Sammy's and having the gribenes. You can only go to Sammy's once a year.

JS: We want that and we remember it and. . .

JC: The chicken eggs and things like that. It's our history. Our mothers made the chopped liver and they would put in the gribenes. Absolutely. The kids today, they don't know how to make this.

JS: Is this going to survive?

JC: No, it's not going to survive. They'll read about it in our history books. That's about it.

JS: Does your son Mitch know the cuisine? Farfel, kasha varnishkes?

JC: It's sad, but no. We brought up our kids NOT to eat this, because it wasn't healthy. We learned so much about everything else. We let them eat the Fruit Loops, or Captain Crunch, you know, which was just as bad, but we didn't want them eating the same type of food. My mother could only make so much and then it was. . . It's not the same anymore. You sit down for a meal, a Shabbos dinner, broccoli and rice and chicken and this. It doesn't happen anymore. Families are too busy.

JS: Absolutely. Are you to any degree Orthodox or religious?

JC: No, but when the holidays come by, the family gets together as best as we can. One is in California, one is in Pennsylvania. It's not easy to get the family together anymore. Work schedules and marriages going one way or the other. It's not easy.

JERRY COHEN
Owner, Economy Candy
INTERVIEW BY JORDAN SCHAPS

Sweetheart —
it's our anniversary
coming up.
Last year
we went around
the world.
How about this year,
we do something
really new?
How about
a visit
to the kitchen?

Fruit Slices

Sammy's Roumanian

Sammy's entrance on Chrystie Street, 2014.

My father Stan won Sammy's in a poker game in 1975. That might boggle the minds of some, but that's really how it happened. My father had a little bit of experience in hospitality, in that he owned a coffee shop in Newark, New Jersey, called Professor Zookey's. Very old-school. My father sat at the front at the cash register, cigarettes behind the counter, selling coffee, donuts. It was just like any other coffee shop from that era.

My father grew up in the Bronx and knew Sammy from a cousin or someone in the family. He started playing poker with Sammy; the game was held at the restaurant. And, as the story goes, one day Stan was the new owner.

Sammy was pretty much a constant and degenerate gambler. Once he lost the restaurant to my father, he became a waiter at Katz's and he worked there for 20 years. And once my father took over, he basically kept the restaurant exactly the same as Sammy did, with a few notable exceptions.

But first, let me tell you about the day my father walked in after the poker game. One of the old time waiters—and we've had a ton of those, guys who've been around forever—told me, "Your dad just walked in, wearing his white jeans and his cowboy hat (it WAS the 1970s, after all!) and looked at us and said 'I'm the new boss.' And just like that, there it was." Overnight transaction. No paperwork or lawyers arguing. One day Sammy, the next day Stan.

Our staff stay with us forever. We had one waiter with us for over 30 years and we had one cook with us for 40-plus years. It was truly like a family there. Sammy himself died about 14 years ago. I only met him once, a month or so before he died. He came into the restaurant with a racing form in one hand and a rabbi friend on his arm. A real gambler right up to the end. Of course, I treated him to his dinner and sat around and heard his great stories about the old days.

Today, Sammy's business breaks out into three specific segments. Sundays are mostly families, and the time when we get the most Eastern Europeans in the place. They love it because not much has changed since they all started coming here as kids and now they come here with kids and grand kids themselves. Fridays and Saturday nights are the younger crowds. And weekdays are more corporate—more after-work parties.

Even though it's called Sammy's Roumanian, we really don't have many Romanian customers left, and likewise, we have very few Russian patrons. Many of them are dying off and now Romanians wander in by accident, if you want to know the truth. My father tweaked the menu and made it a bit more Ashkenazic when he took over the restaurant, as opposed to having a strictly Eastern European menu, the way that Sammy had it. And today, with our family-style portions, it's got the feeling and menu of a very lively Bar Mitzvah.

I remember the first time I was brought to see the

restaurant with my family. I said, "This is IT?? This is the amazing place I've heard all about?" We used to call it, "The Joint." And eventually, we started to say, "It might be a little joint, but we make big memories here."

It's a great place for families to dine and "re-Jew-venate," as I like to say. Now I have a family myself, but with three kids under the age of six, most of the menu is a bit beyond them. If I wanted to serve them our famous tenderloin, I'd have to put it in the blender first. But I do love to see my kids run around the restaurant—I see myself in them. Our family motto was, "Once you can walk, you can work," so when my kids are in the restaurant, I give my oldest the job of bussing tables and passing out Alka Seltzer for dessert (we keep a big supply of Alka Seltzer up front!) And we all dance the hora together with the customers each night.

Everyone seems to gravitate to the same beloved dishes at Sammy's. The chopped liver. The steaks. And what we call "the latke vodka party" spread; latkes and a bottle of vodka encased in a frozen block of ice. . .always a winner. Traditionalists love the garlicky beef and veal sausages, karnatzlach, and mititei, the meat and garlic rolls, which are both classic Romanian dishes so they stay on the menu, as opposed to the sliced brains and the p'tcha (jellied calves' feet), which are gone.

It was my father who introduced the idea of the frozen ice block around the vodka. He learned the trick at culinary school at CCNY. Today, we offer Stoli, Ketel One, or Grey Goose as choices. There's a bottle on nearly every table. Myself, I studied hotel management at the University of Delaware. I'm an only child, so they said, "Well, he'll be a doctor or he'll own Sammy's." I like to say I've become a doctor of schmaltzology.

Our customers are mostly Jewish but we are good for at least one Asian table a night. And when goyim do come in, well, it's like a *Seinfeld* episode. Take the pitchers of schmaltz: Non-Jews think it's orange juice for the vodka. And once they pour it into their glasses, the waiters tell them, "You can't waste it; you have to drink it!" Likewise, when we have big groups of guys after work, inevitably, they start throwing money into a pile on the table, daring each other to do shots of schmaltz.

Yes, the Lower East Side has really changed and lots of the old places are gone. We were sorry to see Ratner's go—maybe if they had gone to the Lansky's Lounge model a little earlier from a traditional dairy restaurant, they would've had a better chance. We're careful to keep abreast of the changes we need to make so that we stay in business. As an example, we used to have garmentos come in here in three piece suits for breaded cutlets and Scotch on the rocks business lunches; lots of two- and four-top tables. Now, it's mostly bigger groups, eating family-style. We have more women coming in so we offer a salad now. But some things never change. Every table gets up and holds hands and dances the hora every night—where else does that happen? It's just egg creams and rugelach for dessert, nothing else and no coffee or tea—after this meal, who has room for anything else? The hipsters and the old timers, in the end get up and do the hora with everyone else. My father (now living in Boca Raton, retired at 70) very much catered to the older clientele; he spoke their language, looked like them, but understood that when I took it over, I would try to appeal to both the traditional customers as well as the new ones. And he admired that and appreciated it. He always said, "Keep tweaking the place but keep the original flavor." And I'll tell my kids the same thing when I retire and they take it over from me.

DAVID ZIMMERMAN
Owner, Sammy's Roumanian
as told to Abbe Aronson

The classic Sammy's T-shirt.

Schmaltz it up at Sammy's
157 CHRYSTIE ST.
212-673-0330

Joe and Ethel Morris dancing on their 50th anniversary on November 11, 2001. She died the following year.

HOW SAMMY'S SAVED THE DAY

Sammy's Roumanian restaurant, in a basement on the Lower East Side, is nobody's idea of glamorous. But in the wake of 9/11, flying was impossible and so plans for an elaborate 50th anniversary party for my parents in a fancy mountain resort down south had to be scrapped.

At the very last minute, we booked a banquet table for 15 and I hired a Klezmer band with a clarinetist—my father's favorite instrument. I arrived early to find the chopped liver and seltzer bottles on the tables but no brother with place cards. President Bush was in town and traffic was making everyone late. In addition, my mother, who was infirm, had been feeling particularly immobile that day.

When she and my father finally showed up with the rest of the guests an hour late, I couldn't get the Israeli keyboard player we were paying to wish them a happy anniversary. And while I had been promised a clarinet, the musician playing saxophone instead insisted my father would like it just as much. The place was noisy, the food dodgy, the décor totally unacceptable and of course, the help particularly confrontational.

Yet halfway through my second vodka and third ministroke, I looked up from my plate and saw my parents dancing in the middle of the room, between tables, entwined like two kids slow-dancing at a prom. Years and illness fell away, and there they were, in the comfort of simple, old fashioned brisket, kosher pickles, and the music they danced to when they first fell in love decades ago.

We weren't toasting them on a cruise or in a fancy resort and there were no celebrities around, only a couple of old friends joining the celebration. But we had each other that night and our party had heart. And that isn't chopped liver.

Although, of course we had that too.

BOB MORRIS
Author; contributor, *The New York Times*

PHOTOGRAPH BY ROBERT TEPPER

I SAY IT, THEN YOU SAY IT. . .L'CHIAM!

Madame, I see you're eating our famous Roumanian tenderloin steak. I must say it's always nice to see a lady who can handle 18" of meat!" It's those kind of jokes I tell throughout the evening. Periodically I say, "Everyone raise a glass." All the shots that have been poured from a bottle of vodka in a block of ice are held high in the air with pride. . ."I say it, then you say it. . . L'chaim!" From behind my electronic "one man band" setup, I sing "Hava Nagila" (or some other traditional Jewish gem). Seventy-five people get up and do a hora in a room the size of a studio apartment. Covering the walls are photos of customers throughout 35 years as they "Schmaltz it up at Sammy's." It's like a Bar Mitzvah gone wild!

From the kitchen I watch as dishes fly. Each table orders the "prix fixe." Chopped liver with gribenes, radish and schmaltz, pirogen, karnatzlach, kishka, stuffed cabbage. Those are just the appetizers. Forks dig into wooden bowls of roasted peppers, green tomatoes, and kosher pickles. All accompanied by loaves and loaves of rye bread. Old-fashioned bottles of seltzer to wash it all down. I go on to sing songs from the 40s, 50s, and 60s as people dance and sing along.

The entrees appear. Lamb chops, huge rib eyes, and the famous 18" Roumanian tenderloin, all smothered in garlic. Bottle after bottle of frozen vodka, in a block of ice, replacing its empty predecessor. All the while waiters with larger than life personalities move from table to table and kibbitz. When the entrées are half eaten, the lights dim, the colored gels ignite and it's time for me to DJ "classic" disco music. People from 5 to 95 are dancing with each other. One table celebrates Bertha's 80th. Another is Lou and Vicki's anniversary. Ivan is getting married. Karen and her merry band of ladies out for the evening. David and Pat having a romantic evening. Reunions of every kind.

Passover, 2005, singing "Those Were the Days."

Tourists from all over the world. So on and so on. . .

I'm well into entertaining for two hours of non-stop eating, drinking, singing, and dancing. The crowd is going strong. The room has become one big, happy family. They have sung Yiddish songs, danced to klezmer hits, and boogied the night away. It's time for dessert. Out come plates of rugelach. The waiters carry cartons of milk for each table. The moment everyone has secretly been waiting for. The whole crowd turns into seven-year-olds as the bottles of Fox's U-Bet hit the tables. Time for egg creams! First the milk is poured into the glass just under a quarter ways. The seltzer sprays all the way to the rim. Finally the syrup is poured in. Mixing with the ingredients and making the concoction overflow with bubbles and syrup (this IS the definitive way to make an egg cream and I dare anyone to say otherwise). Waiters have their signature pour. One stands on a chair as he pours. One pours the last bit of chocolate on the tablecloth to make a design. Smiles on everyone who can't wait to get his or her hands on a glass and make it.

As the evening comes to a close there is one last slow dance for lovers. Then the last song is always the same. "That's What Friends Are For." Small and large groups huddle with each other and sway left to right, in a circle, singing at the top of their lungs. As I look around the room there is an aura, a palpable feeling. Love. They have all become mishpocha.

The song ends and lights begin to brighten. It's time for good-byes. It takes awhile before the last person leaves. I shut down the one man band setup. Sit with my own egg cream. I reflect upon the moments that people connected with me. Most of all, I'm excited that tomorrow night it happens once again. People will come to "Schmaltz it up at Sammy's."

ROLAND MENCHELL
Former entertainer/DJ, Sammy's Roumanian

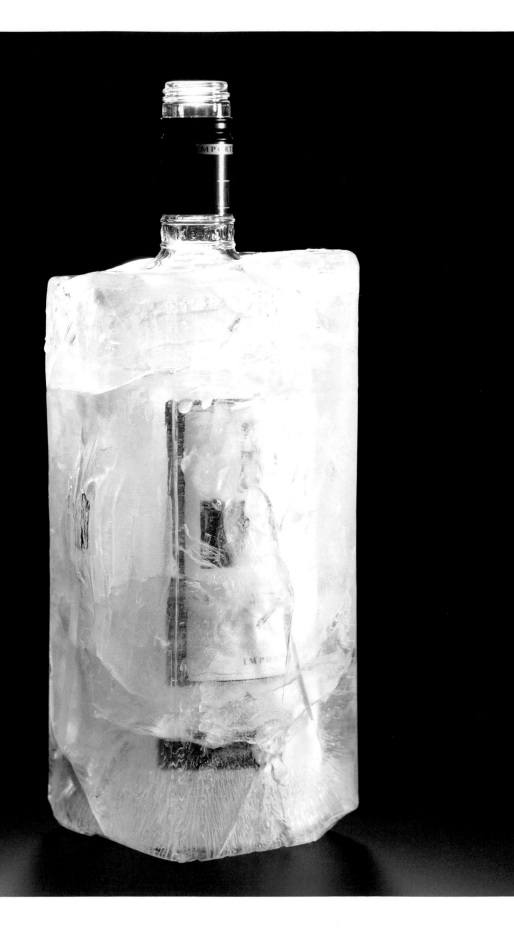

Vodka

Schmaltz

WHY MY FAMILY SHOULD NEVER BE ALLOWED OUT IN PUBLIC

Of course it was my "aunt" Tillie, my mother's best friend, who first discovered Sammy's. "You gotta see this place," she cackled. We were used to Tillie leading the way; it was the early 60s and Tillie was one of the top salespeople at R&K Originals, a huge dress-house in the Garment Center. She was adored at work, surrounded by "homosexuals" and Christian Scientists, people who sought her opinion on everything. I never saw her wear the same thing twice. She made more money than anyone else in my parents' circle, and because she didn't have children of her own, spoiled us all with extravagant gifts.

On weekends Tillie cooked huge meals—pea soup with flanken, fried veal cutlets, lasagna with giant pieces of sausage. All the other couples had children who were near my age. We referred to each other as cousins and became each other's best friends. We kids would crowd around Tillie, waiting for a taste, wanting just to be near her. On special occasions she made blenders full of daiquiris, and let us slurp some before we brought the glasses out to our fathers. She taught us to say "shit," and never tired of hearing us try to use it in a sentence. She let us do all the things our mothers said not to, and made us feel safe while we did them.

So when a buyer from Neiman Marcus came up from Dallas and took Tillie to Sammy's Roumanian, she knew right away that we all should go. "He had to show me what was right in my own backyard," she marveled, her Parliament seemingly stuck to her lower lip

That weekend she schlepped all of us from Queens to the Lower East Side. All us cousins pushed into a big booth and had to listen to stories of what the neighborhood had been like when Tillie and our parents were growing up. But when the food started being piled on the table, everyone forgot about rolling our eyes and just started eating. And eating.

The portions weren't big—they were enormous. Steaks literally hung off the plate; veal chops were "as big as my thigh," my zaftig aunt shouted. In fact, everyone shouted, from the waiters to the busboys to all of us, pouring chicken fat from pitchers onto everything in sight and slurping our egg creams. I don't remember if there was the frozen bottle of vodka on the table that first time; if there was, it was probably un-drunk. We were Jews, after all—gamblers, but not drinkers.

"Yours is better," we all told Tillie after every bite of every single thing, but only half of that was true.

Before we left, Tillie tacked her R&K card high on the wall, next to thousands of others. Every time we went back to Sammy's, and we went often in those years, we looked for it, but it was as if we couldn't remember in which booth we had been seated, or where that pink thumbtack had landed.

Martha Frankel with Roman Polanski, Paris, 1991.

Fifteen years later, I am squeezed into a booth at Sammy's, with all those cousins and their wives and husbands. We have just come from Danceteria, and we can hardly sit still, what with the coke coursing through our heads and the sexual tension. A lot of us have slept with a lot of others of us, and friendships are starting to fray, relationships are becoming too complicated. Between trips to the bathroom, we argue. Who did what, who said what, who feels what? Then back to the bathroom.

That bottle of frozen vodka has our attention, alright, and we clink our glasses loudly. We order another. And then another. We are now Jews and drunks—we sure showed them!

As we throw money into the middle of the table to settle the bill, a business card falls off the wall and lands right on the check. Tillie Kaplan, Head Buyer, R&K Dresses.

We start shrieking like the wild people we are. We are, in the vernacular of Sammy's, plotzing. Our spouses are taken aback, but it brings us cousins closer, and for a few months we put our petty bickering aside.

Ten years later I take off for Paris to interview Roman Polanski. Despite the unlawful sex with a minor, I am inclined to like Polanski: he was pulled away from his parents when he was in kindergarten and brought up by strangers because they were taken to the death camps during the Holocaust; his wife, the actress Sharon Tate, was brutally murdered by the Manson Family while pregnant with his child; he fled America after the judge reneged on his plea agreement. If the girl at the center of the sex story can forgive him, surely I can too.

But it doesn't work out that way. Polanski and I cannot stand each other, and the seven days I am forced to be with him turn out to be the longest week of my working life.

All of this comes to an awful head while walking down the Champs Élysées. We are arguing about everything, from where we should eat (I want classic French food, he wants to take me to an American-style bistro), to Euro Disney (he loves it and insists I must see it while in Paris). We are screaming at each other when he pulls at my T-shirt. "And this," he says dismissively. "What is this Sammy's?"

Q

What does

a Jewish princess

make for dinner?

A

Reservations!

I stop, and all of it comes flooding back; the grated radish with onions and gribenes, drenched in chicken fat; the broiled liver with fried onions; the sound of my aunt Tillie's laugh, louder than all the rest.

I take a deep breath and let this putz steer me towards his favorite restaurant. From that moment, my Sammy's T-shirt becomes my talisman, and I wear it to hundreds of interviews before it finally falls apart.

MARTHA FRANKEL
Author, *Hats and Eyeglasses:*
A Family Love Affair with Gambling;
executive director, Woodstock Writers Festival

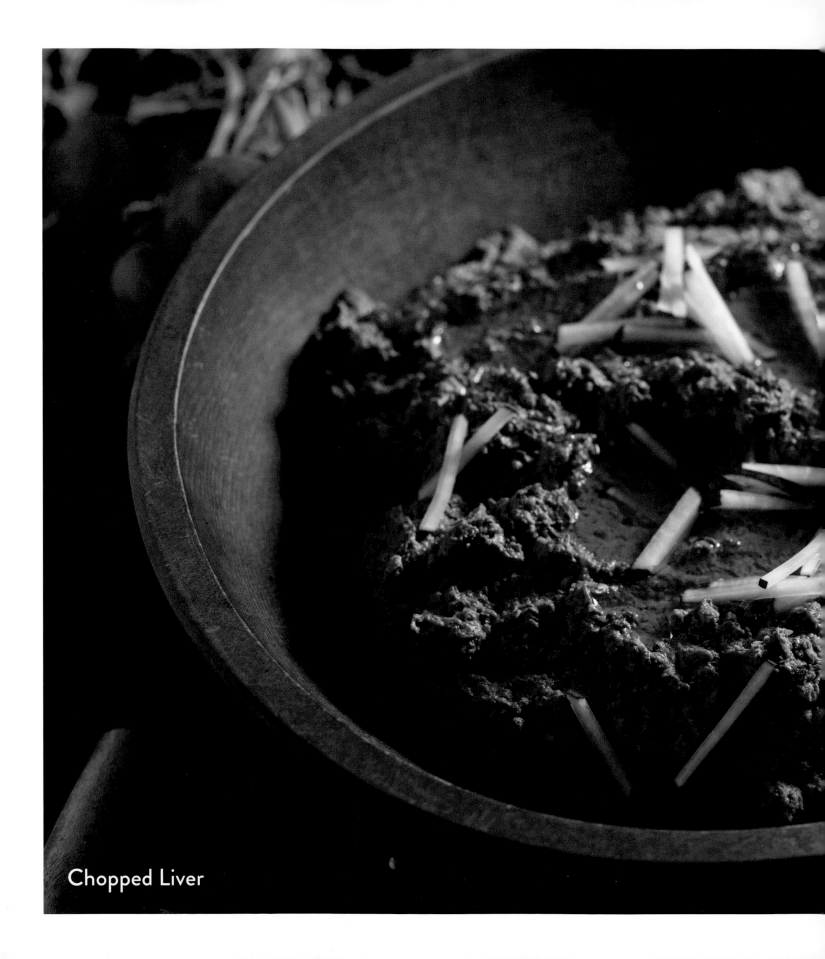
Chopped Liver

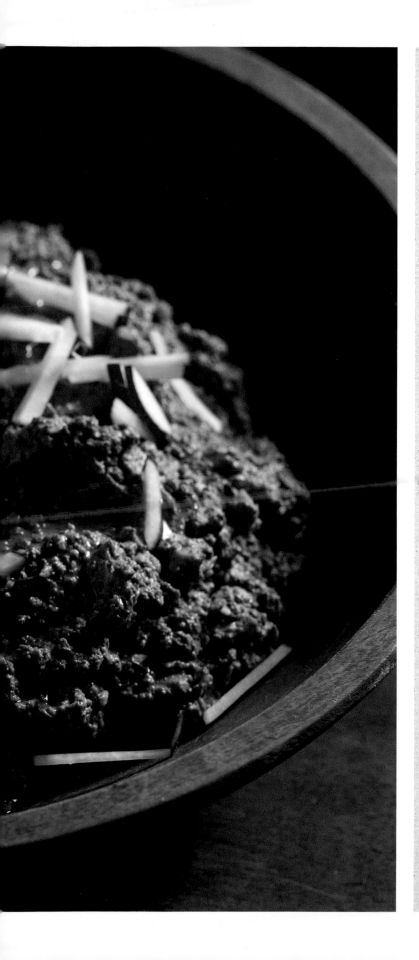

2 pounds chicken liver

4 large eggs

2 cups chopped onions

1 cup chicken fat

2 teaspoons kosher salt

1 teaspoon black pepper

1 teaspoon sugar

Put the eggs in cold water in a saucepan. Bring to a boil and simmer for about 10 minutes. Cool and peel.

Sauté onions in 2 tablespoons of chicken fat over medium-high heat until the onions start turning brown.

Add the chicken livers to the sautéed onions with a teaspoon of sugar and cook, turning the livers once or twice for about 5 minutes until they are firm. Don't overcook the livers or they will be dry. Let cool for 15 minutes.

Chop together the livers, hard-boiled eggs, and sautéed onions using a food processor until coarsely chopped. Season with salt and pepper.

Add 1 or 2 more tablespoons (optional) of chicken fat and mix.

Add a little dash of good luck!

JEWISH CAESAR SALAD
(As served tableside at Sammy's)

black radish, skinned and grated

diced raw onion

gribenes with caramelized onion

In equal amounts, add ⅓ of each of the above to a wooden bowl. Add the chopped liver. Mix it up; "human Cuisinart style." Give it a 1, 2, 3 pour of schmaltz, throw a little kosher salt over shoulder for good luck.

Schmear on rye or eat with a fork.

FAR DI KINDER

When I was a kid I had 85 grandparents, at least for three months of the year, as my grandmother and great-aunt were two of the founders of a hiking group turned bungalow colony called "Followers of the Trail." We'd drive up from Brooklyn to the hilly shtetl near Peekskill, New York on the last day of school and not put our shoes back on until September. We'd get yelled at, we'd get our cheeks pinched, we'd get pulled into singing sessions, go "tanzen un shpringen" (dancing and jumping) in the casino, and we'd get fed—by everyone. Nobody knocked on doors. We just walked in, and as we did we'd hear the Yiddish change to English "far di kinder."

My mother was not much of a cook. She loved white bread and tater tots, and made some dish called "concoction," an unappealing combination of mushroom soup, tuna fish, green peas, and rice. It was from the "alter cockers" that I learned most of my culinary tricks.

My grandmother and great-aunt made the best chopped liver, and for it to be real there had to be blood in it—their knuckles scraping against the grater was a sign of love. Bertha taught me to put cooked noodles in right before you served the chicken soup instead of cooking them in the soup until they were mush. And the arguments about what kind of cheese to use in kugel made me understand much about choice and detail in life.

I am told that my syntax in speaking, my Scottish strathspeys, Irish reels, and even the square dance tunes that I've written all sound Jewish, and when my musical wanderings brought me around to klezmer, it was that care for historical detail that opened the door to my embracing it.

I have always had the good fortune of walking into houses just as food is being served. Is it intentional? I don't know—it is simply a knack. As a musician it is a very good knack to have. Musicians love to eat almost as much as we love to play.

LISA GUTKIN
Of the Klezmatics

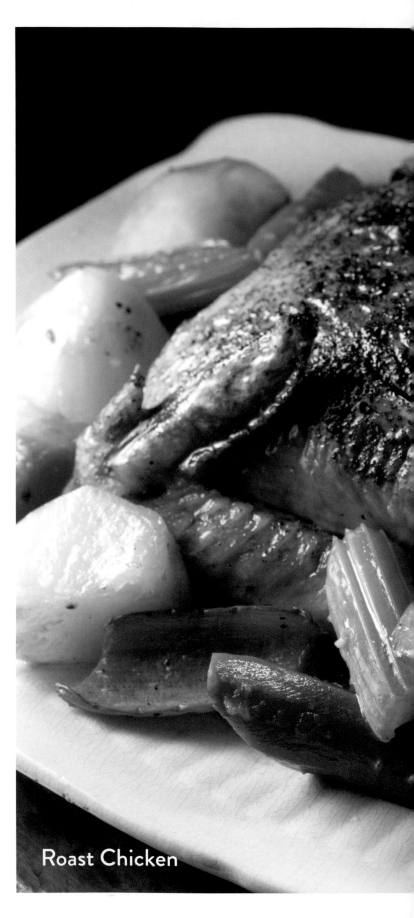

Roast Chicken

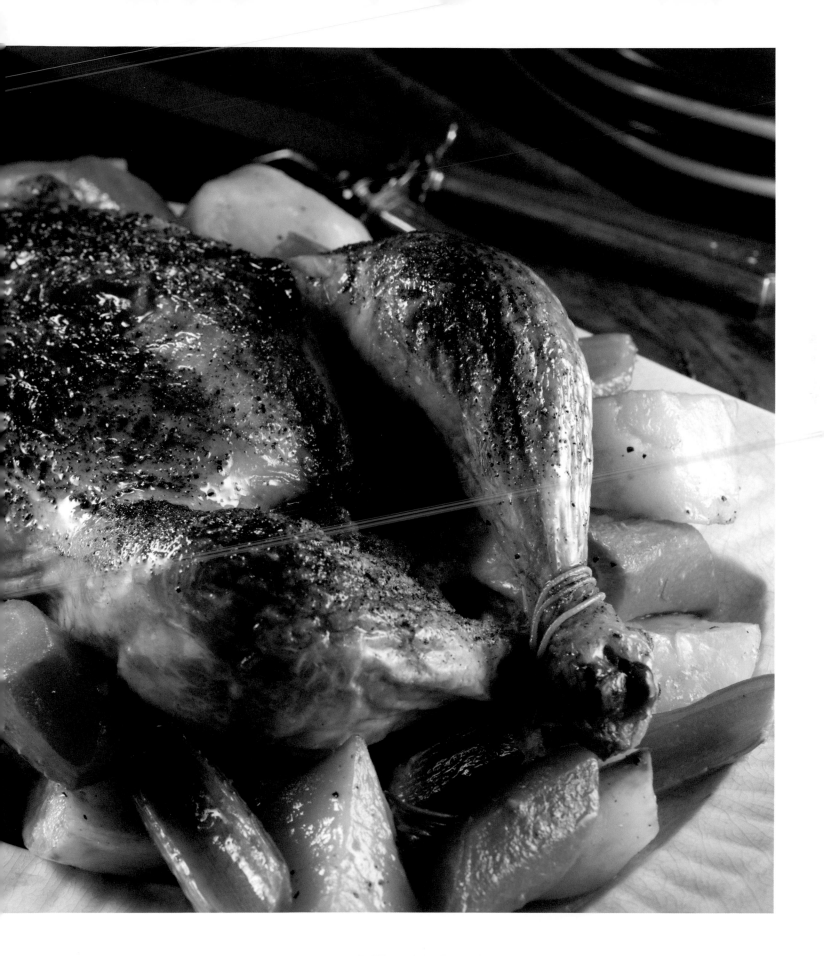

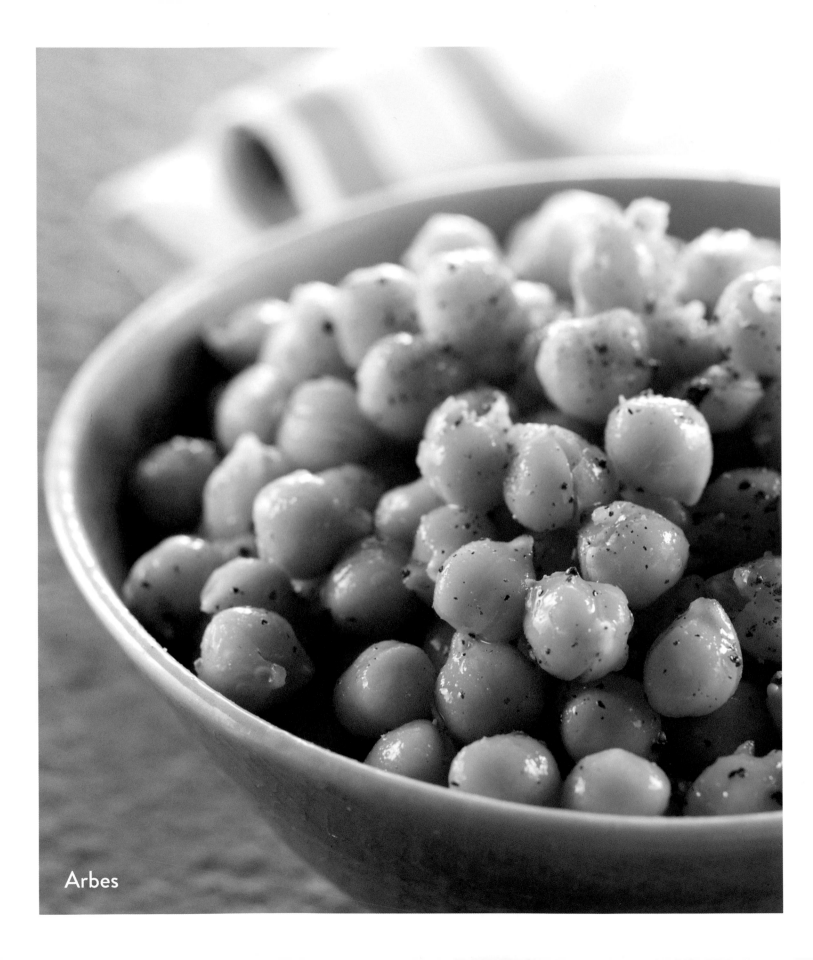
Arbes

Little Yossi and his family
were having dinner at his bubbe's house.
When everyone was seated, the food was served.
As soon as little Yossi got his plate,
he started eating from it right away.

"Yossi, please wait until we say our prayer,"
said his father.
"I don't have to," Yossi replied.

"Of course you have to," said his mother.
"Don't we always say a prayer
before eating at our house?"

"Yes, but that's our house," Yossi explained.
"This is bubbe's house
and she knows how to cook."

SHKA DA & DUERS

Kishka. Stuffed derma. Intestines. As a kid, I couldn't stand the thought. The very idea was completely disgusting, but when I was growing up, somewhere along the line someone got me to try it and it was actually pretty good, especially with brown gravy. I'm a big fan of brown gravy on anything.

The turning point—when I became a major league fan of kishka, was when I was in college in Buffalo, New York. I lived off a major street—Hertel Avenue—which ran all the way up to the main campus. I lived on Traymore Street, which intersected Hertel, and on Hertel was this little hole-in-the-wall deli called Ralph's.

Ralph's was owned by Ralph and his wife. They must have had the place for a million years or close to it; they were pretty old. It was a sliver of a store with a counter and stools and few tiny tables for two in the back.

And back then, it was a small community. They knew us; we knew them and we stopped in there after classes often. Well, their kishka was divine. It wasn't very firm—it was actually rather loosely packed but it was exceptional and I remember that even the chopped vegetables in their kishka were terrific.

My great kishka memory however, comes from my old friend Steve Sheinberg, now a dentist in New Jersey. "Sheins," as we called him, coined the expression, "Shka Da and Duers."

Shka = kishka

Da = cream soda

Duers = two roast beef sandwiches with Russian dressing.

I actually wasn't big on the roast beef sandwiches but Sheins was, and so were a lot of other people.

So there you have it. Shka, Da and Duers from Ralph's, which, for me, was all about the kishka. That's my story—short and to the point. Hope you recorded it because I'm not sayin' it again!

HOWARD GREENBERG
Owner, Howard Greenberg Gallery NYC

WHAT? WHAT DID I FEED HIM?

My mother, whose name is now legally "Alava Sholom" Florence Steinberg, was the greatest Jewish cook in the history of Judaism. And I dare say, the only woman in the world who actually killed three people eating. One of the gentlemen she said actually left her apartment, walked across the street to his apartment, and had a massive coronary. What she fed to him was breaded veal chops made in schmaltz, potato pancakes made with schmaltz, and a schaum torte, and it is made with nothing but the bad part of eggs and pounds of sugar. Her only comment when I told her she killed him, "What? What did I feed him?" That is a great cook.

It was a breaded veal chop *fried in schmaltz*, just to be clear.

There was no actual event for the slaughter of my father but it was a steady diet of schmaltz, red meat, sour cream, onions, and sugar that did him in at 54 years of age. The third victim was her second husband and he just simply had it coming.

DAVID STEINBERG
Her only surviving son so far;
entertainment manager

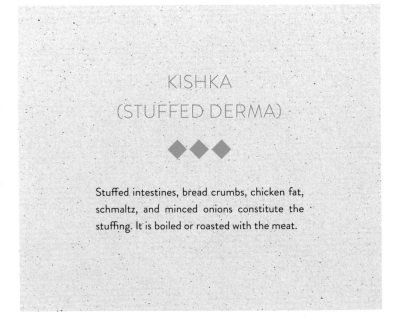

KISHKA
(STUFFED DERMA)

◆ ◆ ◆

Stuffed intestines, bread crumbs, chicken fat, schmaltz, and minced onions constitute the stuffing. It is boiled or roasted with the meat.

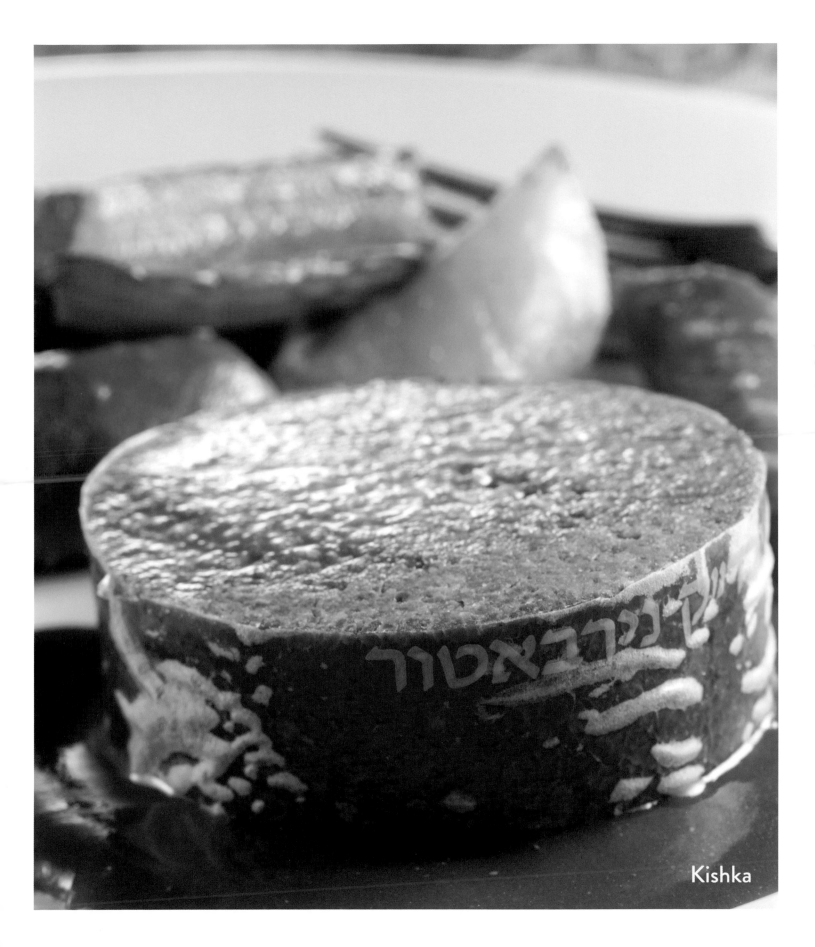

Kishka

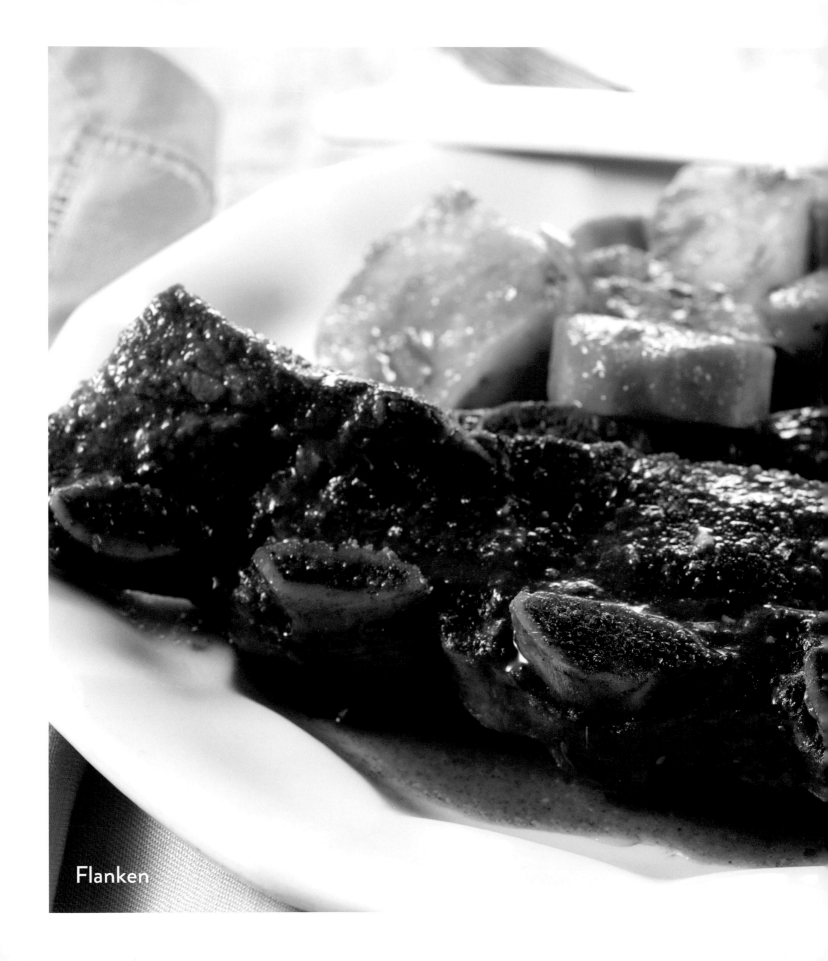

Flanken

ARTHUR SCHWARTZ'S
SWEET AND SOUR FLANKEN

◆◆◆

Makes 4 to 6 servings

Flanken is short ribs cut across the bone instead of between the bones. So each slice of flanken will have several small bones across its length. When flanken is fully cooked, however, it should be falling off those bones. Here, the beef is braised in a subtly sweet and sour tomato sauce, a flavor profile that is very popular among Ashkenazi Jews. It's great to top kasha or mashed potatoes, or noodles, or for dunking bread (make mine challah). Brisket or a chuck roast can be cooked this way, too. And beef cheeks, a cut popular among Orthodox Jews who use them to make cholent—the meat, beans, barley, and potato casserole that is cooked overnight at low heat. I use that slow cooking technique here because it results in extremely tender meat.

This recipe can easily be doubled or tripled. And, like most Jewish meat recipes, it is best served the day after it is made, when the flavors will have melded and when it is easy to remove the solidified fat.

Salt

2 pounds relatively lean beef flanken
(preferably the meatier breast flanken,
not fattier plate flanken, but
either is delicious)

1 15-ounce can Hunt's tomato sauce
(it's kosher)

1–2 tablespoons vegetable oil

2 tablespoons brown sugar

juice of ½ lemon
or ¼ teaspoon sour salt
(fine citric acid crystals)

Preheat the oven to 250° F.

Generously salt the meat.

In a heavy stove-top casserole just large enough to hold the meat—for instance, an enameled cast iron casserole—over medium-high heat, heat the oil until very hot, but not smoking. Brown the meat well, a few slices at a time, on all sides. Remove the slices to a platter as they are browned. Be careful not to burn the oil or any of the film on the bottom of the pan. If you see a spot getting too dark, put the next piece of raw meat on it.

When all the meat has been browned, pour off the fat in the pan. Add ½ cup water to the pan, and scrape up the browned film and bits on the bottom of the pan. Let the water evaporate by about half.

Add the can of tomato sauce, rinsing out the can with another ½ cup of water. Stir in the brown sugar and the lemon juice or sour salt. Arrange the meat in the pan with the sauce. Add any meat juices that may have accumulated on the platter. There should be enough liquid to almost but not completely cover the meat.

Bring the liquid to a gentle simmer, then cover the pot and place it in the oven for 1 ½ to 2 hours, possibly up to 3 or 4 hours, depending on the meat and the amount. When done, the meat should be fork tender.

If serving immediately, let the meat rest for at least 30 minutes, then tilt the pan and skim off any fat that has risen to the top. Better, however, is to serve the meat the next day: Refrigerate it when it comes to room temperature. The next day you can pull off the hardened fat on top. Reheat gently to a simmer, and serve very hot.

GROWING UP KOSHER

Helene: The chicken man was someone we knew about when I grew up in Brooklyn. He worked for someone who raised chickens (kosher) and delivered fresh killed chickens to our home on Thursday evening. Mom wanted them Thursday since Friday she always cooked fresh chicken soup and often Friday night we had chicken for dinner. Unlike her mother who used the same chicken in the soup and then roasted it, my mom used separate chickens for soup and roasting. The main thing when you made chicken soup was also to get extra feet—the fat on the feet was particularly good and gave a great flavor to the soup. The chickens were plucked and depending on what you ordered—roasting chicken or broiling chicken—they were cut or whole. Also, the chicken man could bring extra livers and stomachs (chicken stomachs also cooked well in the soup). The chicken livers were turned into chopped liver.

Ken: The chickens we bought from the butcher had a metal clip in the wing that signified that they were kosher. It was hard to get that damned clip off. You couldn't just pull it off the wing since it was attached to the skin of the small joint that was extremely rubbery. And separating the clip was also impossible. You had to take a paring knife and cut it off but the skin fought the knife. It was a battle between the wing and your ability to cut it off without stabbing yourself. Ultimately, you won but the chicken often got its little revenge in your frustration and a pricked finger.

Helene: When I was a kid—after 13—I was commissioned to stop on Friday afternoon at the bakery when I came home from school. Dubin's Bakery was located on Church Avenue at 19th Street in Brooklyn—and it was a short walk from my junior high and high school. My job was to get seeded onion rye, challah, sometimes a chunk of corn bread (that is not the corn bread you think of today), and raisin challah. After doing this for a few weeks, my father asked my mother one evening if Dubin's was not putting the heels of the bread into the bags. I spoke up since I was eating the heels of the bread on the way home from Dubin's—after all, it was a half mile walk! I was no longer allowed to eat all of the heels. My father would negotiate with me as to which heels I could eat that week.

Ken: Speaking of bakeries, when you bought a bread from the bakery (usually seeded rye though we also got the now nearly extinct corn rye) the aforementioned heel had a little square paper stamp affixed to it with a bit of egg wash. Yes, the heels were a treat but you could never peel off all the paper from it and so for every bit of bread heaven you also got a bit of paper hell.

My favorite dessert was the Charlotte Russe, a round of sponge cake topped with a generous swirl of whipped cream which was anointed with a maraschino cherry on top. But when my mother made her order, I got a different kind of cherry as a little treat from the baker. It was a shriveled candied half cherry that the baker's thumb had pressed into the driest butter cookie known to man. A cookie so dry no seltzer or Dr. Brown's could counteract its gritty, sandy consistency. Still, to make the baker happy and to show my appreciation I had to pretend to eagerly consume it while trying vainly to summon up enough spit to help it along my alimentary tract.

Back at home, we had the typical sets of different dishes for milk and meat. On the sink were two bars of Rokeach kosher soap. One bar had a red dot running through its interior—this was for washing fleishig dishes. The other bar had a blue dot that was used for milchig dishes. When, heaven forbid, a fork or knife meant for milk was accidentally used for meat it was decreed by some unknown Biblical scholar that the offending utensil had to be buried in dirt for a year. Some families buried their cutlery outside but my mother preferred to "decorate" the many potted plants on the kitchen windowsill. When the morning sun came through the window, the knives, forks, and spoons glittered and gleamed.

Helene: My bubbe and zeyda had a house on Dahill

Road in Brooklyn and when they were dead, the children were selling it. My mom learned from the people who bought the house that a lot of silverware was found buried in the backyard. The new owners were calling to ask if the children wanted the silverware. Of course, that's what my family did—buried the silverware—and in our case, we were told it needed to be buried two years!

Ken: Different kosher homes had different rules about bringing in food from the outside world. Cheese pizza and other parve foods could be eaten on regular plates. But anything with meat in it (and pork and shellfish were banned completely) had to be eaten on paper plates.

Every Sunday afternoon we went to the local Chinese restaurant for lunch—soup, entrée, egg roll, and your choice of Jell-o or ice cream for dessert. Although we weren't allowed to order pork or shrimp, everybody ate egg rolls. My father especially liked them with the sinus-clearing mustard. We tried to tell him that egg rolls had little pieces of pork and shrimp in them, but he refused to believe us. Or just chose not to.

It was at a Chinese restaurant that my kosherness was finally broken. My family made a car trip up to Toronto to see a relative who had actually escaped the Nazis by walking across the Alps (take that Von Trapp family). He lost some toes in the meantime but he gained his freedom. Anyway, there was a polio scare in Toronto so my parents decided not to take my sister and myself into town, so we met my third or fourth cousin twice or three times removed on my mother's side out-of-town at a Chinese restaurant. He ordered Chinese spareribs. And, for some reason, my parents let me eat them. When I did I wasn't struck by lightning but rather the light that went on in my head told me that pork could be delicious and that I wasn't actually going to be buried headfirst in one of my mother's pots on the kitchen window.

HELENE BLUE AND KEN BLOOM
Two friends with a common kosher background

Q

What's a Jew's biggest dilemma?

A

Free pork.

BEI MIR BISTU SCHOEN

The Golden Age of Yiddish Theatre. Second Avenue. What a time. What magic. It was the link for immigrants from Europe and Russia that reminded them of where they came from. I grew up in the Yiddish Theatre. . .literally. My grandfather, Jacob Jacobs, who is primarily known as the author of *Bei Meir Bistu Schoen* and *Mein Shtetele Belz*, was also an iconic entrepreneur who wrote, produced and starred on radio (the famous *Yenta Telebende* series with my grandmother Betty Jacobs) and in Yiddish Theatre from the 1930s through the 1970s. Most of it on Second Avenue and the Lower East Side. I showed up in the 1950s and thought that backstage was where you went after school and did your homework.

My grandfather worked with the greats of the Yiddish Theatre: the actors Menasha Skulnik, Aaron Lebedoff, Maurice Schwartz, Leo Fuchs, and Molly Picon to name just a few, and world famous composers the likes of Sholom

AN ORIGINAL CAST ALBUM DECCA
JACOB JACOBS presents LEO FUCHS
in SHOLOM SECUNDA'S New Musical
BEI MIR BISTU SCHOEN
Book by LOUIS FREIMAN
Lyrics by JACOB JACOBS

ALSO STARRING
Jacob JACOBS Miriam KRESSYN Leon LIEBGOLD
Seymour REXITE Rebecca RICHMAN Charlotte COOPER Thelma MINTZ Rose GREENFIELD
Staged and Directed by LEO FUCHS
Stage Manager: MORDECAI YACHSEN

Secunda and Alexander Olshanetsky. He wrote music for radio, for theatre, and for anyone who needed a song. Most of all he loved performing and kept producing those shows as long as anyone would come.

By the 60s, my grandfather had formed an ensemble company that he used for most shows. Seymour Rexsite, Miriam Kressyn, Fyvush Finkel, Leon Liebgold, Freydele Oysher, and everyone else who was around at that time. He put them all to work when he could. When you form that kind of family, with it comes the family dynamic. Fighting. In fact, whenever Leo Fuchs was starring in one of my grandfather's shows *Bei Mir Bistu Schoen* (the musical) and *The Laughing Cowboy* (the musical) they spent the entire work season not speaking to each other. It was strictly business. As a child I didn't quite get it. I sat on his wife's lap and they helped me with my homework. We were family.

The fights were about everything from how large the names were in the ads and on the posters to whose picture was more prominent to who got which song and how much applause. It never stopped. BUT, when the screaming ended the most important issue became, "Where do we eat??" I kid you not. Fighting makes you hungry. The discussion became whether it would be The 2nd Avenue Deli for brisket or pastrami or chopped liver; Ratner's for those delicious cheese blintzes, or Sammy's for those amazing Roumanian steaks. Then everyone would go to dinner and be friends. Not a word about business. At least until after dinner and the curtain came up. Then it was back to fighting. Nothing personal. Food was the common bond. The mother tongue was their bond and of course performing was their lives. The link with their families. Friendships continued. Life went on. And most of all. . .the food was great.

MELANIE MINTZ
Playwright;
granddaughter of Jacob Jacobs

Noodle Kugel

The Next Generation

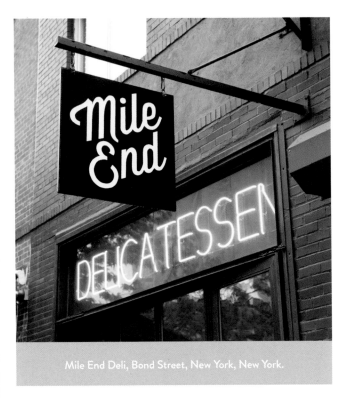

Mile End Deli, Bond Street, New York, New York.

A s I moved into my first Brooklyn apartment on Atlantic Avenue in 2010, I passed a small shop around the corner plastered with butcher paper. A small black sign hanging outside read: Mile End. I expected another hipster coffee shop or bar selling a rotation of locally brewed beers. But two weeks later, I spotted a row of pickle jars in the glass window and a petite pastrami and rye sandwich on the counter.

I walked in and met the owners: A scruffy ex-law student from Montreal named Noah Bernamoff and his stylish wife Rae. The couple was smoking their own brisket, making their salami, and curing their gravlax—reviving a traditional way of deli that was nearly extinct in New York City and unknowingly, starting a city-wide Jewish food Renaissance.

Growing up, "bubbe fare" rarely graced my family's kitchen table. Gefilte fish was served at Passover and brisket made the occasional appearance, but our Shabbos meals were more likely to be a filet of grilled salmon and seasonal vegetables than roasted chicken and sweet tzimmes.

I came to know Jewish food through its revival in Brooklyn and Manhattan where a small but growing group of young Jews like Bernamoff are reaching back into the kitchens of their grandparents and the Lower East Side tenements and rediscovering recipes that were nearly forgotten. These chefs and food artisans are preserving these traditions and restoring them to their former glory—and often updating them with modern ingredients and food sensibilities.

Within a few years of Mile End's opening, nouveau delis that were smoking ethically-sourced meat, baking their own rye bread, and creating artisan versions of the egg cream were popping up in San Francisco, Toronto, Portland, Washington, and beyond. Deli mavens and owners flocked to New York in October of 2012 for a deli summit that included panels on development, a pastrami tasting, and an epic nine-course Shabbos dinner at pop-up restaurant spot City Grit.

The chefs devised a dinner that was at once both Old and New World. Dishes like an elegantly plated lamb's neck served over kasha with preserved tomato and p'tcha reinterpreted as a colorful tri-layered terrine would have been unrecognizable to our grandparents, but the flavors were familiar and the meal full of tradition.

While deli owners were heeding author David Sax's call to "Save the Deli," another iconic Jewish food was in a state of crisis—a good bagel was becoming very hard to find. With the closing of legendary Upper West Side bagel shop H & H in 2011 came countless articles bemoaning the state of the bagel. *New York Times* food writer and bagel expert Mimi Sheraton declared the situation "deplorable."

Melissa Weller, a classically trained baker, who had her first bagel at 13, wanted to change that. She started rolling and boiling traditional bagels and selling them at Brooklyn's weekly outdoor food market, Smorgasburg. And, in the spring of 2014, Mile End's Bernamoff followed, opening the wildly popular Black Seed Bagels. The small shop in

Nolita turns out hand-rolled well-seeded bagels that are a hybrid of New York and Montreal bagel traditions (small, slightly chewy, and with a perfect snap in the crust) to daily lines of bagel-starved New Yorkers. Around the corner, Baz Bagel is also making their own bagels and serving plates of pillowy cheese blintzes in a vintage-modern setting. And, on Orchard Street, Russ & Daughters opened its first café this spring, offering baskets of bagels, bialys, and shissle rye alongside cutting boards dotted with slices of sturgeon with butter and smoked sable with goat cream cheese.

But nothing proves that Jewish food is back quite like the Gefilteria, a small artisan gefilte fish company based in Brooklyn. "There's never been a Jewish food more in need of resuscitation" Jeffrey Yoskowitz, cofounder and chief pickler of the Gefilteria, told me. "It was relegated to a joke of a food. . . It was so upsetting that a food that we loved, most of our contemporaries only knew as a gross thing from a jar." Yoskowitz, along with his cofounder Liz Alpern, created the company's signature gefilte loaf with ground whitefish and pike and a bright stripe of ground salmon. The delicious result looks more like a fine fish pâté than a jar of jellied gefilte fish.

As the Gefilteria and this new Jewish food movement grew, Yoskowitz and Alpern were able to sell their products in Jewish inflected fine foods stores that opened in Brooklyn like Peck's (which is owned by Theo Peck, the grandson of the founders of Ratner's) and Shelsky's of Brooklyn, a modern-day appetizing shop. Owner Peter Shelsky spe-cializes is cheekily named sandwiches listed on large chalkboards like The Fancy Pants made with fatty lake sturgeon, house-cured gravlax, cream cheese, tomato, and onion on a bagel or bialy and the Dr. Goldstein Special: duck fat-laced chopped liver with apple horse radish served between two schmaltz fried latkes.

A smaller chalkboard in the shop's farthest corner boasts treyf specials like lobster rolls. "Most Jews in the city serve treyf. If Zabar's can serve lobster salad. . . I draw the line at pork, even though I have a pig tattoo," Shelsky told me. He isn't alone. Other than the Gefilteria, none of these businesses are kosher. Mile End serves a smoked meat poutine (fries topped with cheese curds and gravy) and all of the delis are more likely to use ethically sourced meat than factory farmed kosher cuts. And if you wake up on Shabbos morning craving a good bagel, you won't have to look hard to find one at Black Seed or Baz Bagels. But these places are no less Jewish, rather, they represent a new generation of Jewish food.

For these chefs and food artisans (and myself) these places are a way for us to connect to our heritage, to make sure that the traditions of those who came before us aren't lost, and to make them our own—deliciously, of course.

DEVRA FERST
Associate editor, Eater NY;
former food editor, *The Forward*.

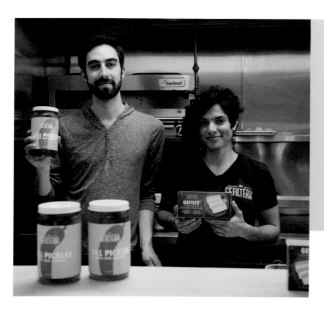

From left: Jeffrey Yoskowitz and Liz Alpern of Gefilteria; Theo Peck owner of Peck's, Brooklyn.

Hanukkah Gelt

HANUKKAH, OH HANUKKAH, COME LIGHT THE MENORAH...

Food, family, holidays—what could be better!? I love spending time preparing for the holidays with my daughters. Baking special dishes we only eat once a year and enjoying being together as we create our holiday masterpiece is a time that I look forward to every year. The girls and I love to make (and eat!) our special kugel. We love to add crushed corn flakes and sprinkle cinnamon on the top. While the kugel bakes and fills the house with smells of Hanukkah, we light our candles to start the celebration. I love the feeling when our family is together enjoying the tastes of the holiday as well as the feelings of warmth and love as we gather around to play a game of dreidel. That is what the holiday is all about!

KYLE RICHARDS

Actress, The Real Housewives of Beverly Hills

GRANDMA LILLIAN'S COOKIES

I didn't see my dad for a long time after he and my mother divorced. One day she told me he wasn't coming home, and I saw him only one time again in the next five years. I remember seeing his car down the street where we lived when he was visiting the woman he left my mother for. But he didn't visit us. I must have missed him, but I don't remember thinking about it much. My father stopped paying his alimony and child support so my mother had to take him to family court to get him to pay. My mother took my little brother and me to court with her, and I got all dressed up because I wanted to look nice when he saw me. I wore an orange and pink dress with puffy sleeves and white rubber boots and I remember feeling both excited and nervous about facing him. We waited and waited but he never showed up and we went home without ever seeing him. Then my mother met a new man, and shortly thereafter they got married.

Everybody loathed my stepfather except my mother. Her mom and dad—my grandparents—disliked him so much they moved to North Miami to be as far away from him as possible. This devastated me, as my grandmother was my favorite person in the world. Grandma Lillian was

Debbie Millman, age 10, with her grandma Lillian, summer 1972, Long Island.

a feisty little lady with coiffed silver hair and shimmery pink fingernails. She made mouth-watering meals whenever I came to visit her Brooklyn apartment on McDonald Avenue: melt-in-your-mouth pot roast with fluffy kasha varnishkes, crunchy potato pancakes, and the softest, sweetest cheesy blintzes with cold sour cream. Every meal ended with my grandmother's famous butter cookies. Shaped like daisies with a single, perfect chocolate chip in the center and baked to a golden perfection, my grandma's cookies were the very definition of happiness to >

Black and White Cookies

212

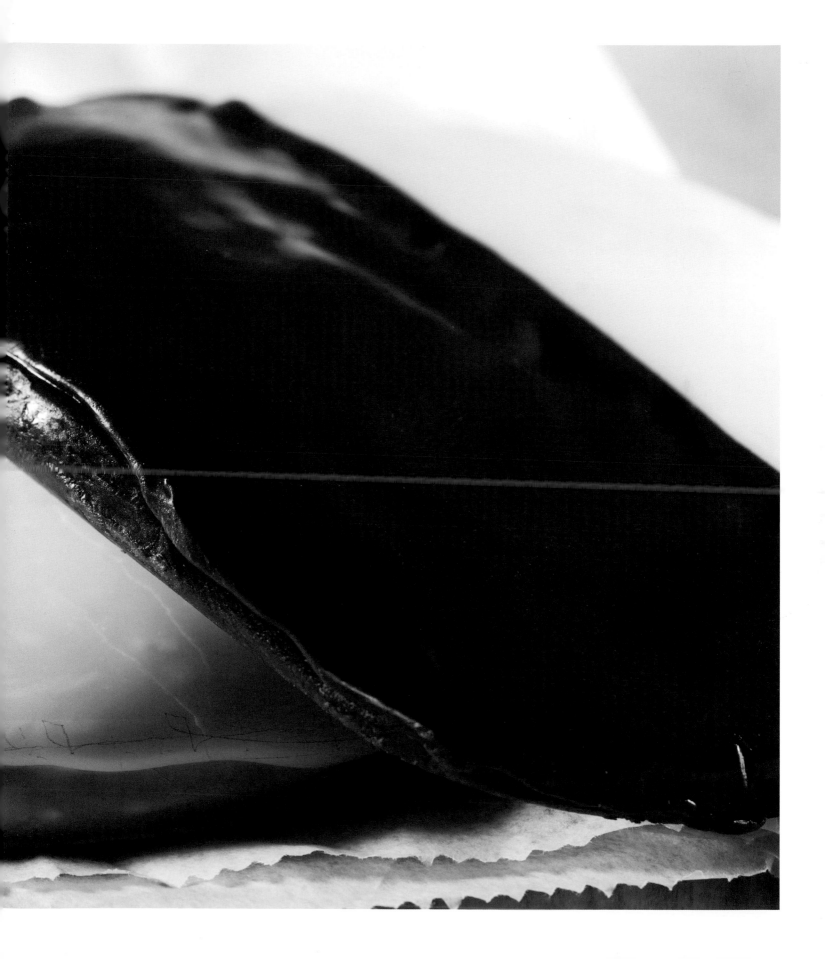

my 10-year-old self.

All that ended when my stepfather moved in. He was short and thick and had the stubbiest fingers I'd ever seen. He was curt and violent and I was terrified of him. My brother braved it in our home until he was 13. When he couldn't take it anymore, he called my father and he came and took him away. I didn't see much of my brother for the next ten years. Neither did my grandmother.

Every couple of months Grandma mailed me a care package filled with cookies. I was gleeful when it arrived—I could always recognize her loopy script and the 50 two-cent stamps haphazardly stuck on the box. I'd take my time opening my precious package, and I would ration the cookies so they'd last as long as possible. I'd imagine her with me as I slowly ate them, fantasizing what it would be like to hear her laugh or feel her hand. I missed her.

> I'd take my time opening my precious package, and I would ration the cookies so they'd last as long as possible.

Years later, after Grandma Lillian died, my mother, my brother, and I met at her funeral. I hadn't seen my brother in a long time and we were both cautious and glum. We tentatively talked about our memories, and I waxed sentimental about our grandmother's cookies. Suddenly he perked up. "Hey!" he said. "Grandma sent me a box of cookies when I was at school. But as I opened them up, I realized that mice had eaten through the box. I had to throw the whole thing away. What a waste."

I didn't know what to say. I looked at him and tried to find the years between us. I wasn't sure if they were there.

DEBBIE MILLMAN
Writer; educator; artist; designer;
podcast host, *Design Matters*

RATNER'S RICE PUDDING

Makes 6–8 servings

3 cups cooked, drained rice

2 eggs

1 cup golden raisins

3 cups milk

2 cups half and half

½ cup sugar

2 tablespoons melted butter

1 teaspoon vanilla extract

cinnamon

In a saucepan combine sugar, half and half, milk and rice. Cook, stirring occasionally, for 30 minutes.

Beat eggs. Put a small amount of hot mixture into eggs and then stir the eggs into the saucepan. (This prevents the eggs from curdling.)

Stir in vanilla extract, butter, and raisins.

Pour mixture into individual serving dishes and sprinkle top with cinnamon.

Cool the rice pudding and refrigerate until ready to serve.

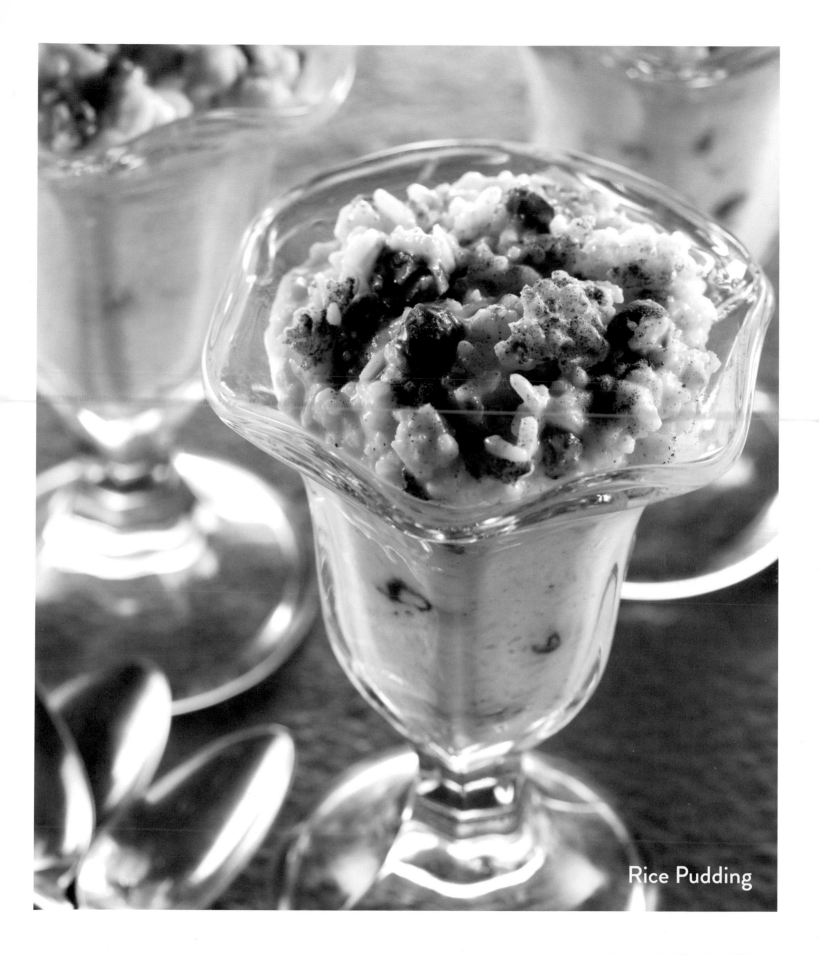

Rice Pudding

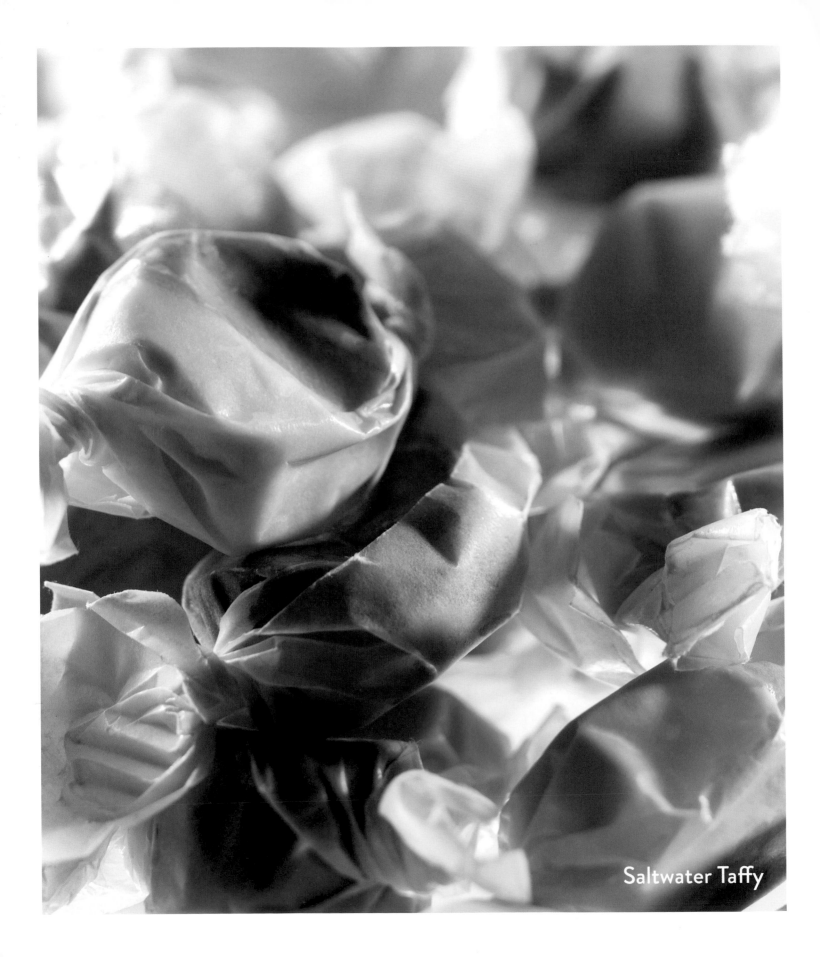

Saltwater Taffy

THE COFFEE CAKE ON 72ND STRASSE

We were only tenuously Jewish as I was growing up in the New York of the 70s and 80s. My parents had both been displaced by World War II: my father sent by his foresighted aunt to a boarding school in London in 1937 (age 16), even though he didn't speak English; my mother and her mother escaping Prague, also to London, in 1939 (age 2). They both lived out the war in England, but only met on a beach in Montauk after they both emigrated to New York postwar. The war experience scarred them in different ways: my father was much like a character in a WG Sebald story, a shadow-man ghosting through the diaspora. Religion, he said, understandably given everything, was an excuse for people to murder other people, a holy cloak for the basest of instincts. My mother's mother converted to Catholicism before leaving Prague and christened my mom, and though the only sign of Christianity in our household was the annual Christmas tree and ham, my grandmother passed on a very low-grade self-hatred that I've seen referred to elsewhere as "social anti-Semitism."

I was not told I was Jewish, and though I probably knew I was on some level, it seemed like a stone not worth overturning. Jews in New York didn't really talk about being Jewish back then; it was a narrative too raw, still, to unmute. In fact, religion was generally seen as anathema to the idea New Yorkers had of themselves as truly cosmopolitan, truly modern. It took a new generation starting in the mid to late 80s, un-traumatized by the war, to feel safe enough to dust Judaism off and openly celebrate its traditions.

We did, however, have the Eclair Pastry Shop. The Eclair, as I learned only after his death, was founded by a half-Italian, half-Czech Jewish immigrant named AM Seliger, who had been a sugar broker in Vienna before the war. He fled in 1939 and opened the Eclair at 141 West 72nd Street to service the waves of Mitteleuropean refugees who swarmed into New York during and after the war. According to the *New York Times* obituary on Seliger, regular customers included a who's who of refugee Jewry: Isaac Bashevis Singer, Bruno Walter, Rabbi Stephen Wise, Barbra Streisand.

My branch of the Eclair was on East 54th Street, and my parents would take me there every Saturday for strudel, cookies (the nice lady behind the counter always gave me two—not just one—for being cute), a stollen around holiday-time, or on special occasions a Schwarzwalder Kirschtorte seven-layer cake. The coffee cake, though, is the cake that haunts me to this day. The term "coffee cake" conjures up different images, but this was unlike anything you'd imagine coffee cake being today: It was flattish, like

> Jews in New York didn't really talk about being Jewish back then; it was a narrative too raw, still, to unmute.

a swollen stollen, riddled through with nuts and sometimes candied fruits, lousy with cinnamon filling, and generously topped with an icing that was sweet but never unctuous. When Eclair went under in the 90s, I searched the city for a replacement. Zabar's comes closest, but that's not really close at all.

I am at times haunted by memories of that coffee cake. Recently, on a trip to Boston that had already put me in an unaccustomedly maudlin frame of mind, I awoke suddenly at 4 a.m. with a profound sense memory of Eclair, the coffee cake, its taste, smell, mouth feel. It felt then, as it does now, tied up in so much unspoken history and longing as to be almost too much to bear.

Oh, and my 12-year-old son Paul, who had expressed no interest in my tradition until a few months ago, announced he wanted to be Bar-Mitzvahed. These things are not unrelated.

MICHAEL HIRSCHORN
Ish Entertainment

With champagne,
Sol and Janice celebrate
their wedding in London.

THE FLYING DUTCH CHEESECAKE

When I became a convert to Judaism and married Sol Tanne, I also became a convert to New York Jewish food. I had a lot to learn. My mother was a Brit: Cook it until it's dead and then half an hour more.

Sol had grown up on Avenue C on the Lower East Side. A Cooper Union engineering grad with years of experience in automation, he was in demand for designing ports around the world in the new era of container ports. He set up his consulting firm in Rotterdam, the world's largest port, a good center for travel.

He commuted. Romance was transatlantic.

What Sol missed was New York Jewish food, most especially New York cheesecake. In a flood of romance I decided to make cheesecakes so he could take one with him when he flew from New York to The Netherlands every few weeks.

I consulted my art director—I was then director of publications for a foundation—because his wife was known to be a good cook. She may have had Polish ancestry but she surely had a recipe for an excellent New York style cheesecake. I have made minor tweaks to the recipe, but here it is, the same cake that Sol took with him from New York to Holland on many a jet for many a year.

And yes, we lived happily ever after.

JANICE HOPKINS TANNE

New York correspondent, *British Medical Journal*

JANICE HOPKINS TANNE'S CHEESECAKE

◆ ◆ ◆

2 pounds cream cheese

7 eggs

7–14 graham crackers

1½ cups white granulated sugar

1 cup heavy cream

the juice of one lemon

1 teaspoon vanilla extract

butter

You need one 12-inch (30 centimeter) flan ring or spring-form pan and an electric egg beater/mixer, because a lot of beating is involved.

Prepare the pan. Lock the two parts together and generously rub the insides with butter, especially where the top and bottom parts join.

Crush the graham crackers and shake them into the prepared baking pan. Make sure all the sides are covered and pat the crumbs to cover the join between the top and bottom of the pan.

Separate the eggs. Put the whites in a separate bowl and beat until they are stiff.

Put the cream cheese (which you have brought up to room temperature) into a big bowl. Use the egg beater/mixer to break up the cheese. Keep adding the egg yolks and the cream until you have a thick liquid. Then add the sugar bit by bit and then the lemon juice and the vanilla extract.

Heat the oven to 350° F.

Now let the egg beater/mixer run for 10 minutes or more to beat up the mixture. Use a spatula to push the batter down from the sides of the bowl to the center.

Gently fold in the egg whites that you have beaten to stiff peaks, using the spatula.

Gently ladle or pour the batter into the cake pan, trying not to disturb the graham cracker crust. The batter should come up close to the top of the pan, but not above the edge.

Slide the pan into the oven and bake at about 350° F for 1–1 ½ hours. Don't look before the first half hour or 45 minutes.

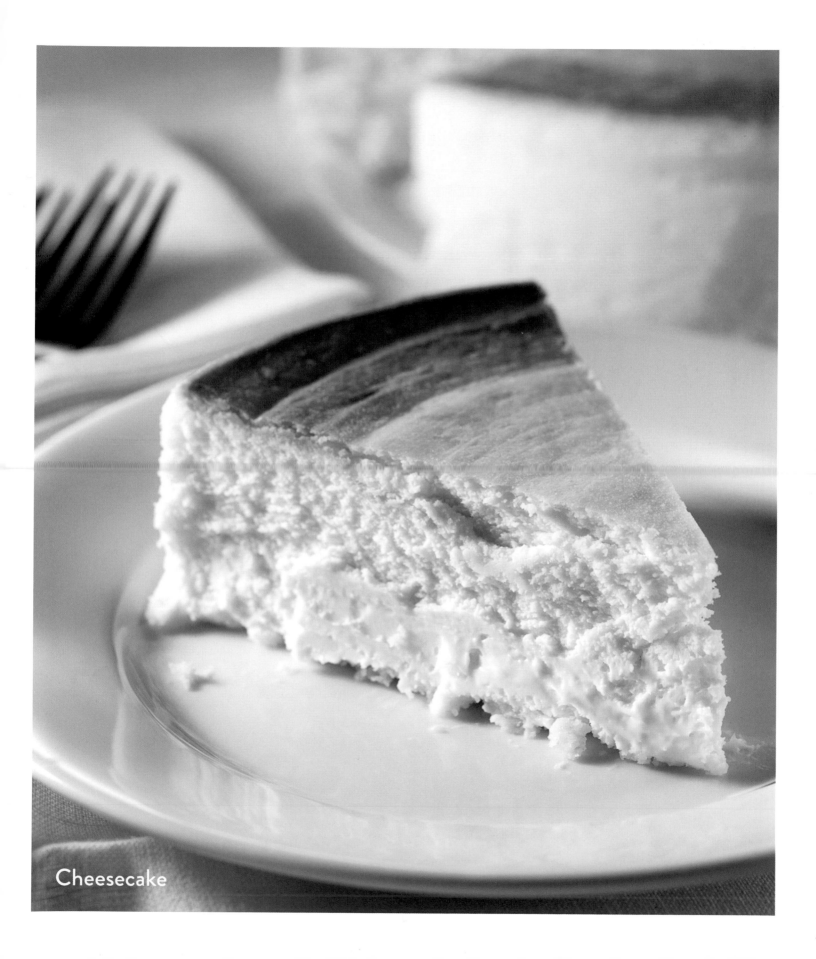

Cheesecake

Charlotte Russe

CHARLOTTE RUSSE

sponge cake

raspberry jam

homemade whipped cream

maraschino cherry

Everyone who comes to Holtermann's Bakery to buy a Charlotte Russe usually has the same story. The story begins with:

"I remember my parents taking me to the bakery, and on the way home we always enjoyed eating the Charlotte Russe, together. . ."

—Cliff Holtermann, owner Holtermann's Bakery, Staten Island, New York

HAD THE WORLD ON A STRING

My parents, my older brother, and I all slept in the same bedroom in a tiny ground floor apartment in Crown Heights on Union Street, between Schenectady and Utica Avenues. My grandparents lived diagonally across the street to the right and my mother's brother and his family lived a few buildings to the left. We all saw each other quite frequently. I don't remember seeing my mother Ruthie, my grandmother Elsie, or my aunt Dottie without an apron on.

Even though no one in my family was religious, we all got together for Shabbos dinners every Friday night. It was more social than religious even though my grandmother always lit candles. We would climb the five flights of stairs to my grandparents' apartment and by the time we hit the third floor you could smell the chickens, briskets, and kugels being prepared. We all got fat on chicken schmaltz and egg creams as well.

I spent many a day playing on the 10 x 15-foot covered concrete porch outside of my apartment building. As a young child I wasn't allowed to venture out, so my entire fantasy world was that limited surface. I wasn't alone. I had my pretend dog to keep me company. He was made out of a shoe box and a string I tied to it so we could go on walks around the small corridor as you entered my building.

When I wasn't playing with my dog, I amused myself by watching others go about their business on the block. I don't know why, but it was acceptable for men to pee in the street between parked cars. That was pretty interesting. We also had a lot of stray cats running around. To this day, I am not fond of cats in general.

The big events of my early life in the 1950s were family circle meetings, walks on Eastern Parkway, my father playing hit the penny with me, and the occasional visit to Nathan's. My father would salt the fries and then shake them in a white paper bag. Nothing tasted better. The men in the family went to Ebbets Field once or twice a year and the women played mahjong once a week.

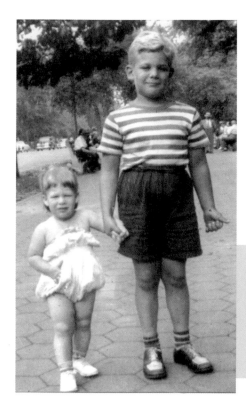

Lois at age 2 with big brother Steve, 6, working off a knish on Eastern Parkway.

Life was pretty normal until we got robbed. Someone climbed through our kitchen window (always left ajar) and snuck into the bedroom where the four of us slept. My brother's bed was adjacent to my parents and my cot was perpendicular to both. The room was totally cramped, so I don't know how the burglar crept to my mother's night table to steal the white gold watch my father gave her. I still get the creeps today thinking about it. The police told us to keep our windows shut, but it was stifling hot in the days before air conditioning. My father slept with a bat next to him from then on and my mother became an insomniac.

The only good thing that came out of the robbery was that my uncle treated everyone to dinner at Dubrow's Cafeteria at the end of our block the next night. In those days, if you wanted a cure for your woes you feasted on pickled herring, lox, bagels, white fish, and chicken soup. We all topped off the meal with a Charlotte Russe for dessert. We ate like it was our last meal. In those days, it could have been.

LOIS WHITMAN-HESS
Co-owner, HWH Public Relations

Kedem Wine

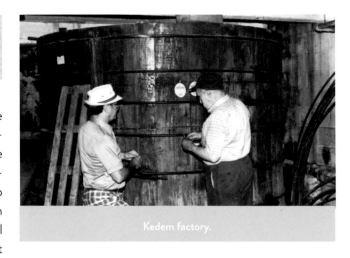

Kedem factory.

Let's begin a twisty tale with a Generation X couple dividing the Sunday paper on the morning of January 5, 1997, in a 14th-floor Lower East Side middle class kitchen. Eventually, 26-year-old Melissa Caruso hands *The New York Times* Metro Section to John Scott, her college sweetheart and fiancé, and asks him to read a curious article out loud about a one-story retail space at 107 Norfolk Street—complete with a basement catacombs containing 28 abandoned jumbo wine casks.

The site, according to the *Times* reporter, once belonged to the country's leading kosher wine corporation, Kedem, and might date to the turn of the 20th century.

Fixated on the casks, the breakfasters forge a screwy plan—they'll loop in that hipster heiress they know who "maybe wants to invest in future projects."

William Gottlieb Management has not spent a dime on staging the property. The heiress is out, but Melissa and John are still drawn to the magical cooperage languishing in the basement. Eventually they tap into their savings, and in a 20-something tradition, max out their credit cards.

Now hopscotch to 1899, a year in which restaurateur Sam Schapiro will smell opportunity in the humble Concord grape.

After arriving in the Lower East Side from Galicia in the Austro-Hungarian Empire, Schapiro has had middling success with his small corner kosher eatery at 83 Attorney Street. There are over 500,000 other Jewish residents of the Lower East Side in 1899, and kosher eateries are a dime a dozen. Kosher whiskey and rum distilleries abound. But what about wine?

Schapiro adds a small kosher winery to the basement of his restaurant, the first of its kind in New York.

Schapiro muses about the Concord grape wine that locals choose to make at home simply because the cheap grape is so readily available in New York.

Schapiro adds a small kosher winery to the basement of his restaurant, the first of its kind in New York.

In 1907, he relocates his shop to 126 Rivington, and the winery does decent enough business.

The original mass-market Concord grape wine has the most memorable advertising slogan in the history of wine and it stays: "So Thick You Can Almost Cut It with a Knife!" Schapiro's soon moves over 100,000 cases of wine.

Meanwhile in 1943 over at 107 Norfolk Street, a one-story building built in 1939 as a kosher meat storage unit is being shown to a potential buyer, Joseph Abraham Hersh.

The stocky, bespectacled, five-foot-nine-inch immigrant son of a Hungarian vintner is a proud and proper man who always wears a suit to walk to his store, where he changes into his work pants. He connects with a man named Harry G. Silverstein, whose family owns 107 Norfolk Street.

Hersh buys 107 Norfolk Street in July and moves in his business. He arranges for local coopers to build 28 casks in two sizes, out of oak and Douglas fir. He also asks his daughter Rita's husband, the articulate and outgoing 20-year-old Meyer Newfield, to serve as his assistant winemaker. Newfield is fit and tall and Hersh needs some extra muscle. Newfield agrees to help out. Newfield is>

now an 88-year-old widower. From his winter condo in Century Village of Deerfield Beach, Florida he can name all the kosher winemakers in the Eighth Ward, 60 years later. "Ganeles-Lenger was number two, Hersh was three, and Lifshitz four. The rest were not so big. But we all made the same sugary wine."

By 1965, the neighborhood is getting dodgy, and Hersh is getting older and ready to call it quits. He calls over at Ganeles-Lenger see if they want to take over the premises. Hersh knows the owner, Rabbi Schmuel Dov Bear Ganeles, who started in Prohibition times with Meyer-Ganeles wine, from way back.

But just one year into the Ganeles' ownership of the new premises at 107 Norfolk, they decide to sell.

So, Hersh is out. Ganeles-Lenger is out. But to understand exactly who the next owner of 107 Norfolk Street is, we must quickly rewind to 1948.

So it's 1948 again, and we're at Royal Wines, a struggling corner store kosher cellar at the skinny Little Italy extension of Delancey Street called Kenmare Street.

At right about this time, Eugene Herzog, a man with many secrets arrives in NYC and approaches the Royal partners who know of the Herzogs. Founder Emanuel Herzog, started making wine in 1848 in Vrbové, Slovakia. Emanuel Herzog's great-grandson Philip Herzog was given the title of baron because Austro-Hungarian Emperor Franz Josef so adored his off-dry riesling.

Eugene Herzog explains that despite the family's early fortunes, he arrived in America with only $3,000 and the Herzog family's wine recipes. During World War II, Nazis seized the winery in Czechoslovakia.

Herzog goes to work for Royal Wine—a good portion of his salary paid for in company shares. When he eventually gains control of the shares, his family decides on the name Kedem, translated as "Moving forward."

But now we are back to the Scotts, back to primetime hipster Generation X Lower East Side when rents are skyrocketing. A losing battle.

LAURIE GWEN SHAPIRO
Writer; filmmaker

YETTA WISE'S MANDEL BREAD

◆ ◆ ◆

1 pound butter

8 eggs

8 cups flour (scant)

6 cups walnuts, cut coarsely

2 cups sugar, creamed well with the butter

2 round teaspoons baking powder

2 teaspoons vanilla extract

1 pinch salt

Mix well. Shape into 1 or 2 loaves and put on buttered cookie sheet. Bake at 350° F until golden brown.

Remove from oven. Slice diagonally with sharp knife while hot into ½-inch slices.

Lay the slices on their sides, replace in oven at 325° F until lightly brown.

Turn on other side (leave another 10 minutes).

To make any of the mandel bread recipes marble, take a small amount of the finished raw batter and add Fox's U-Bet chocolate syrup, mix well, and twist it in with the white batter.

Marble Mandel Bread

"Un a Glazele Tey"

In memory of my father,

who would only drink tea out of a glass.

AARON REZNY

ACKNOWLEDGEMENTS

Over the course of creating this book, numerous friends, colleagues, and family members have provided much assistance and support, to say nothing of the mazel tovs and encouragement. Many have provided us with expert advice, professional services, and support for our book, and we are extremely grateful to each and every one of them.

Thanks to all our contributors for their wonderful, heartfelt, and fun memories: Abbe Aronson, Alan Dell, Alan Katz, Andrew Freeman, Arthur Schwartz, Bette Midler, Bob Greenberg, Bob Morris, Cara De Silva, Caroline Hirsch, Cliff Holterman, Dan Shaw, Dan Weiller, David Rothkopf, David Steinberg, David Zimmerman, Debbie Millman, Denice Mitchell, Devra Ferst, Don Rickles, Dr. Lew Sellinger, Dr. Miles Galin, Edward Kosner, Elizabeth Ehrlich, Ellen Anistratov, Elliott Erwitt, Elliott Landy, Erica Kalick, Erik Greenberg Anjou, Fred Goldrich, Freddie Roman, Fyvush Finkel, Gabrielle Bordwin, Helene Blue & Ken Bloom, Helene Jacobs Fine, Howard Greenberg, Iris Burnett, Irwin Corey, Isaac Mizrahi, Itzhak Perlman, Jack Lebewohl, Jackie Mason, Jake Dell, Janice Hopkins Tanne, Janis Ian, Janna Ritz, Jeff Kagan, Jeremiah Moss, Joan Rivers, Jonathan Ames, Joshua Bell, Joyce Beymer, Kyle Richards, Laurie Gwen Shapiro, Laurie Wolf, Lisa Gutkin, Lois Whitman-Hess, Lou Reed, Lydia Rosner, Malcolm Taub, Martha Frankel, Martin Keltz, Mary Giuliani, Melanie Mintz, Michael Hirschorn, Michael Kramer, Michael Lang, Michael Levine, Milton Glaser, Mitchell Cohen, Paul Goldberger, Rabbi Seth Limmer, Raymond Levin, Renee Silver, Robert Harmatz, Robert Klein, Roland Menchell, Ronald Mandelbaum, Scott Feinberg, Stephen Schonberg, Steven Lutvak, Theodore Peck, W.M. Hunt, and Warren Shoulberg.

Thank you to our agent, Lisa Gallagher, for recognizing our vision; and powerHouse Books, our publishers Daniel Power and Craig Cohen, our editor Will Luckman, and our designer Francesca Richer, for realizing our vision.

Thank you to Arthur Schwartz, Yonah Schimmel, Katz's Deli, 2nd Ave Deli, Sammy's Roumanian, and the former owners of Ratner's, for their generous recipe contributions.

Thank you to Leslie Baxter for her luscious food styling, Sara Abalan for her prop styling and research, Ward Yoshimoto for his help with the photography, and Ber Murphy for his post-production work.

We would both like to thank James Rezny and Kaitlyn Rezny, Aaron's children, for their never-ending help, encouragement, and support.

From Aaron: A heartfelt thanks to Allegra Wilde for helping me find what was lost.

In memory of my parents Hyman and Molly Rezny. Thank you for the love and nourishment.

From Jordan: A heartfelt thanks to my late parents, Sam and Helen Schaps, my sister Carole (Garman), and Bubbe Ethel Raben from whom I learned unconditional love.

We would both like to thank Ed Kosner for being there for us year after year, always with support, wisdom, and care.

To Lois Whitman, Lisa Mionie, Janna Ritz, and Michael Todd for graciously helping us with contributors.

Also, thanks to: Richard Andres, the team at Fotocare, Michele Karas, Degen Pener, Dr. Lew Sellinger, John Killacky, Dan Weiller, Elena Paul, David Lombardo, Ellen Gould, Laurie Wolf, John Carroll, Erin Hosier, Joyce Beymer, Gillian Cilibrasi, Lisa Protter, Jerry Fastman, Stephen Steiner, Art Klein, Cara De Silva, Paul Goldberger, Desiree Portugues, and Efrem Zelony-Mindell for their great contributions, help, support, and encouragement. And a special thank you to Stephen Dubner for great advice.

Thank you to Fyvush Finkel and the Finkel family for his eloquent Foreword to our book. It is truly appreciated.

A special thanks to Abbe Aronson, grande dame of Abbe Does It, for all she did, with never-ending enthusiasm.

Special thanks go to the fabulous Joan Rivers for her Introduction, and of course, to Jocelyn Pickett and Jonathan Van Meter for being the machers who arranged for us to hear Joan's wonderful story.

FINALLY: Aaron Rezny would like to thank Jordan Schaps and Jordan Schaps would like to thank Aaron Rezny.

They tried to kill us.
We survived.
Let's eat.

PASSOVER PROVERB

EATING DELANCEY:

A Celebration of Jewish Food

Photographs © 2014 Aaron Rezny
Compilation and editing © 2014 Aaron Rezny and Jordan Schaps

All individual texts © their respective authors and used with permission.
Archival photos © their respective owners and used with permission.
"Eating Delancey" is a trademark of Aaron Rezny, Inc., all rights reserved.

All rights reserved.
No part of this book may be reproduced in any manner in any media, or transmitted by any means whatsoever,
electronic or mechanical (including photocopy, film or video recording, Internet posting,
or any other information storage and retrieval system), without the prior written permission of the publisher.

EGG CREAM Written by: Lou Reed ©1996 Lou Reed Music. All rights administered by Sony/ATV Music Publishing LLC,
424 Church Street, Nashville, TN 37219. All rights reserved. Used by permission.

"Mushroom Barley Soup," "Matzo Balls," and "Potato Latkes" from THE SECOND AVENUE DELI COOKBOOK:
RECIPES AND MEMORIES FROM ABE LEBEWOHL'S LEGENDARY KITCHEN
by Sharon Lebewohl, Rena Bulkin and Jack Lebewohl, copyright © 1999 by Jack Lebewohl.
Used by permission of Villard Books, an imprint of Random House, a division of Random House LLC. All rights reserved.

Published in the United States by powerHouse Books,
a division of powerHouse Cultural Entertainment, Inc.
37 Main Street, Brooklyn, NY 11201-1021
telephone 212.604.9074, fax 212.366.5247
e-mail: info@powerHouseBooks.com
website: www.powerHouseBooks.com

First edition, 2014

Library of Congress Control Number: 2014942941

ISBN 978-1-57687-722-7

Printed and bound through Asia Pacific Offset

10 9 8 7 6 5 4 3

Printed and bound in China

Food Styling by LESLIE BAXTER
Prop Styling by SARA ABALAN

BOOK DESIGN BY FRANCESCA RICHER